Discovering the Powerhouse Museum

**Crowds queuing to
see the exhibition,
*Treasures from the
Kremlin: the world
of Fabergé.***

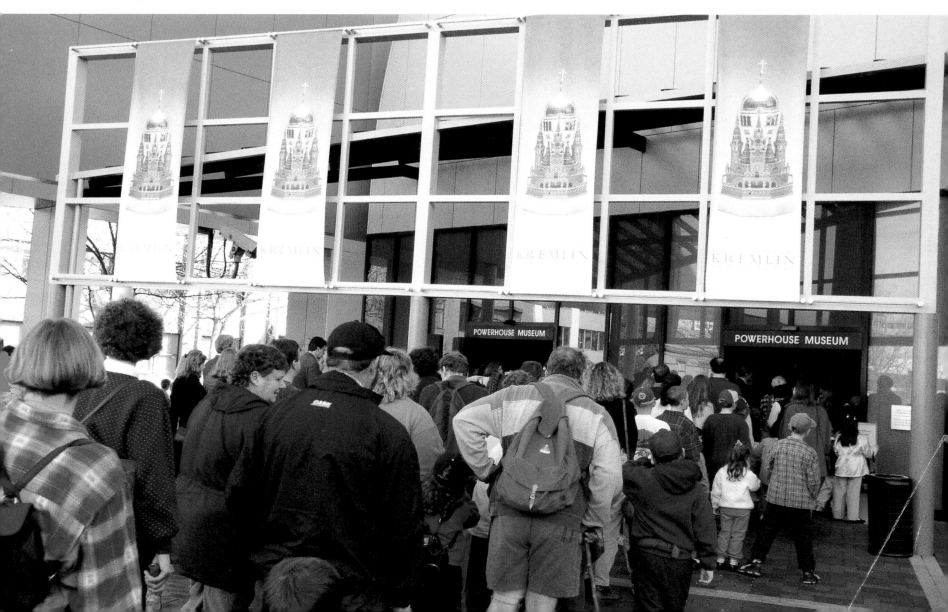

contents

discovering
the
Powerhouse
Museum

a personal view by
the Director
Terence Measham

Produced by The Beagle Press for
Powerhouse Publishing, Sydney

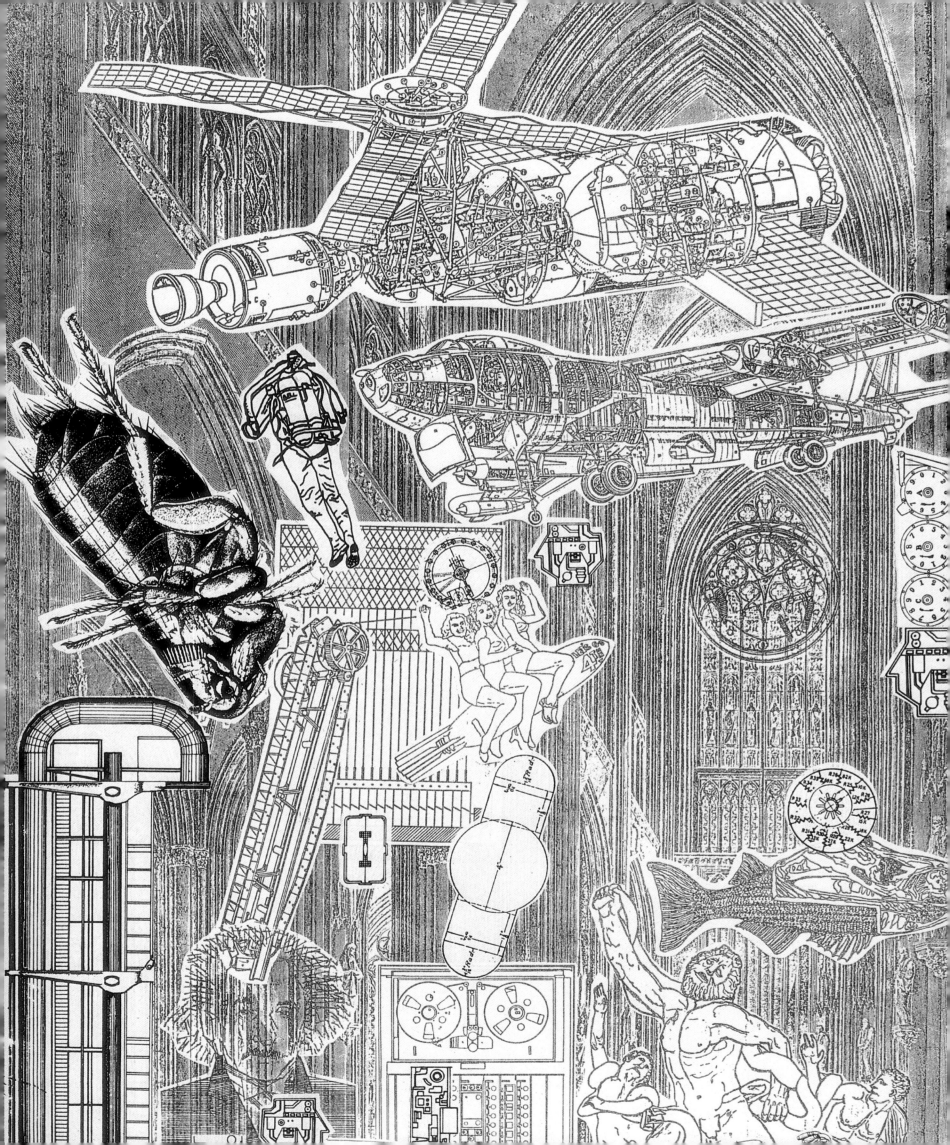

introduction

Objects, wonderful objects, old ones and new ones, were the subject of my last book, *Treasures of the Powerhouse Museum*. The theme of that book was, however, about more than the objects themselves. I set out to show that the whole was greater than the sum of the parts. The book advocated the special value and significance of a collection rare in its diversity. Few collections anywhere cover so many fields of human endeavour – across the sciences, technology, design, crafts and social history. Thus, I argued that the Powerhouse offers unique opportunities for people of all ages to engage in learning without the distortions and constraints of today's conventional boundaries of knowledge – and for individuals to enjoy learning at their own pace.

I also used *Treasures* specially to promote new acquisitions; objects acquired over the period of the previous five years or so. One strong reason for doing so was to celebrate the existence of the museum's Collection Policy, a substantial document hammered out in the early 1990s by a group of committed Trustees and dedicated colleagues on staff. Without that Policy guiding the museum, several spectacular acquisitions might never have been made. I'm thinking particularly of purchases made at auctions in New York or London when fast decisions are imperative.

The notion of a sequel to the *Treasures* book was simple to begin with. I wanted to publish more wonderful objects, more spectacular acquisitions which came in since that last publishing date. To a large extent I did continue with the idea of important new acquisitions (as well as catching up on a few old favourites) but a new and wider theme emerged. Why not take you, the reader, behind the scenes and give you at least a glimpse of the preparatory work which leads to exhibitions. After all, my real purpose is to explain as far as possible what a museum is. I have noticed that some members of the public tend to see little difference between museums and, say, exhibition halls such as those used for motor shows, boat shows or home shows. It is true that there is a small degree of overlap between some of our programs and such commercial promotions. We do create and receive travelling exhibitions, but it is usually the case that all our objects on view are unique and irreplaceable. That means that, for us, standards of atmospheric control, lighting levels and security are more crucial. It is also the case, generally, that our exhibition design is prototypical; it is one-off and inevitably expensive. Even when we send out exhibitions to other museums, we usually have to modify our design radically to suit local conditions. A motor show, by contrast, is laid out in modular fashion, allowing quick installation and removal. And if a Holden Commodore or a Ford Falcon gets scratched, a body panel can be quickly replaced from stock. Or a whole new car can be substituted, again from stock.

Museums do not have stockpiles. It is true that 97 per cent of the Powerhouse collection is kept in store. And that our storage facilities are filled to capacity, indeed to crisis levels. However, I will not dwell on that headache here.

The Powerhouse Museum has some ten thousand objects on view in the permanent galleries, as well as about twenty temporary exhibitions each year. And we carry out frequent changes to the permanent displays.

All this requires a great deal of expertise and work on the part of our staff. Curators play a key role in developing the collection and conceiving exhibition themes and story lines. Conservators see to it that objects are made ready for exhibition and enjoy optimum environmental conditions.

Registrars keep tabs on the locations of all objects and are expert in how to move them. That might mean transporting an aircraft with its wings taken off for the purpose or carrying a small porcelain plate where one slip means catastrophe. (I muse on this when watching cricket. When a fielder drops a ball the crowd reacts with emotion but that is nothing like the agony and despair which would be created by a 'drop' in the museum.) The people responsible for the presentation of objects are our exhibition designers, whose creative flair does much to attract visitors.

It is the expertise of museum staff that I have tried to reveal to some extent, as well as the objects that they care for, in this book. The museum profession is unusual in this day and age in that staff learn a great deal on the job from their more experienced colleagues. In universities, there are many excellent courses on museology, but all they can reasonably do is to equip graduates with a good theoretical foundation and a modicum of practical experience. I mention this partly for the benefit of those young readers who are curious about how to become qualified for museum work but mainly to emphasise the fact that in a special sense, museums are the people who work in them. Skills are passed on and initiatives have indelible consequences. Museums work on long time-lines. As I walk through the Powerhouse,

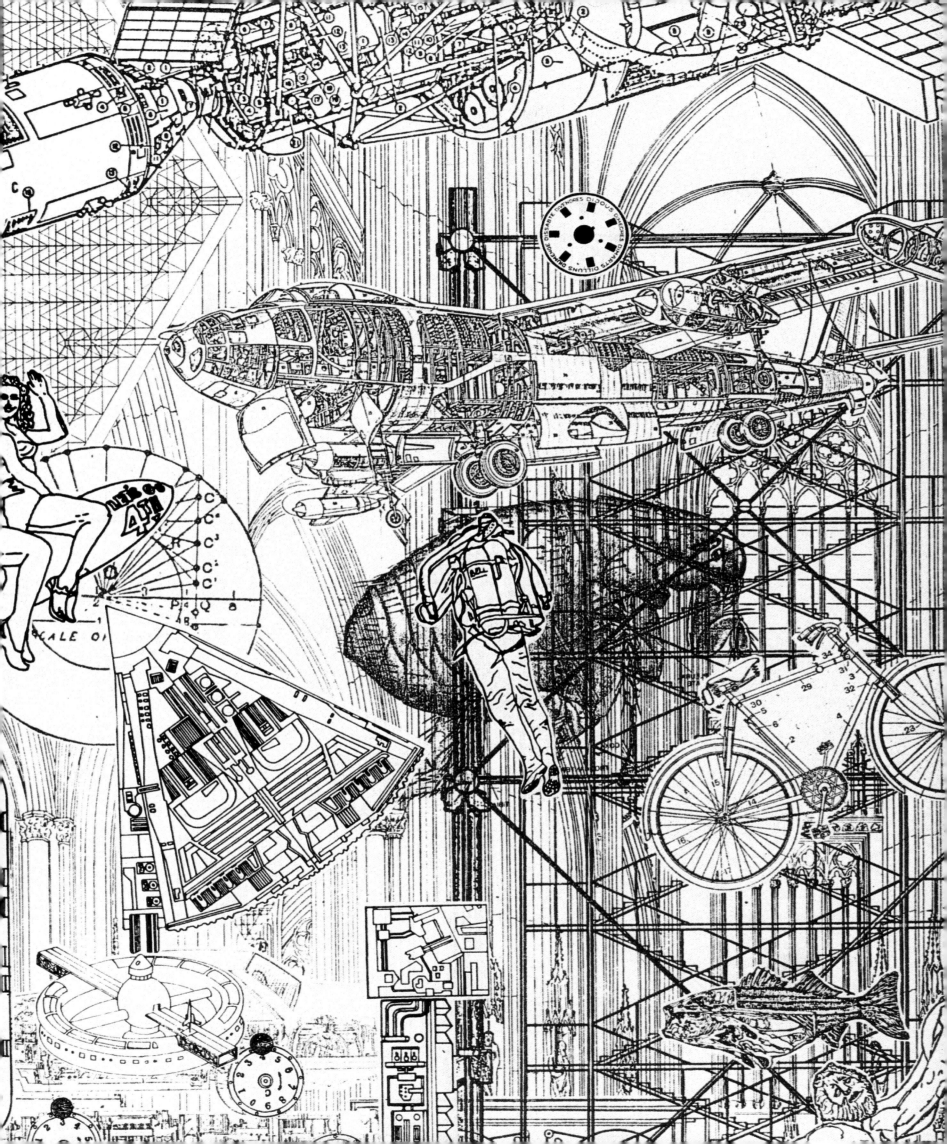

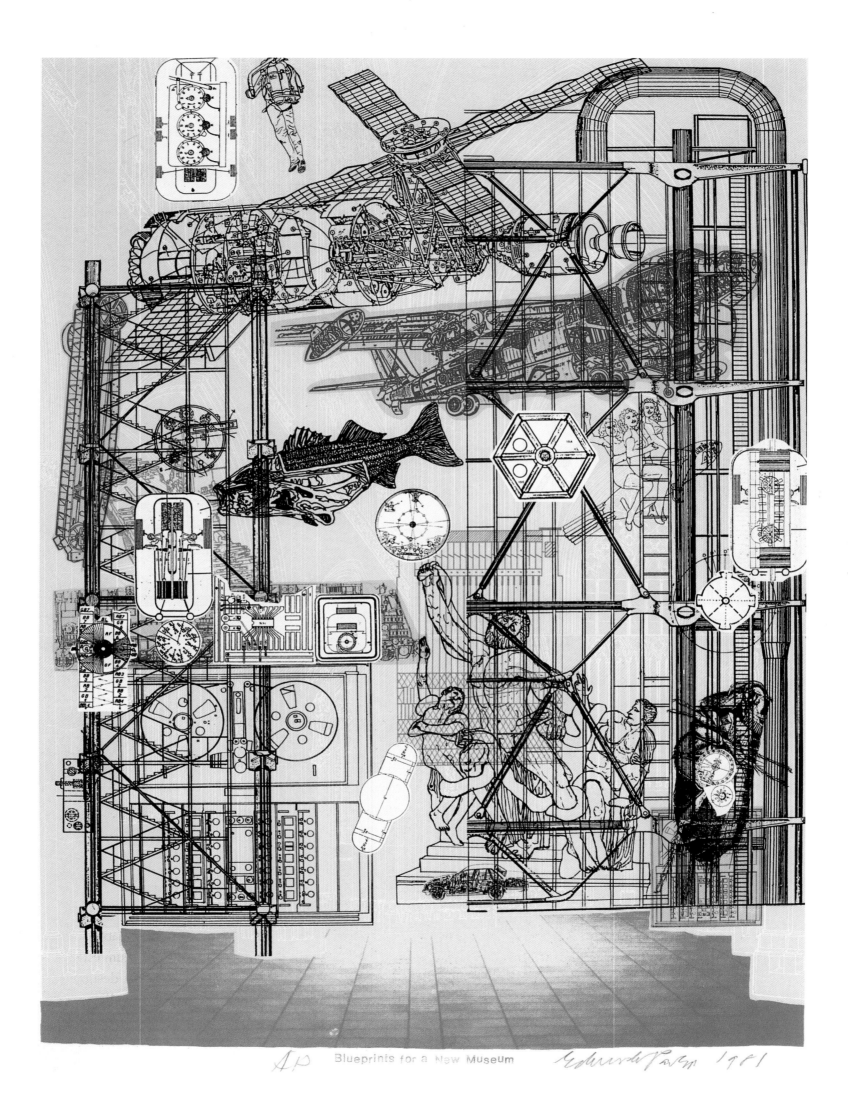

Blueprints for a New Museum

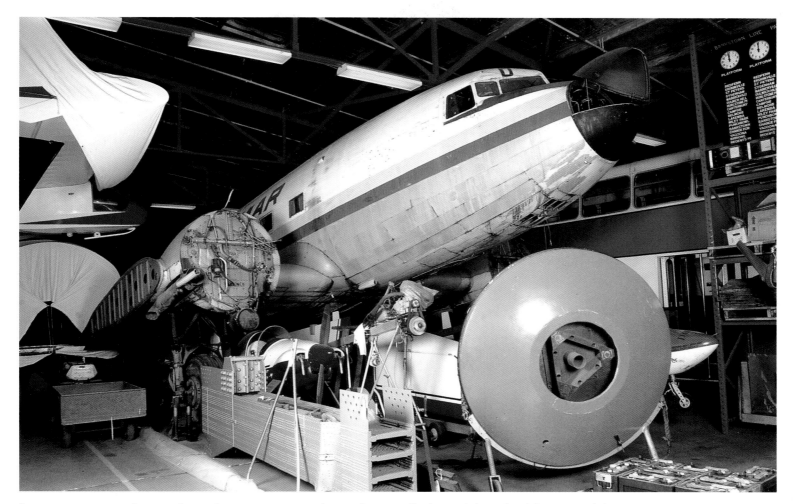

I can see at a glance the achievements resulting from decisions made a century ago.

Museums change. In recent years we have seen the introduction of interactives. These are devices which give visitors, mainly younger ones, something to do rather than remain passive. The Powerhouse has been a leader in interactives design, and their presence in the museum, interspersed among collection displays, has proved a popular drawcard. We make our own interactives, most, but not all, computerised, and our interactives design team is boundlessly creative. From time to time, however, I am alarmed when professional visitors embrace the idea that interactives are the key to the museum experience, making the collection redundant. The rise of science centres is partly to blame for this dangerous misconception. That is one reason, among others, why the Powerhouse maintains a judicial detachment from the science centre movement. We are less than siblings but probably not less than cousins.

For fifteen years, the museum presented displays at the Sydney Mint building on Macquarie Street. The history of the Mint is long, rich and somewhat chequered. That history and our association with the building is described in chapter 4. From 1997, our collection objects which have taken their turn on Macquarie Street, will reappear in the Powerhouse. This is because the NSW Government has decided to take the Mint on to the next stage in its varied history, as part of a new, integrated grouping of Macquarie Street's cultural precinct. The museum wishes the Mint well as we wave it goodbye. We were fond of it and I hope that chapter 4 will stand as a fitting record of the Mint's days as part of the Museum of Applied Arts and Sciences.

Museums change but not always predictably. In the nineteenth century, the first great age of museum establishment and expansion, august museums were designed as Palladian palaces or Roman temples. Occasionally, as in the

case of London's Natural History Museum, the building is suggestive of a cathedral. The second age of museum expansion has been in our own time and now, rather than occupying newly conceived fantasy buildings, museums have taken over redundant edifices. The Powerhouse Museum is a classic example (indeed, 'leader' is a safe claim) of this trend; originally founded in 1880, its first building was a *fin de siècle* arts and crafts design, complete with gables and terracotta tiles. More than a century later, in 1988, it occupied the recycled remains of a giant electricity generating station which had lapsed into dereliction, a ruin. This extraordinary rebirth was in fact predicted in an uncanny way in a suite of prints in the museum's collection. Eduardo Paolozzi, *chef d'école* of the British Pop movement, produced his vision in 1980 of a museum of the future. For this grand concept, he appropriated the interior of Cologne Cathedral. In all other respects he presaged with astonishing accuracy the complex displays of the Powerhouse Museum, with hanging aircraft, space travellers and bicycles.

Paolozzi is one of the most energetic of artists; his vision for a museum is full of that energy, an energy which is matched and realised at the Powerhouse Museum, as befits our name and our history.

It gives me pleasure to acknowledge the assistance, support and cooperation which so many colleagues and associates have extended to me. I am grateful to the Board of Trustees for their approval to do the book and I have enjoyed exchanging ideas with Jim Spigelman QC following his appointment as President of the Board in January 1996. I have appreciated the expert advice I have received from curators and other museum staff; several are mentioned in the text but the book is a tribute to all of them. Most of the illustrations are the work of staff photographers and the reader can judge how excellent they are. My thanks to Gara Baldwin for copyright clearances. For all other in-house aspects of the book I have depended entirely on Irma Havlicek, whose knowledge of the collection and the museum's programs has become prodigious. My gratitude to her is beyond words. Finally, it has been a great pleasure to work again with Lou and Brenda Klepac of The Beagle Press. They are an extraordinary mixture of passion and patience for whom the word 'civilised' might have been invented.

Terence Measham

A view over the *Transport* **exhibition, featuring the Catalina flying boat** *Frigate bird II* **in the foreground.**

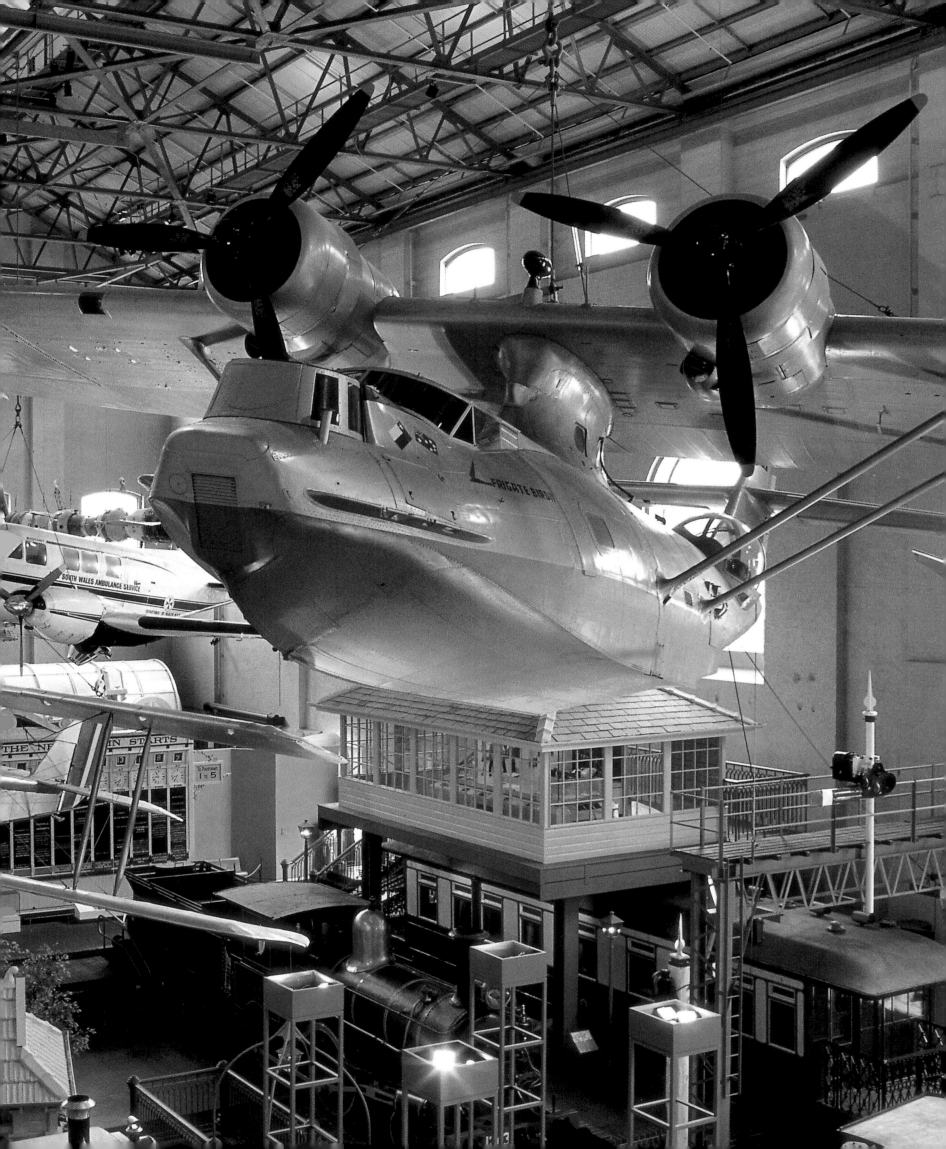

when
one
Dior
opens

More than 60 original designs by Christian Dior were on display in the 1994 exhibition, *Christian Dior: the magic of fashion.*

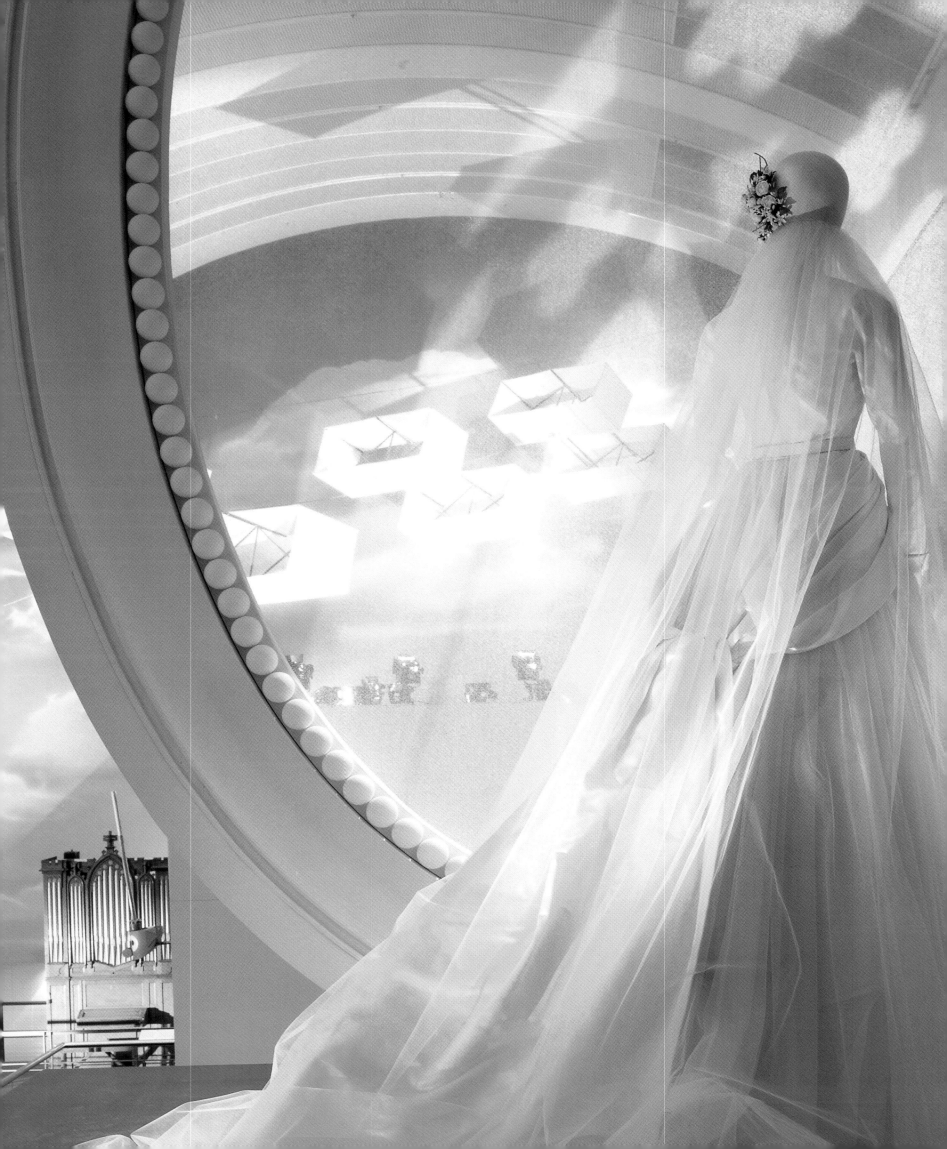

Different exhibitions for different audiences. **below** This guitar has laser beams, not strings, to withstand constant playing by visitors. Designed and made by the museum's Interactives Department for the *Real wild child: rock music then and now* exhibition.

The museum's collection has been developed since 1880, but most people think of the Powerhouse Museum as a new, or at least young, organisation. We have set out to win new audiences, to attract visitors who are perhaps not accustomed to museum visits. Compared with other museums and art galleries, we are visited by a much larger number of people who do not think of themselves as museum goers. Something in the order of 15 per cent of our visitors fall into this category. Natural history museums tend to receive very few such people and art galleries none at all.

We carry out a good deal of market research to try to understand who comes and why, and who doesn't come and why they don't. We also study the behaviour of the two different types of visitor – the frequent visitor and the infrequent visitor. The demands, the needs of both types of visitor, are quite different. The frequent visitor knows what to look for and goes straight for it. The infrequent visitor sees the visit as very much a social outing, probably comes with a group of friends and will be particularly disappointed if museum staff fail to provide exemplary customer service.

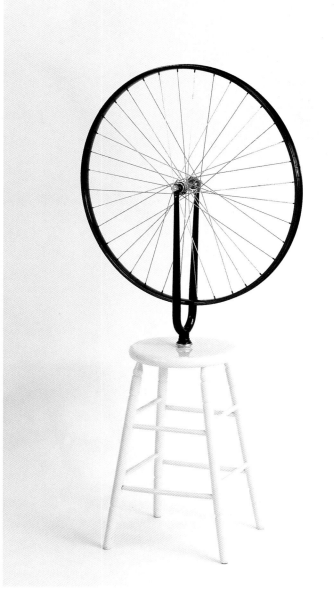

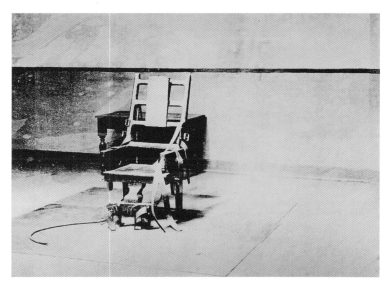

left MARCEL DUCHAMP (France)
(1887–1968)
Bicycle wheel 1913
bicycle wheel 64.8 cm; mounted
on stool 50.4 cm.
Collection: National Gallery
of Australia, Canberra.
Duchamp produced this absurd
assemblage in 1913 as a conscious
assault on aesthetic values.
Despite this, it became
a collectors item, with replica
versions in 1916, 1951, 1961,
1963. In 1964, a limited edition
(another absurdity) of eight was
produced, each signed, dated
and numbered. Number 4 was
bought by the National Gallery
of Australia where it is an
object of public veneration.
© 1964 Marcel Duchamp/ADAGP. Reproduced
by permission of VISCOPY, Sydney, 1997.

below ANDY WARHOL (United
States) (1930–87)
Electric chair 1967
synthetic polymer paint screen
printed onto canvas
137.2 x 185.1 cm.
Collection: National Gallery
of Australia, Canberra.
Violent death, car crashes, suicides
etc. were a principal theme of
prominent Pop artist Warhol in the
1960s. His *Electric chair* series
was shown in major exhibitions in
Paris and Stockholm. The image is
based on a photograph of the
electric chair in New York's Sing-
Sing gaol. The National Gallery of
Australia bought this example.
Visitors admire the mis-registering
of the screen-printing process
which gives a richer texture to an
otherwise deliberately bland
surface.
© 1997 Andy Warhol Foundation for the
Visual Arts/ARS, New York

The most important realisation to come from our market research is that a big, complex and diverse museum such as the Powerhouse cannot rely on a single audience but must attract multiple and separate audiences. In this regard, art galleries are different. By comparison, the clientele for an art gallery is much more homogenous. Some people may be especially keen on contemporary art and others on old masters, but the dichotomy that existed between those two tastes during the first half of the twentieth century is no longer an issue. Modernists in those early years were iconoclasts, and several movements, from impressionism onwards, such as fauvism, cubism, dadaism, futurism and surrealism, amounted to an assault on traditional art. Traditionalists, for their part, angrily dismissed the moderns as bunglers and confidence tricksters. Decades later, the art audience is much more sophisticated and unified. Everyone accepts continuity as essential to the nature of art. Art gallery goers enjoy walking across from old master galleries into those containing the moderns. Contemporary artists are at pains to reveal in their work their respect for the great painters of history and, of course, gain by the association.

Not only do the art gallery visitors form a single, homogenous group but they also use the art gallery in a way

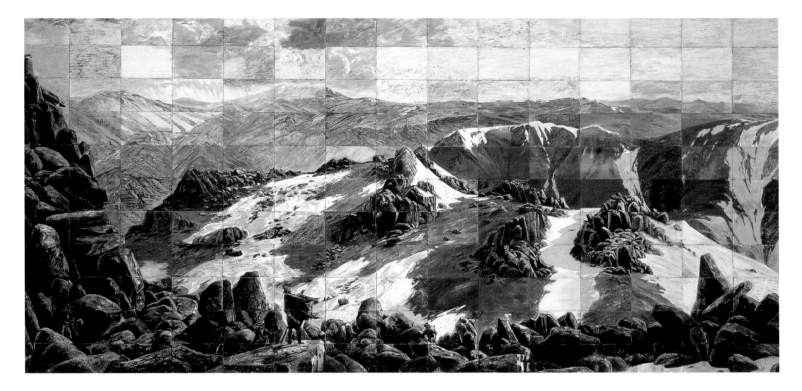

above **IMANTS TILLERS (b 1950)**
Mount Analogue **1988**
oil stick, synthetic polymer paint on 165 canvas
boards 279 x 571 cm.
Collection: National Gallery of Australia, Canberra.
right **EUGÈNE VON GUÉRARD (1811–1901)**
North-east view from the northern top of Mount
Kosciusko **1863**
oil on canvas 66.5 x 116.8 cm.
Collection: National Gallery of Australia, Canberra.
Contemporary artists enjoy making references to
famous paintings from the history of art. Here,
Imants Tillers makes a play on one of the National
Gallery of Australia's most celebrated paintings, a
view of the highest land formation in the country.
Von Guérard's landscape has a magical history:
improbably, the NGA discovered it in Mexico City
whence they acquired it in 1973.

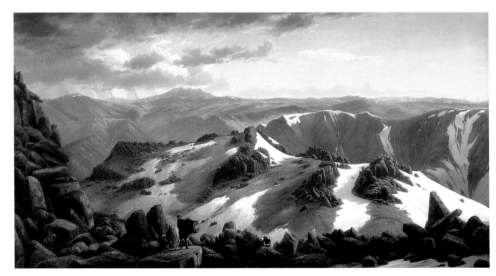

that is different from the way people tend to use a museum. Art galleries are a little bit more like churches; people want to join, to affiliate. Art enthusiasts encounter their fellows in the café. They might meet a well-known artist there or perhaps a curator. It is much more of a 'scene' than occurs or is wanted in a museum. The art world has greater social cachet. In New York, several decades ago, a pattern evolved which allowed opportunities for upward social mobility for those with money but lacking background. This pattern, like so many American cultural influences, has spread to other countries and Australia, with its multicultural mix,

has been affected. The art world is nowadays far more accessible to the novitiate thanks to the vast industry of art publishing, including books and magazines, which has grown since the 1960s.

This industrial phenomenon is linked to the other industry of mass tourism which permits package travellers, guidebooks in hand, to tick off old masters at a fast rate with much greater efficiency than was previously possible to aristocratic connoisseurs on their grand tours. Moreover, twentieth-century art requires very little connoisseurship compared with past ages. In modern times, artists go in for

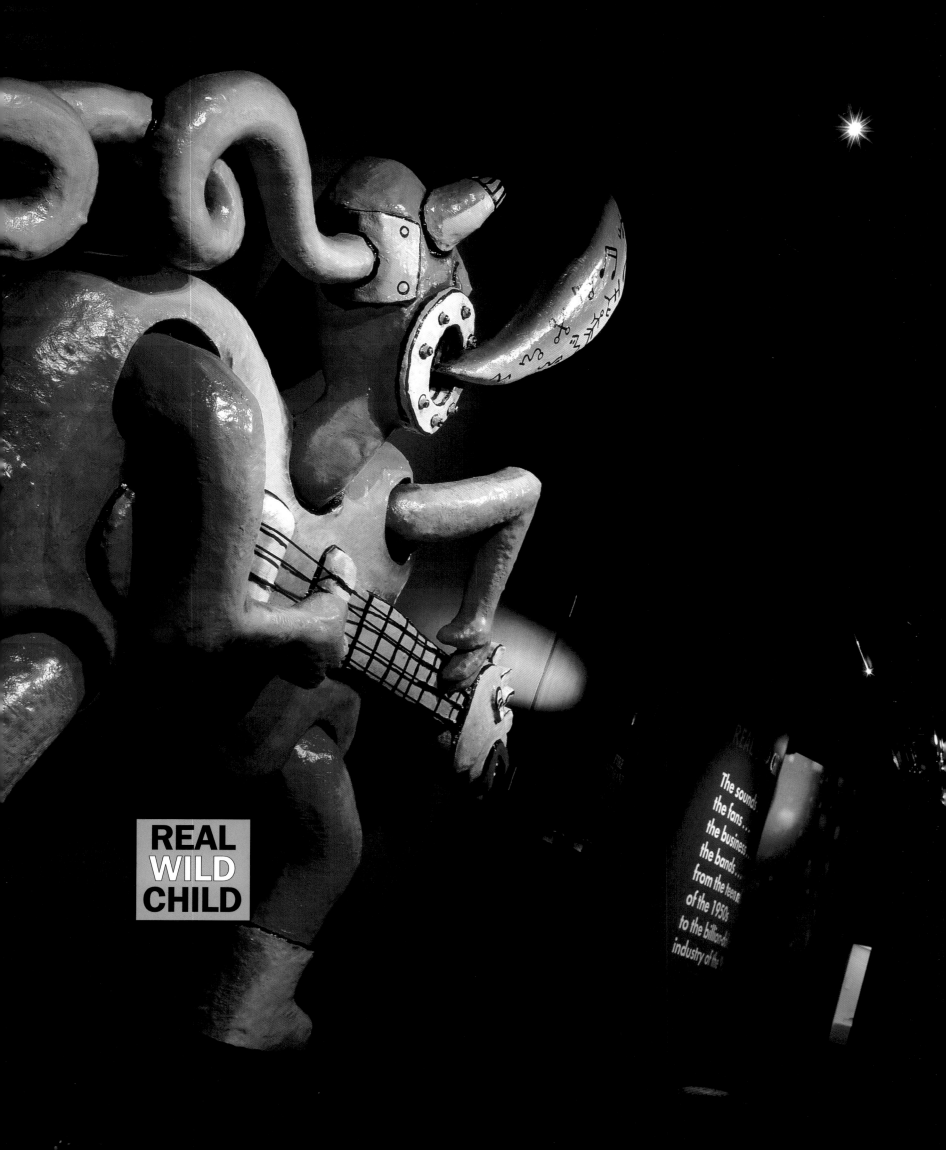

REAL
WILD
CHILD

The sounds...
the fans...
the business...
the bands...
from the teen era
of the 1950s
to the billion-dollar
industry of the

The logo at the entrance to the *Real wild child* exhibition was designed by Reg Mombassa, Sydney, 1994. Mombassa is best known for the designs he produced for Mambo, and as a member of the rock band Mental as Anything.

'branding', that is, they take care to develop brand images to try to make their work instantly recognisable. The old requirement to develop 'a good eye' through years of experience is no longer required.

A further major difference between the two types of *attraction* as the tourism industry calls us (to distinguish us from hotel bedrooms and plane tickets) is that for art galleries there are usually plenty of travelling exhibitions available at any one time. Paintings are light in weight and easy to package in both senses, physical and thematic. All the 'isms' mentioned above, and more, come ready themed. (It should be noted that 'isms' were initiated in the nineteenth century precisely for packaging reasons, because the salon system of showing paintings jumbled together made it hard for artists, especially newcomers, to get noticed. Other strategies were tried, besides creating stylistic movements. For example, Turner used varnishing day at the Royal Academy annual exhibition, when rival artists put a final coat of gloss on their pictures, to virtually create his painting in its entirety, leaving no scope for imitators who might steal some of his thunder. The tactic is similar to the present day unveiling of a new model in a motor showroom. (The French to this day call an art exhibition preview or launch a *vernissage* or varnishing.)

Museums need to compete for the same cultural dollar as art exhibitions while continuing with all their other work, much of it invisible, such as the management of collections, and organising thesauruses so that objects can be named and catalogued digitally. Even health and safety is more of an issue in a technology museum than in an art gallery where paintings are harmless, physically at least. The operation of the Powerhouse's historic machines must be carried out with caution and care to avoid accidents.

The Powerhouse has planned conscious strategies to attract different sections of society, by identifying these sections and then providing relevant or appealing exhibitions. If possible, our aim has been to attract different audiences at the same time. In 1994, for example, we opened a major show on Australian rock music. In the same year, we staged a glamorous exhibition of the work of the Paris fashion designer Christian Dior.

Real wild child featured the story of Australian rock 'n' roll legend, Johnny O'Keefe.

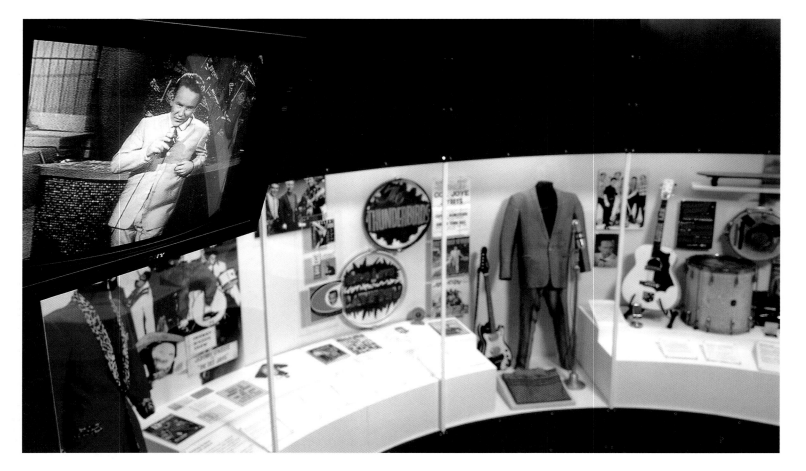

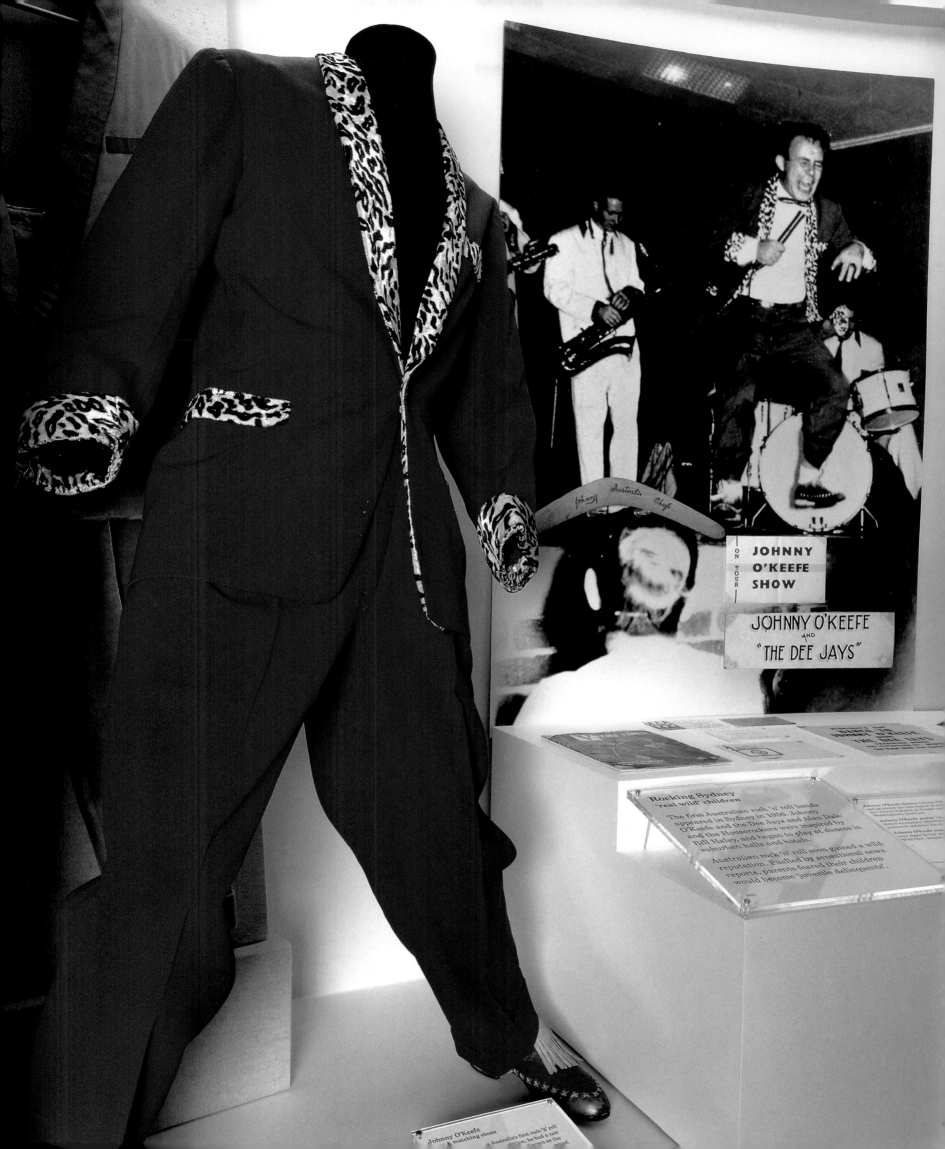

JOHNNY
O'KEEFE
SHOW

JOHNNY O'KEEFE
AND
"THE DEE JAYS"

Rocking Sydney
'real wild' children

The first Australian rock 'n' roll bands
appeared in Sydney in 1956. Johnny
O'Keefe and the Dee Jays and Alan Dale
and the Houserockers were inspired by
Bill Haley, and began to play at dances in
suburban halls and hotels.

Australian rock 'n' roll soon gained a wild
reputation. Fuelled by sensational news
reports, parents feared their children
would become 'juvenile delinquents'.

Johnny O'Keefe
matching shoes

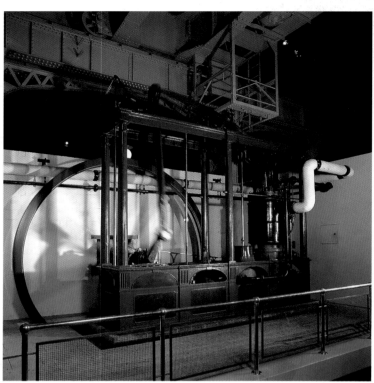

Steam engine made by Maudslay, Sons & Field, England, 1837, which drove a Goulburn flour mill and brewery equipment. Gift of Mr W J Bartlett, 1929.

The idea of a rock or popular music exhibition came from a determined effort by Powerhouse staff to appeal to one large and powerful section of society that is notoriously reluctant to visit museums – teenagers. No doubt many people in their teens have been introduced to museums on school trips but this is no guarantee that they will come later under their own steam. Most museums maintain the claim that visits by school parties lay down the foundation for later individual visits by adults but I have always been sceptical about such a proposition. It may even work in reverse. Most people seem to have mixed memories about their school experience, with many a negative association. I am persuaded, however, that visits for youngsters organised by their parents and families are a much stronger indicator of an adult museum habit.

Whatever the case, a museum must offer something very strong to attract people between the ages of, say, 15 and 25. **Real wild child**, borrowed from the words of a Johnny

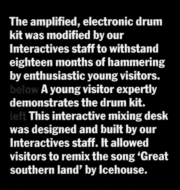

The amplified, electronic drum kit was modified by our Interactives staff to withstand eighteen months of hammering by enthusiastic young visitors. *below* A young visitor expertly demonstrates the drum kit. *left* This interactive mixing desk was designed and built by our Interactives staff. It allowed visitors to remix the song 'Great southern land' by Icehouse.

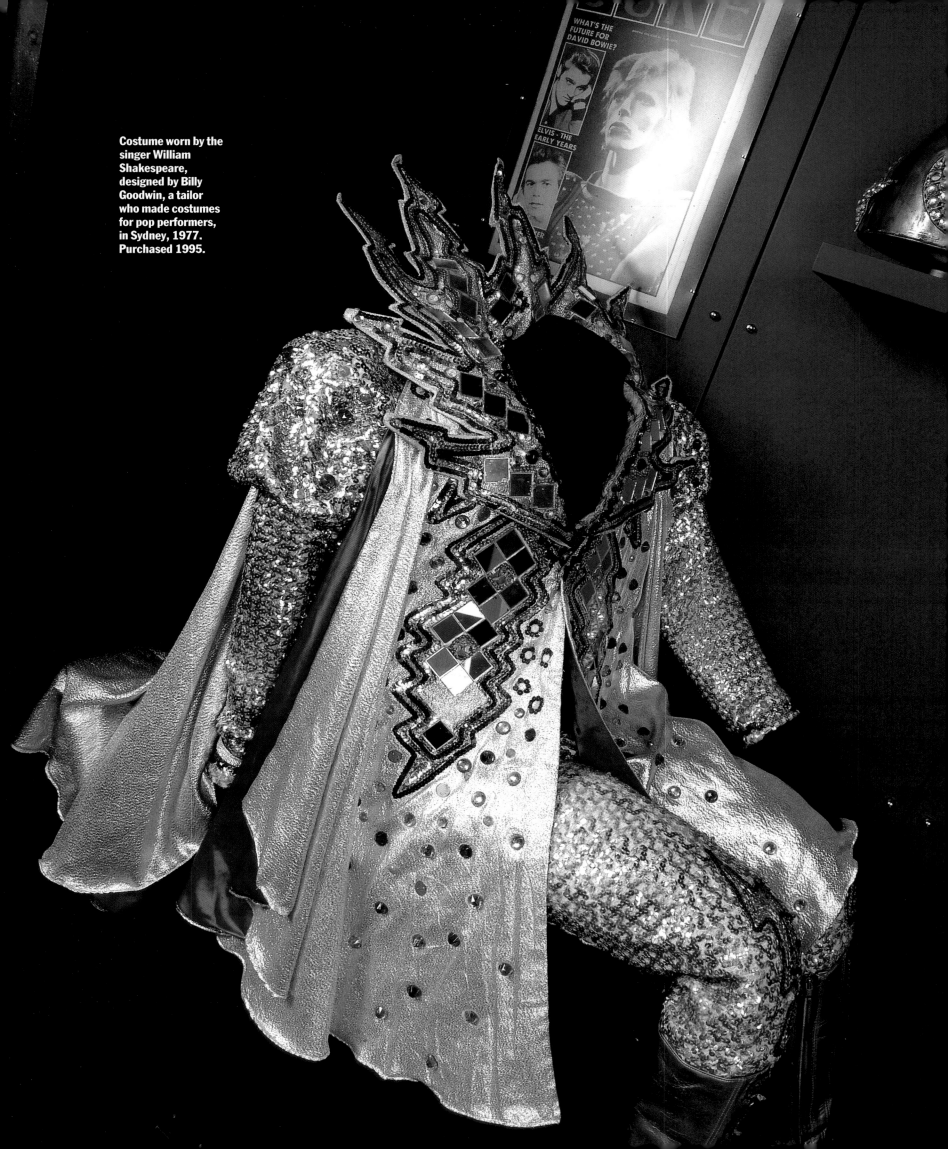

Costume worn by the singer William Shakespeare, designed by Billy Goodwin, a tailor who made costumes for pop performers, in Sydney, 1977. Purchased 1995.

O'Keefe song, was the title of our exhibition and it worked. It worked much better than we could have hoped. Before the event, many thought that a museum exhibition of rock music was a contradiction in terms. How could something noisy, alive, dynamic, be showcased in a static display? The design of the exhibition allowed for plenty of music. Visitors could engage with a large number of interactives and audiovisuals. Drum pads were there for everyone to have a go. Mixing

whatever, but mum, dad, brothers and sisters can find consensus about a visit to the Powerhouse. Another of the reasons for this broad appeal flows from the museum's readiness to organise ephemeral events in association with and alongside exhibitions. Sometimes, exhibitions and events, even workshops, are so aligned as to be indistinguishable. In connection with *Real wild child*, we organised popular gigs in the evening, under the generic title **Hot summer nights** and we managed

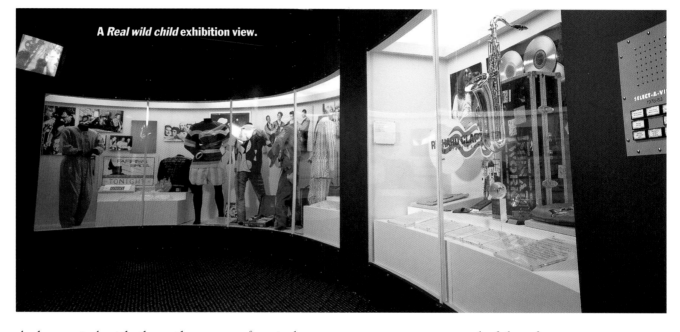

A *Real wild child* exhibition view.

desks carried with them the sense of an industry, very much part of our theme. Every era in the history of rock, from the 1950s to the present, was given its own sound-proofed bay. Costumes were, to say the least, lively.

In addition to teenagers, the exhibition attracted baby boomers and every shade of generation in between. Living legends of pop music visited the exhibition, stars such as Peter Garrett, who opened the show, Deborah Conway, Archie Roach, Marcia Hines, the Hoodoo Gurus, Little Pattie, Jon English, Richard Clapton, Jenny Morris and Col Joye.

A great advantage which the Powerhouse enjoys for a family outing is that there is something for all the members, something for everyone. There might be family dissension about a trip to the beach, to the cinema, to tenpin bowling or

to secure some wonderful performers.

In order to reach another also untapped audience, we decided to stage an exhibition of the fashion designs of **Christian Dior**, the most magical and illustrious name in the international world of *haute couture*.

Fashion and textiles have played an important role in the museum's activities since 1880. One of the great strengths of the Powerhouse is its textile collection and its textile storage, which is unrivalled anywhere. This was brought home to me in Moscow in 1995 when I travelled out of the city to the textile stores of the Museum of History. The museum itself has been closed for some years. It is housed in the large, intensely red brick, neo-gothic building next to the Kremlin, at the opposite end of Red Square from the gilded and striped domes of St Basil's

THE IDEA WAS TO PUT TOGETHER A SHOW OF DRESSES THAT HAD NEVER BEFORE LEFT PARIS, BRING THEM EXCLUSIVELY TO SYDNEY AND DEMONSTRATE THE SINGULAR INFLUENCE THAT DIOR HAD EXERTED ON FASHION IN AUSTRALIA.

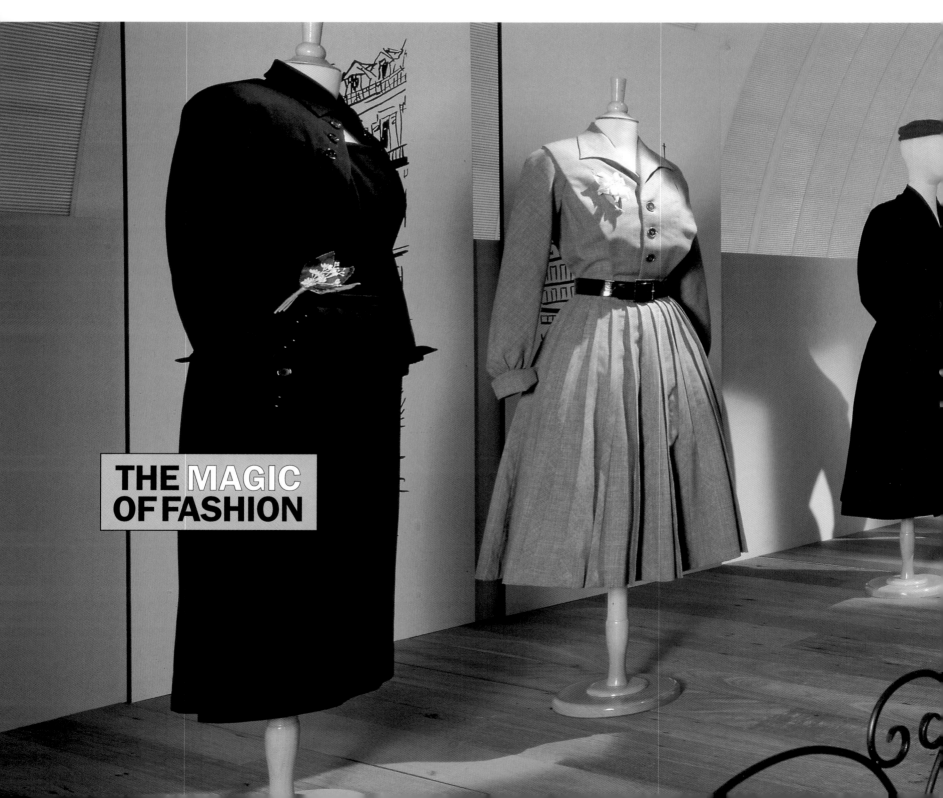

THE MAGIC OF FASHION

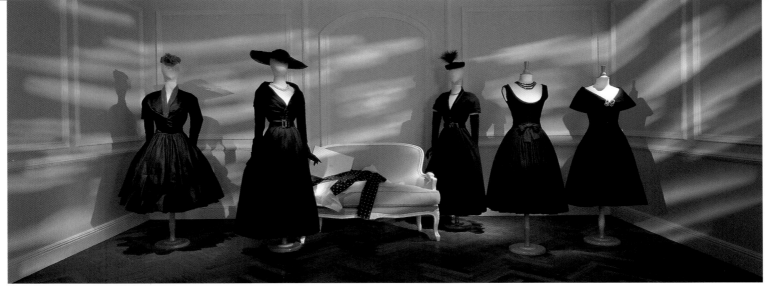

Exhibition views of the museum's *Christian Dior: the magic of fashion* exhibition.

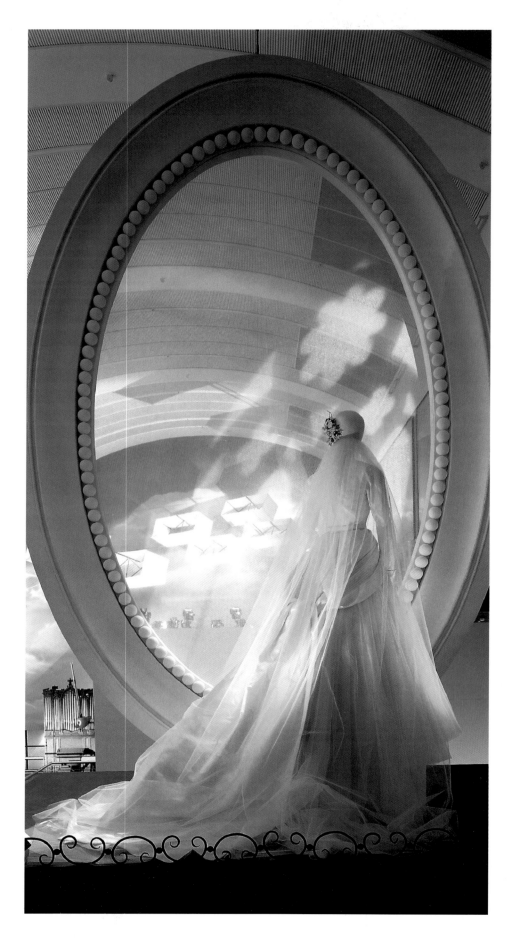

Christian Dior silk bridal gown with satin bodice and tulle skirt, *Fidelité* (*Fidelity*), Autumn-Winter 1949. Collection: Archives Christian Dior.

Cathedral. From many viewpoints, the towers of the museum blend with those of the Kremlin, making it seem part of that magnificent complex.

Moscow's treasures most certainly include a vast collection of folk costumes, which vary considerably from one village with its own traditions to the next. This enormous collection is kept well, though without environmental control. When I was there, the outside temperature was well over 30 degrees Celsius and distinctly humid. Inside the store, it was cool and dry but no doubt vulnerable to the extremes of Moscow's climate. I also noticed that access to any particular garment was not easy without disturbing other items in storage.

We also have acute storage problems. Our storage facilities are full to overflowing. However the Powerhouse textile store enjoys state-of-the-art climate control. More than this, it is designed so that scholars and other specialists can inspect any item without messing about its neighbours. This is the key factor with all forms of textiles: you need to be able to unfold, say, a garment, while leaving all else in an immaculate state. Of course, only specialists would be qualified to appreciate this level of care and to understand its necessary cost in dollars.

One person who would understand all this immediately is Marika Genty. She is curator of the Christian Dior Archive in Paris. Another is her colleague Lydia Kamitsis, curator at the Union Française des Arts du Costume (UFAC) also in Paris. The confidence and cooperation of these two organisations were essential if we were to assemble the exhibition proposed by Jane de Teliga in 1992. Jane was then our fashion

Three-piece day
ensemble of midnight
blue wool serge,
designed by Christian
Dior, 1950.
Purchased 1994.

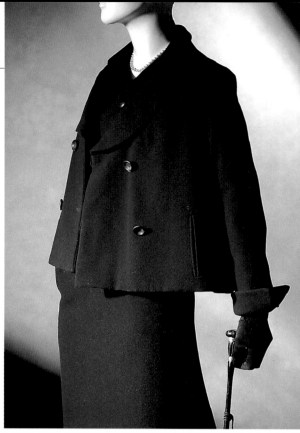

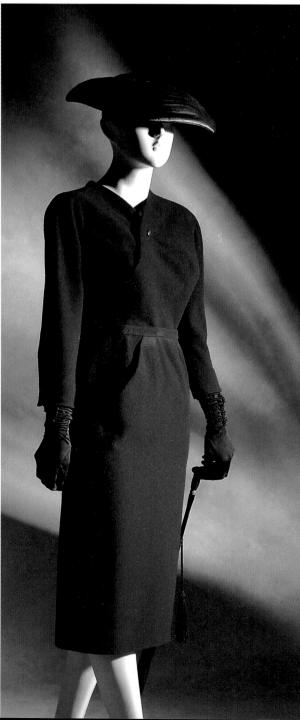

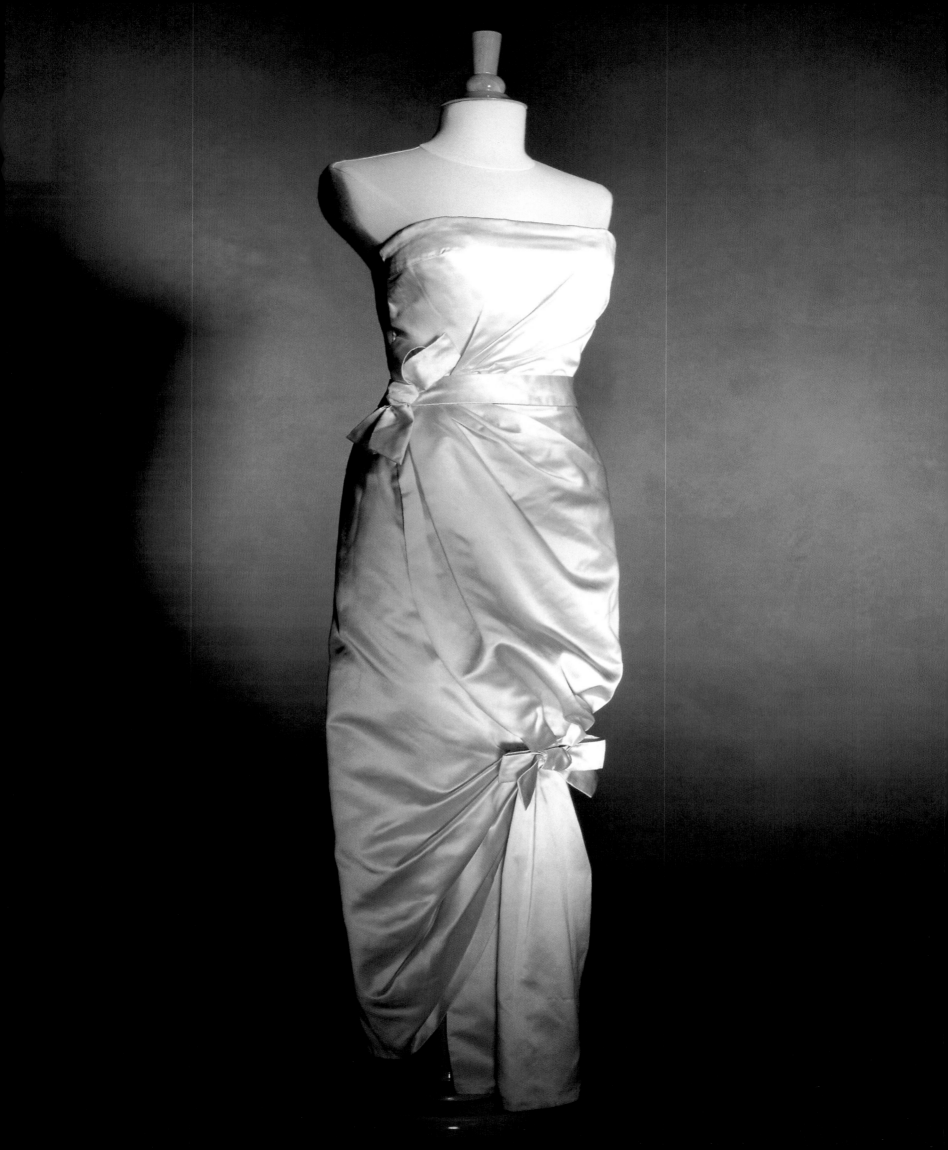

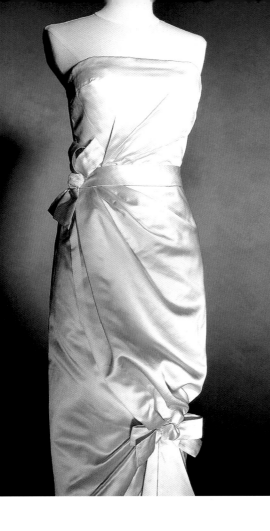

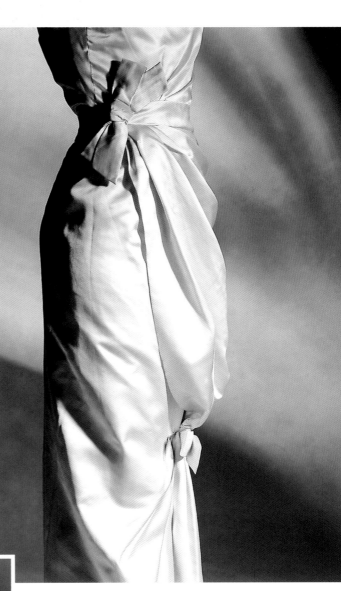

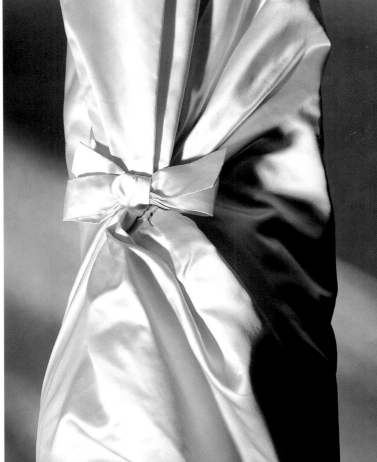

Glamorous ivory silk
satin evening sheath
dress, designed by
Christian Dior for his
Spring Collection, 1957.
The waist measurement
is 58 cm (23 inches).
Purchased 1994.

curator. She is now the leading fashion journalist on *The Sydney Morning Herald*. The idea was to put together a show of dresses that had never before left Paris, bring them exclusively to Sydney and demonstrate the singular influence that Dior had exerted on fashion in Australia. In fact, Sydney was the first place outside Paris where Christian Dior launched his 'New Look' in 1948. The whole story, in its wealth of detail, is narrated by another Powerhouse curator, Louise Mitchell, in an essay in our catalogue for the exhibition.

The exhibition **Christian Dior: the magic of fashion** opened in July 1994, after two years of negotiation and preparation, and was a huge success until it closed in October that year. Dior proved to be a figure of great significance for women in metropolitan Sydney, just as we had anticipated. To my eye, many of the frocks on view were unexceptional, although our curators told me of their enjoyment in handling all of them because of the way they were designed and stitched. Other gowns, however, were overwhelmingly glamorous. They were divine, dreamlike creations that would make a Hollywood movie set look drab. Fashion events were arranged to accompany the exhibition and as models were selected, the museum seemed to fill up with gorgeous clones who were all very tall and all dressed in black. They also seemed rather thin. Yet, surprisingly, Dior's wasp waists were even smaller than those of the slenderest of models.

The temporary exhibition gallery which we used for Dior is close to our administration offices and so it was easy for me to see the people who crowded into the exhibition week after week. It was mostly women who could remember the excitement of the post-war years when Dior led a revival of couture after the frugal and spartan wartime look. After seeing the exhibition, they had coffee or tea and a scone in our restaurant nearby and then left the museum. These were visitors who knew what they wanted to see and, having seen it, had no inclination to linger and look at science. They were, however, enthusiastic about the subject of fashion and bought catalogues – indeed, bought them all and we had to reprint.

Dior was relevant to the scope of the Powerhouse Museum for two important reasons. The first is obvious: we are a museum of design. But the second is of equal significance: we are a museum of industry. The act of parliament which governs us says that we are a Museum of Applied Arts and Sciences. These quaint words still have some meaning. They have to do with the creation of wealth, with making things that people need and want and are willing to pay for. Fashion is an industry. Over the last few decades, *haute couture* has been a public relations exercise, a loss-leader. For Dior, Yves Saint Laurent, Chanel, Balenciaga and the rest of the fashion houses, the revenue has come from their *prêt á porter* or off-the-peg garments, made under licence all over the world. A Dior blazer or an Armani shirt looks little different, if at all, from any other. The product, the thing you buy, is really just the label. In fact, the real profits are made from branded perfumes. The whole industry is a virtuoso exercise in branding.

Know-how: the guide to innovation in Australia CD-ROM is the largest research and publishing project undertaken by the museum.

The Powerhouse collects and shows Australian material in an international context. We are keenest of all, quite naturally, to tell Australian stories, particularly success stories. If Australian museums don't do this, nobody else will. And there are many stories of Australian success. So many that we can't exhibit them all and have resorted to electronic means to communicate them. In mid-1996, the museum released a CD-ROM called *Know-how*, which presents 350 success stories, along with games, quizzes and so on, all of

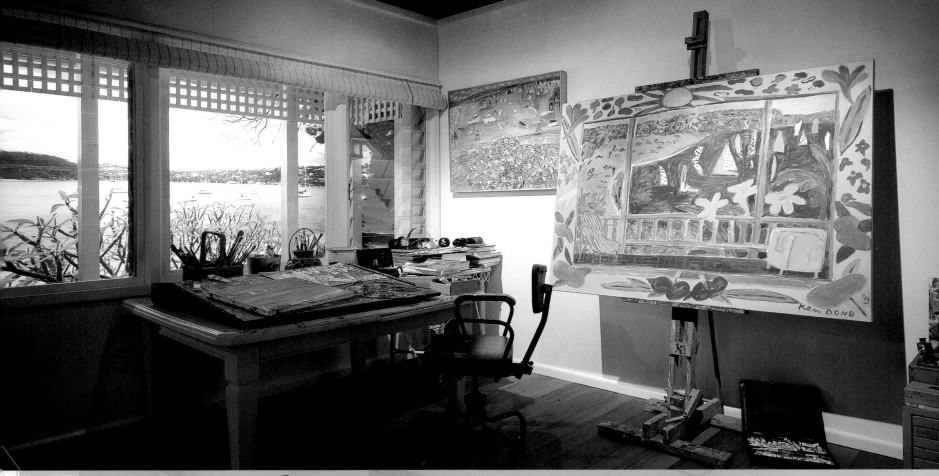

The museum's exhibition *Ken Done: the art of design* contained a re-creation of Ken Done's cabin studio on Sydney Harbour. The re-creation is at the top of the page; the shots below it are of the real studio.

which make this sophisticated program fun to have. It is a product in itself, one that Powerhouse staff have produced in-house in order to master the processes of production.

One designer whose work we have shown comprehensively in a major exhibition is Ken Done, who for many years also practised as a painter, a fine artist. Done Art and Design is a highly successful Sydney-based company. In recent times, it is Ken's wife, Judy, who has steered

production but the inspiration for each design still comes from Ken's paintings, on which he nowadays concentrates almost exclusively. He is very much the painter of Australians at leisure, and the Sydney beach on which he lives is his principal subject. His studio is at the water's edge. It is a magical environment from which he can gaze out on water sports, boat traffic and all manner of sunlit colours. This studio is at the heart of all Done Art and Design activities, so

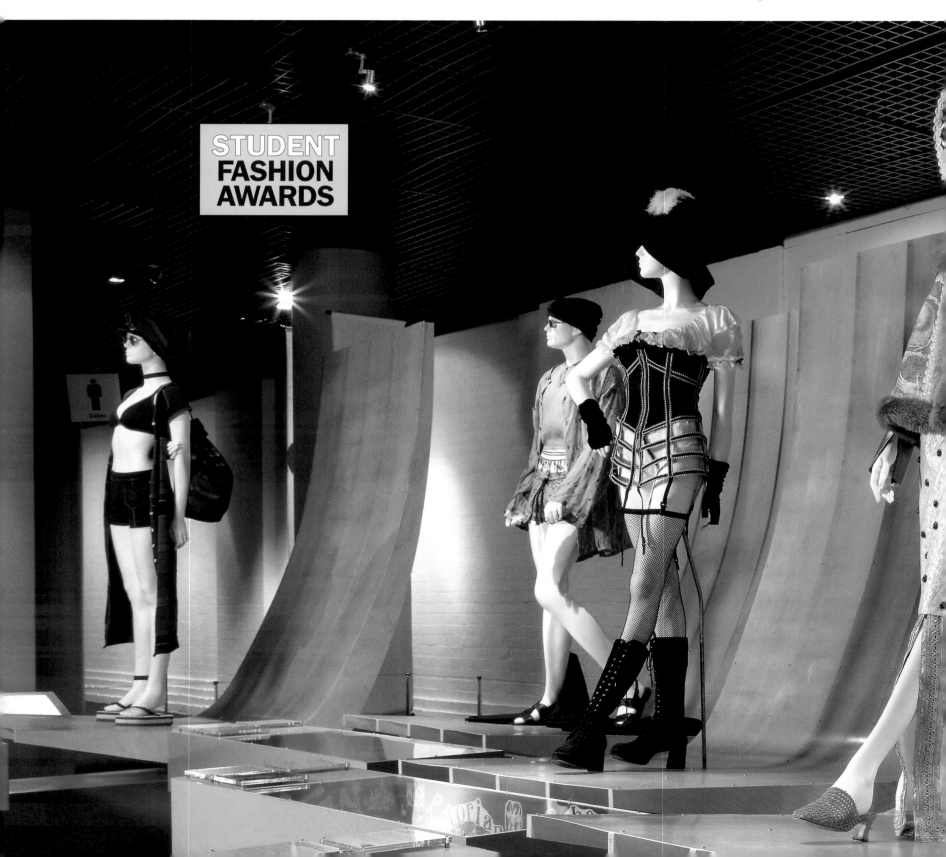

I decided that we should re-create it with meticulous accuracy as part of our exhibition. We did so with such fidelity that Ken himself, on visits, almost forgot he was in a museum and found himself inclined to open cabinets and start work.

I have always found it odd that art galleries do not trouble to re-create artists' studios as part of exhibition installations, at least some of the time. With almost all artists that I have known, the essence, the true meaning of their work, is to be found in their studios. There you see their working methods, their processes, the way they think. Of course, you can't have everybody traipsing through the real studio while the artist is absorbed in his work. Or can you? The custom used to be widespread. Rubens received daily visitors into his studio in Antwerp and continued painting while he conversed with them. Collectors and amateurs could not afford to miss the experience. In the mid-

The annual Australian *Student fashion awards* exhibition is a showcase for the creative talents of student fashion designers.

industry-sponsored awards

encouraging new talent

Each year fashion design students from all over Australia enter a variety of student fashion awards sponsored by industry. The awards aim to encourage and support new talent and enable students to present their designs in spectacular parades before the fashion industry, as well as offering a cache of prizes.

The Smirnoff and Mary MacKillop design awards encourage students to showcase their imagination and creativity. On a more practical level the Australian Fashion Awards and the Du Pont Lycra awards are aimed at developing the students' commercial attitude.

This page, opposite top and top-right Nicole Serjeant based her creation on a space suit. opposite lower left Space suit (detail) used by Air Force Lieutenant Colonel Gennady Manakov on his maiden flight aboard *Soyuz TM 10* in 1990. Purchased 1994.

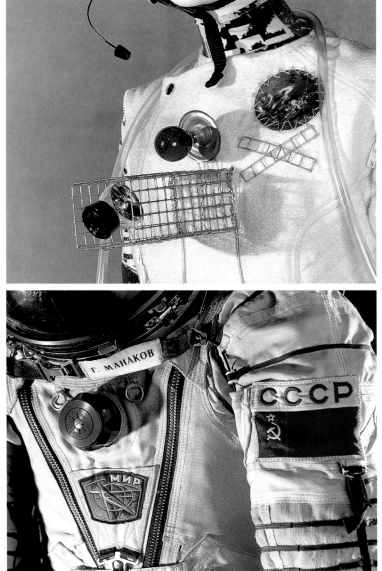

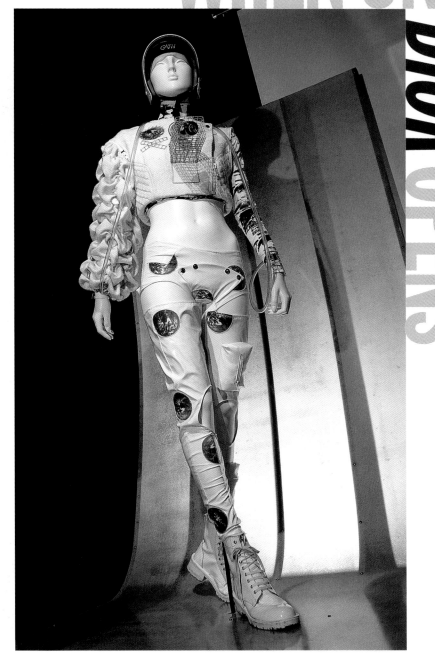

nineteenth century, no English visitor to Rome would miss Frederick Leighton's studio where they would observe the great Olympian at his task.

As well as famous names, the Powerhouse Museum is also interested in people at the other end of their career, people just starting out. Each year we are delighted to mount an exhibition of students' fashion design. I have to admit that I usually find it more compelling than the proven products of well-known brands. It is adventurous, imaginative, full of flair and frequently quite cheeky! And so it should be. At the outset of their careers, students are free of marketing constraints. Their designs can be, and usually are, uncompromising. The annual show gives me an awful lot of pleasure, particularly when it contains students' versions of

things already in the collection. The museum is a resource for fashion design students, an important resource and, in Sydney, just about the only one.

Design and industry, yes, but the Powerhouse is also a museum of social history. I still find that some people are not familiar with the term. It is a more recent field of study than political or military history. Probably the first time it was used in any prominent way was as the title of the famous book by G M Trevelyan, *English social history*, published in 1944. For practical purposes, social history is different from most other histories because it does not confine itself to the stories of victorious elites. Rather, it describes the habits, the mores of all levels of society, and sees significance in the ways of ordinary people as well as the celebrated. When the

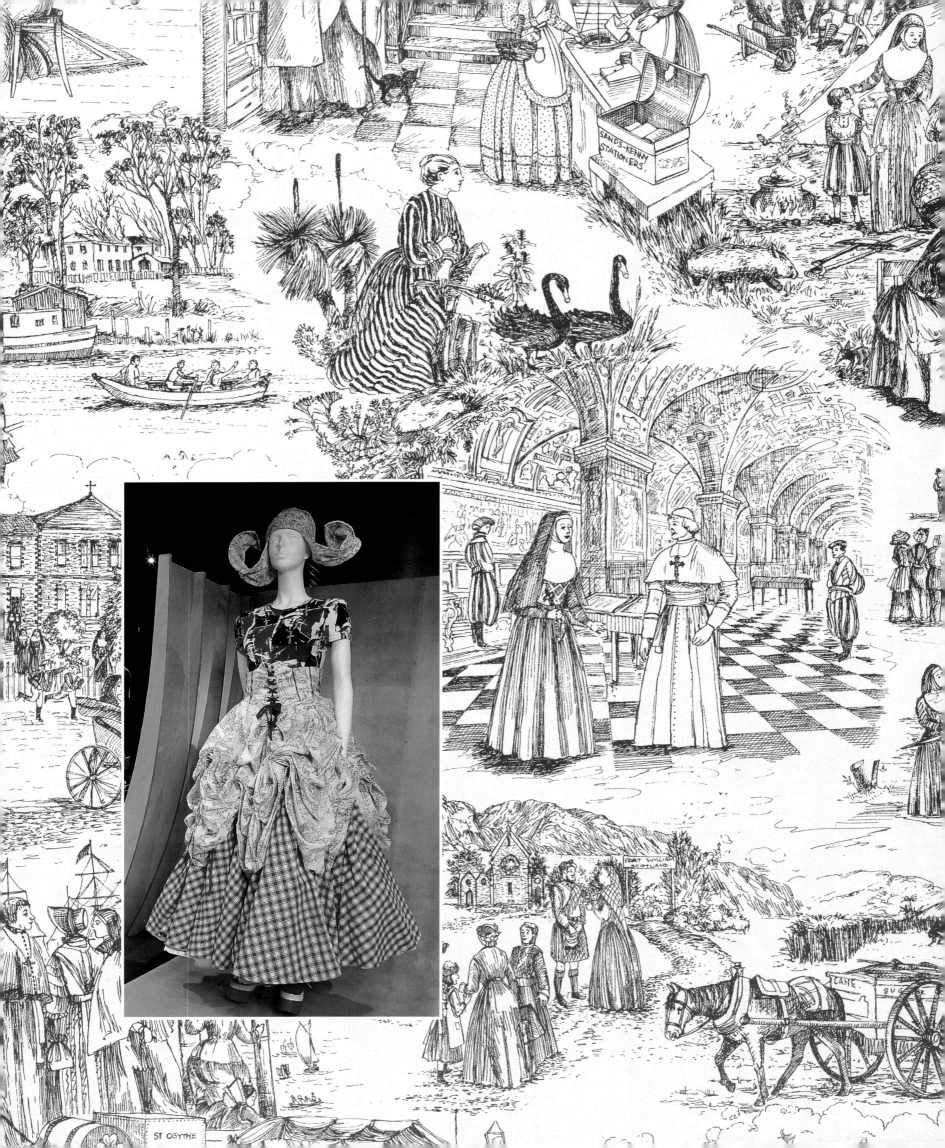

main picture left **The Mary MacKillop Commemorative Toile**, designed by Pamela Griffith, 1993. It depicts 31 different scenes from the life of Sister Mary MacKillop. Gift of Mary MacKillop Secretariat, 1993.

inset left **Nicole Serjeant** won the 1994 Mary MacKillop Design Award with this outfit which incorporates the MacKillop Toile. Displayed in the *Student fashion awards* exhibition in 1995.

right **Jocelyn Pitsillidi's** *CD-ROM* outfit incorporates technology into fashion; it is made of chiffon, CDs, plastic and wire. Displayed in the *Student fashion awards* exhibition in 1996.

Cotton blossom is the costume in the foreground of this *Absolutely Mardi Gras* exhibition view. Designed and made by Ron Muncaster in 1993–94 and worn by him in the 1994 Sydney Gay & Lesbian Mardi Gras parade, where it won the judge's prize for excellence. Purchased 1996.

museum began to develop its social history programs as late as the early to mid 1980s, the departure was seen to be both radical and subversive. After all, the subject was not mentioned in the Act which governs us, an Act framed in 1945 when social history as a topic was barely heard of.

By the mid-1990s, most people associated with the museum had become less uneasy about social history, and at the very least the subject can be seen as a kind of glue which binds the disparate activities of the museum together. It

certainly supplies context. Designs and products are created in response to society's needs. Society uses them. Today, a museum looks thin and inadequate if it just sets out objects in their classes and categories – a room full of engines here and a hall of vases there. Nobody experiences the world in such a manner, and that sort of display, characteristic of the 1950s, has a low boredom threshold.

A prominent aspect of the social complexion of Sydney is its gay and lesbian communities. They lend their particular set of styles to certain districts,

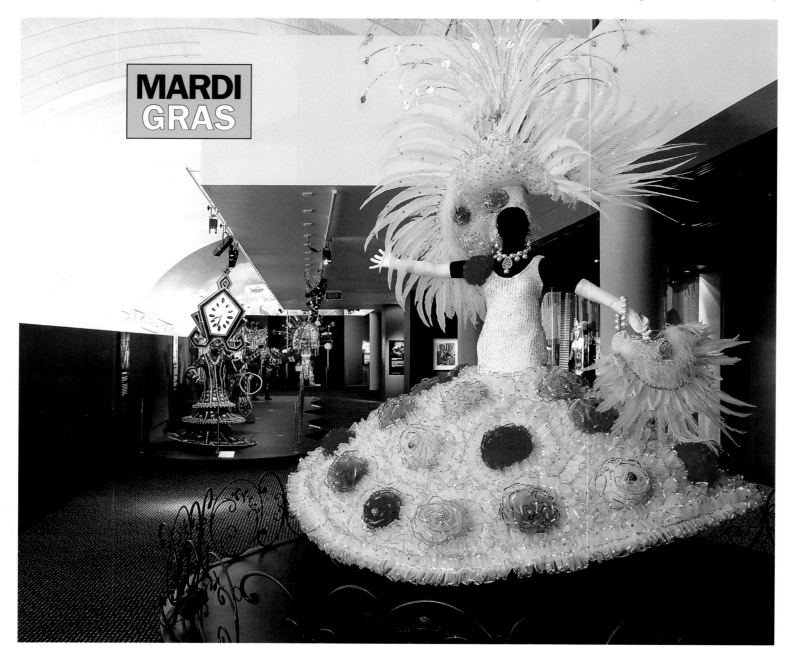

Costume, *Mardi Gras*, designed and made by Peter Tully in 1990, and worn by him in the 1990 Sydney Gay & Lesbian Mardi Gras parade. Peter Tully (1947–92) was one of Australia's most inventive designer-makers, probably best known for his jewellery and costume designs. He was artistic director of the Sydney Gay & Lesbian Mardi Gras from 1982 to 1986. Purchased 1995.

Costume, *Gingham woman,* designed, made and used by Brenton Heath-Kerr (1962–95) in 1991, and displayed in the museum's *Absolutely Mardi Gras* exhibition. Purchased 1994.
opposite Costume, *Woodwoman,* designed, made and worn by Brenton Heath-Kerr in 1993, and displayed in the exhibition, *Absolutely Mardi Gras.* Purchased 1994.

notably Oxford Street and Darlinghurst, but there are other places with a presence such as Newtown. Each year, the community stages a spectacular parade which it calls the **Gay & Lesbian Mardi Gras**. For those who wished to avoid crowds, the event was seen in its entirety on ABC television. It resembles the kind of wild carnivals that have come down from medieval Europe, where whole communities have a fling before the Christian season of Lent, when all self-indulgence is avoided in favour of a period of denial. Like their European counterparts, many of the designs of floats and costumes of the Sydney Mardi Gras are spectacular and extravagant. Well, not extravagant in the sense of using expensive materials. As our exhibition (February to April 1996) demonstrated, Mardi Gras designers have managed for years to create their eye-popping effects with the slenderest of means, by employing throw-away materials. Not only are their designs great fun, but they are also pioneering in their novel and imaginative use of the non-precious.

We commonly hold fashion parades in the museum. They are always extremely popular. People like to look at designs that move, that are on live bodies. It is pure theatre, of course. The Powerhouse is in so many ways the most theatrical museum I know. Strange though it may seem, models on the catwalk don't look out of place in a building full of locomotives and other large machines, with gigantic aircraft hanging from the ceiling. But these are not the only models in the museum. We have models of another type altogether and they are the subject of the next chapter.

a model museum

Model of a
1934 C30
Cierva Autogiro
(see page 68).

POWERHOUSE
MUSEUM

Locomotive 3801,
the first of the 38
class engines, arrives
in the courtyard at
the rear of the
Powerhouse Museum
for an excursion.
inset is a model of
this loco.

DANGER
NO SMOKING
NO NAKED LIGHTS

S cale is of the utmost importance in museums. Just inside the Natural History Museum in London, for example, the gigantic skeleton of a blue whale takes the breath away and sets the tone for all other experiences in the museum. Afterwards, the memory of its awesome length and of its vast, arching ribs is what remains indelibly in the mind. No souvenir postcard can convey the physical excitement engendered by being in the skeleton's formidable presence.

In the Powerhouse Museum, there are several large-scale exhibits which determine the character of the museum for most visitors. The huge, suspended Catalina seaplane, *Frigate bird II*, is an obvious example; the Boulton and Watt steam engine is another. But perhaps the most memorable impression made on visitors is that of a nineteenth-century locomotive and its train of carriages, **Loco No. 1**. Even today, the age of steam locomotion retains its fascination for many adults and children. Should we have models in museums? No scale model of a whale would inspire visitors as the great skeleton in London does. But models do have a role to play; in fact, they have several.

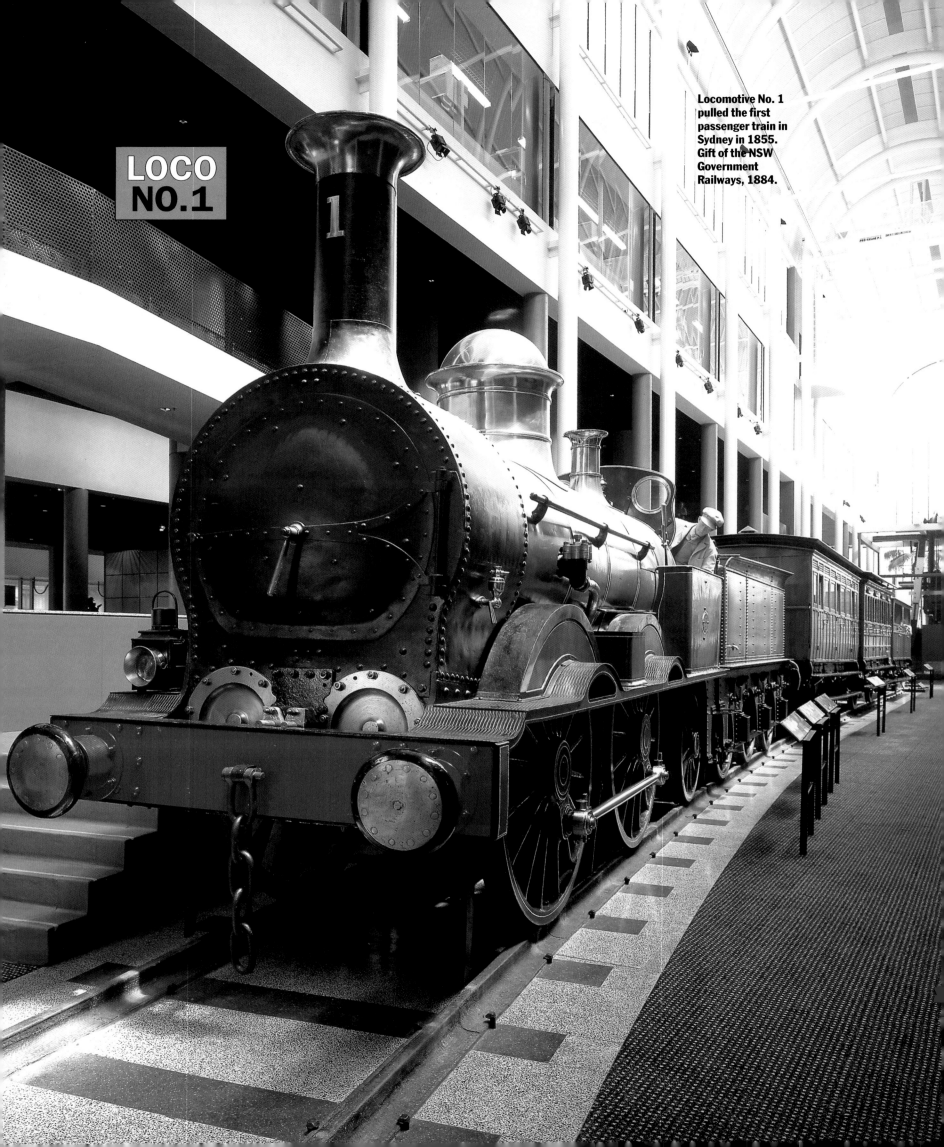

LOCO NO.1

Locomotive No. 1 pulled the first passenger train in Sydney in 1855. Gift of the NSW Government Railways, 1884.

right and overleaf **Locomotive models, NSWGR 38 Class 'Pacific' 3801 and 3830, researched and commissioned by Precision Scale Models, Melbourne, Australia; made by Samhongsa Company, South Korea, 1995. Length 363 mm; width 62 mm; height 73 mm each. Purchased 1996.**

The museum is currently restoring a great locomotive in its collection. This is the last of the 38 class engines, manufactured in 1949. Because there were thirty of them originally, this locomotive is called 3830. According to plan, the restored locomotive will soon be on the rails, steaming across country New South Wales. In the meantime, the museum has acquired an accurate model of **Locomotive 3830**. The workmanship and detail that have gone into this tiny scale model is phenomenal, making the model itself a worthwhile addition to the collection.

The real thing is in the final stages of restoration in a cavernous workshop in the State Rail precinct at Eveleigh, in southwestern Sydney, and just four or five minutes away from the Powerhouse Museum via our own direct rail line. The restoration cost has exceeded a million dollars in cash

and kind, mostly the latter and mostly donated. Many expert volunteers have given freely of their time and expertise to bring this mighty beast back to a working state.

One of the museum's conservators, Ross Goodman, has worked miracles to achieve this goal. For instance, no manufacturer could be found to replicate the crown bolts which keep the firebox in position inside the cladding just in front of the driver's and fireman's cabin.

To solve the problem of the crown bolts, Ross went to a neighbouring shed in the precinct at Eveleigh, an industrial blacksmith's workshop, the best preserved of its kind in the world and therefore a rich part of Sydney's heritage. Here, Ross 'woke up' a defunct machine and taught himself how to use it. With the assistance of highly experienced volunteers, Ross experimented with this obsolete technology and, after many trials, learned how to make a good crown bolt. Having done so, he went on to produce, one by one, some 600 of them. Each one is a rod of metal about half a metre in length. In place, the bolts are angled this way and that for

BUT PERHAPS THE MOST MEMORABLE IMPRESSION MADE ON VISITORS IS THAT OF A NINETEENTH-CENTURY LOCOMOTIVE AND ITS TRAIN OF CARRIAGES, LOCO NO.1.

main picture The inner firebox, looking out from inside.

insets from top left

Volunteer, Tom Anderson, finishing off wall stays on the firebox exterior.

Asbestos removal.

Volunteer, Don French, and the museum's conservator, Ross Goodman, involved in the removal of the boiler from the locomotive.

The repaired inner firebox.

Volunteer, Tom Robertson, during welding operations.

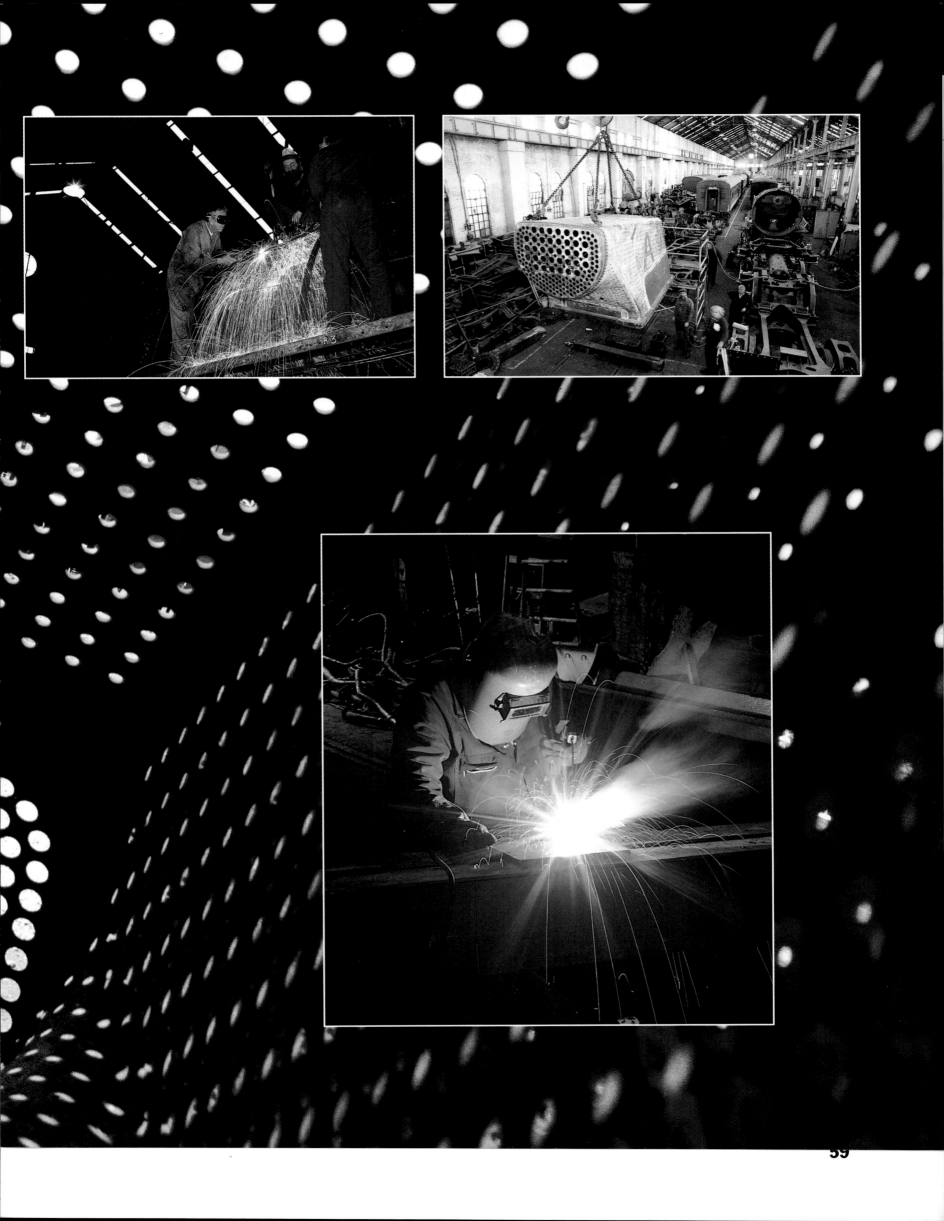

LOCO 3830

The reassembly of the tender bogies, with volunteer, Albert Taylor (left), the museum's apprentice, Jennifer Power (centre) and volunteer, Tom Anderson (right).

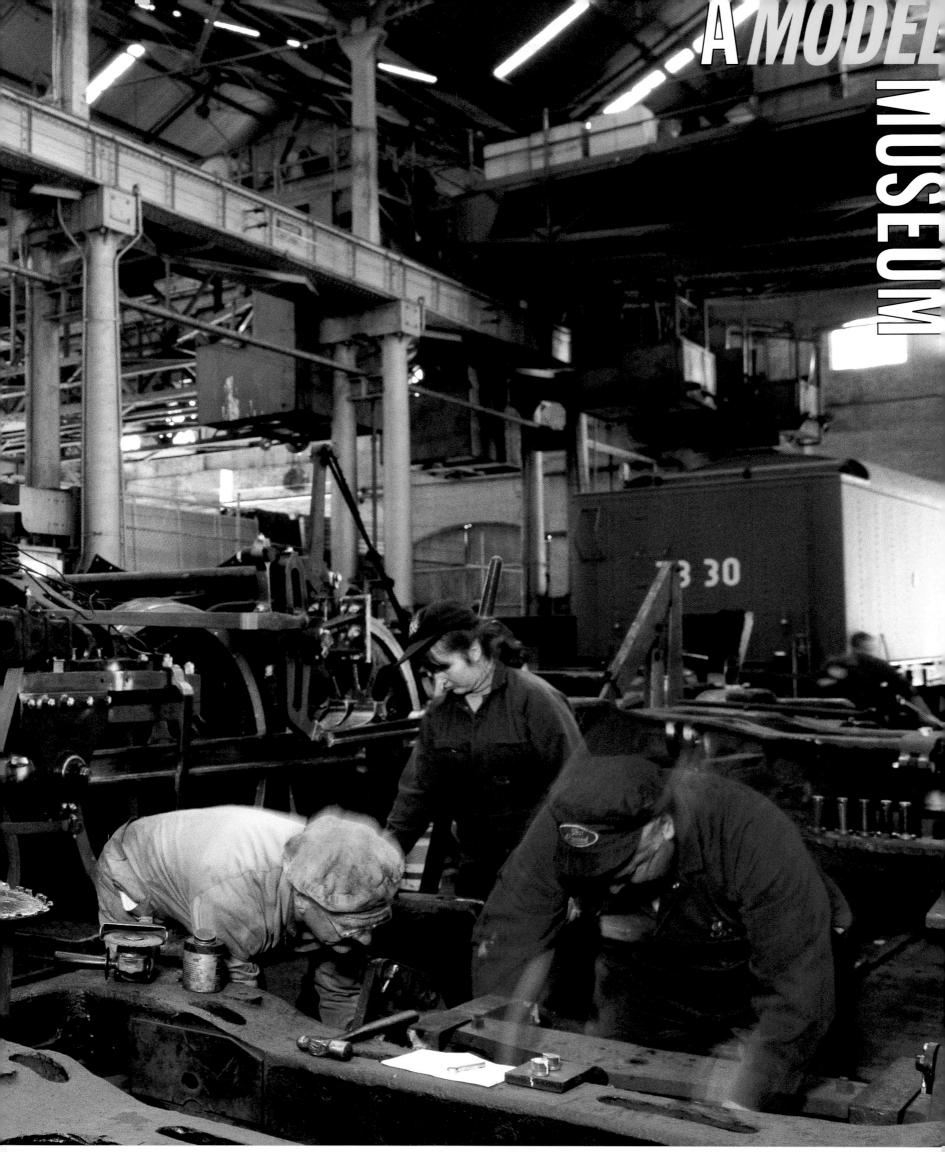

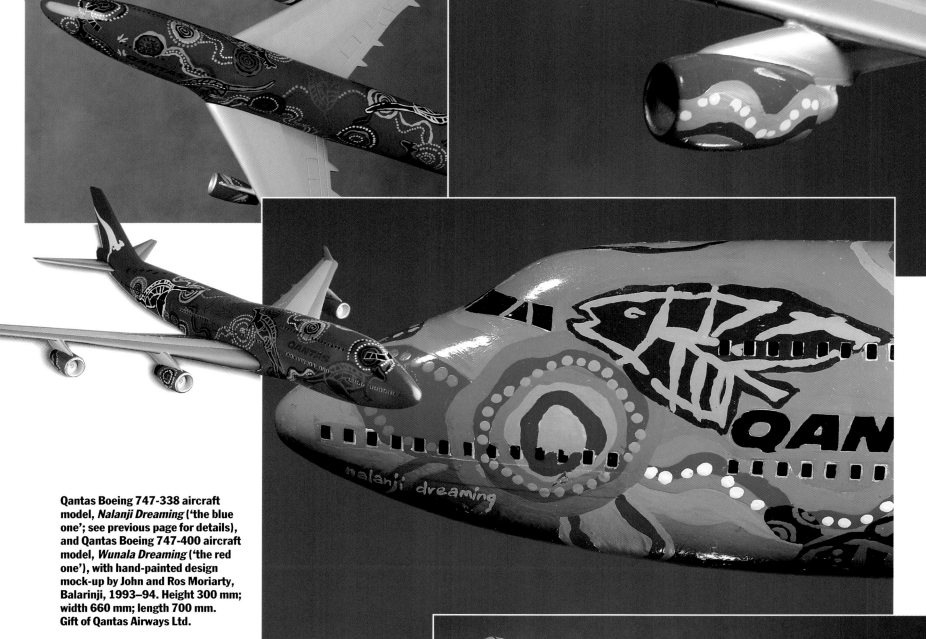

Qantas Boeing 747-338 aircraft model, *Nalanji Dreaming* ('the blue one'; see previous page for details), and Qantas Boeing 747-400 aircraft model, *Wunala Dreaming* ('the red one'), with hand-painted design mock-up by John and Ros Moriarty, Balarinji, 1993–94. Height 300 mm; width 660 mm; length 700 mm. Gift of Qantas Airways Ltd.

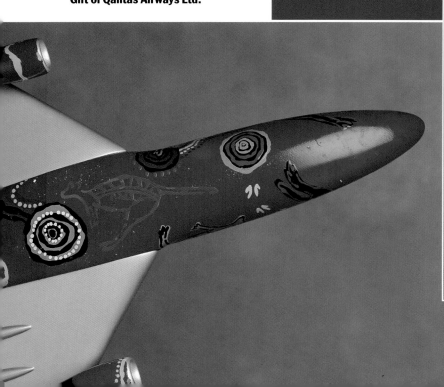

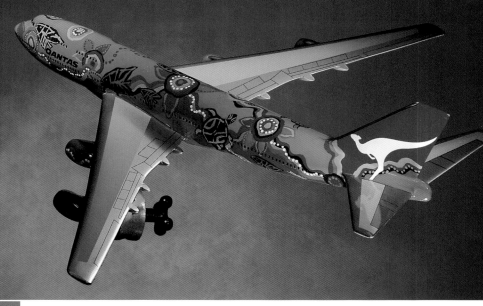

ancestors in the form of kangaroos and their tracks and waterholes, because he is an Aboriginal himself of the Yanyuwa people from Borroloola, on the Gulf of Carpentaria in the Northern Territory. A serious man, he has throughout his life been sensitive to and conscious of his tribal heritage. Today, the big red aircraft emblazoned with the imagery from that heritage is a frequent but still arresting sight in the skies above Sydney.

The original model is now a treasured possession of the Powerhouse Museum. Following my importunate request to Qantas, Garry Saunders personally delivered it to my office with what can only be described as mixed emotions.

Soon afterwards, when the model went on display in the most prominent spot in the museum, we invited Qantas staff to a small reception to express our gratitude. With John and Ros Moriarty present, Garry spoke on behalf of Qantas. As we listened, we recognised that the executives, the captains and other staff of Qantas take great pride in their organisation. Qantas is an airline with soul. At this ceremony two senior Qantas executives, after exchanging many furtive glances, finally let me in on a secret. They told me that to celebrate the seventy-fifth anniversary of the foundation of the airline, Qantas was soon to launch a second Jumbo painted with designs provided by Balarinji. They assured me that I would have the honour to be invited along on the maiden flight. This turned out to be a kind of joy flight for some 300 Qantas employees, plus a few odds and sods including journalists and myself. The route was from Sydney and flew low over Winton and Longreach in Queensland, where the company set up its headquarters in 1921, before circling over Brisbane, where Qantas is still officially registered, and then Captain Trevor Jensen also flashed the aircraft at similar low altitudes over the long resort strip of Queensland's Gold Coast. James Strong, the legendary boss of Qantas, presided and entertained all cabins with comments over the public-address system.

THE BLUES AND PURPLES OF THE FLINDERS RANGES, THE OCHRES OF THE CENTRAL DESERT, THE RED OF ULURU, AND THE LUSH GREENS OF KAKADU.

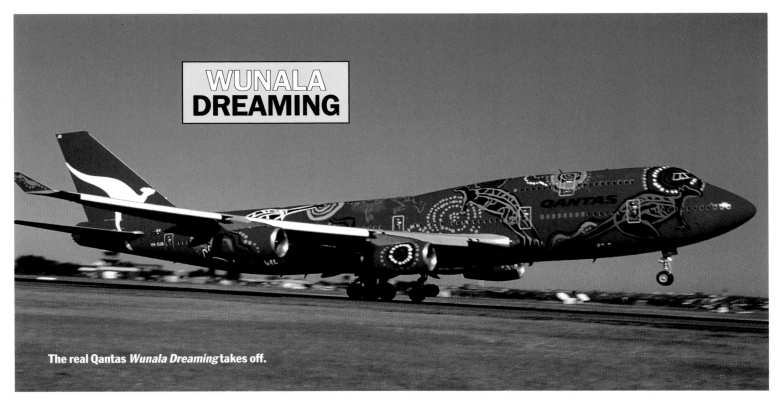

The real Qantas *Wunala Dreaming* takes off.

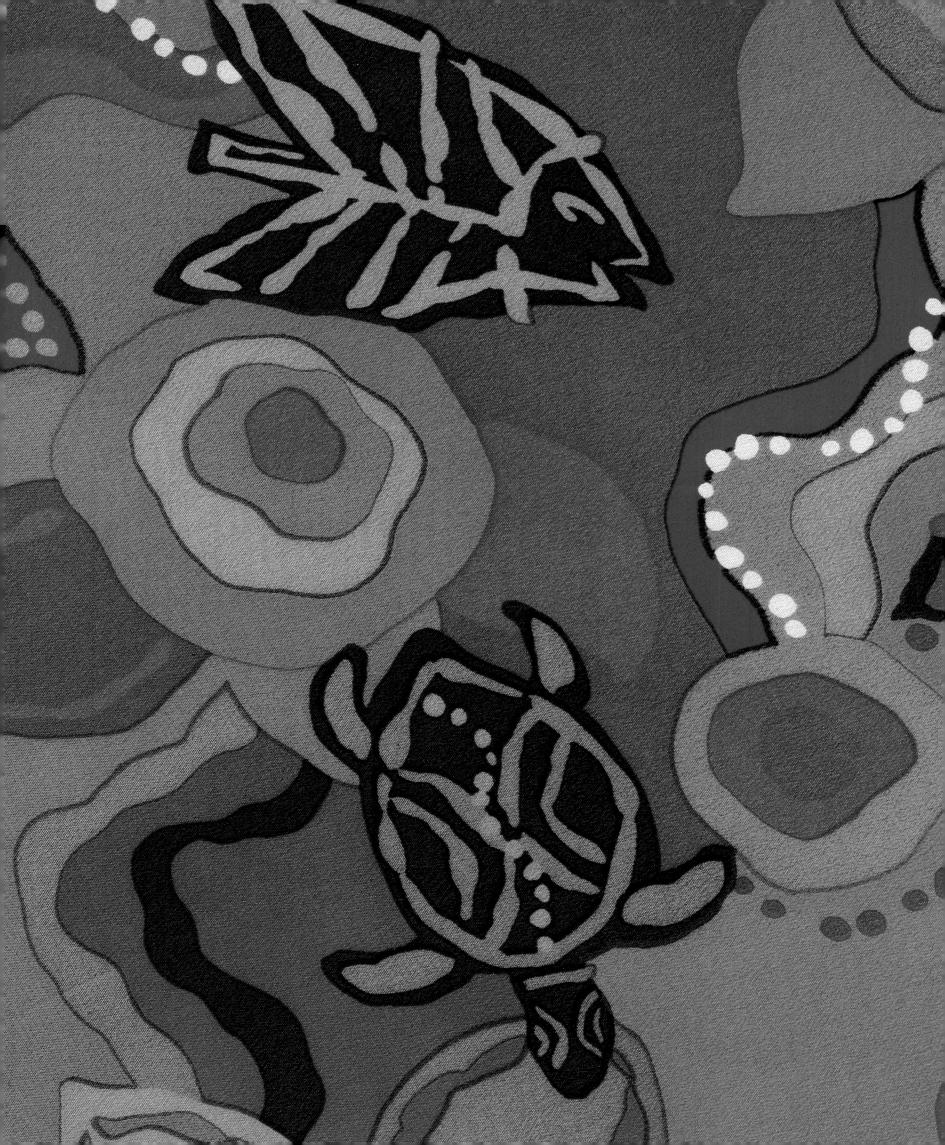

far left **Scarf, *River turtle*, designed by John and Ros Moriarty for Balarinji, 1993. Purchased 1994.**
left and opposite **Details from a silk scarf which is part of the merchandising exclusively available to passengers on Qantas *Nalanji Dreaming* flights. Gift of Qantas Airways Ltd.**
below **The card which accompanied the *Wunala Dreaming* sandshoes.**
bottom **These *Wunala Dreaming* sandshoes were painted by the Balarinji Studio in 1995, and presented to James Strong, Qantas Chief Executive. The shoes were presented to Terence Measham representing the museum aboard the *Nalanji Dreaming* on its inaugural flight which commemorated the 75th anniversary of Qantas Airways. Gift of Qantas Airways Ltd, 1996.**

The second Balarinji Qantas Jumbo is called *Nalanji Dreaming*. 'Nalanji' is the Yanyuwa word for 'our place' and connotes a sense of celebration of harmony in nature. When a Dreaming is associated with a place it also encapsulates the sense of preserving the land for future generations. The colours of *Nalanji Dreaming* are lush and tropical; as well as the land, the blues and greens also reflect reef waters; the reds might be parrots or tropical fruit. The yellows are the sun, life itself.

Nalanji Dreaming entered service late in 1995, and Qantas expanded the concept to include an imaginative marketing package. This consists of a range of merchandise exclusive to *Nalanji Dreaming* flights. For example, passengers can purchase attractive silk scarves, designed and packaged by Balarinji. This initiative is of interest to the Powerhouse Museum because design in all its forms is our central tenet; as well, the museum takes a keen interest in marketing devices, such as this classic add-on, because of the long-standing belief that Australians are not good at marketing their products. It seems clear that in recent times there has been considerable improvement in this field, a trend that Balarinji, after a series of bold and imaginative successes of their own, exemplifies well.

Until September 1994, the museum depended on a model to show a curious stage in the evolution of aircraft design or, to be more specific, in the evolution of the helicopter. An eccentric precursor of the helicopter was the **autogiro** (see page 68). During the early decades of powered flight, many pioneers attempted designs that would allow vertical take-off and descent. It was in 1923 that a Spanish designer made the breakthrough by providing the correct articulation of the rotor above the body of the aircraft. Juan de la Cierva designed universal or differential gearing which enabled rotor blades to

THERE ARE NO MORE THAN EIGHT SUCH AIRCRAFT LEFT IN THE WORLD. THE MUSEUM WAS ABLE TO ACQUIRE ONE OF THESE RARE BIRDS IN 1979.

Model of a 1934 C30 Cierva autogiro. Height 420 mm; width 820 mm; depth 820 mm. Purchased 1935.

cope with the several stresses caused by wind pressure, centrifugal forces and so on. The Cierva aircraft was equipped with a propeller for forward motion but lift was provided by a three-bladed rotor instead of the wings of a conventional aeroplane. In flight, the blades rotate freely; they are not driven by engine power.

There are no more than eight such aircraft left in the world. The museum was able to acquire one of these rare birds in 1979. It is one of a batch of Cierva C30A autogiros manufactured under licence by A V Roe (Avro), the famous British company, in 1934.

This autogiro was bought by Andrew Thyne Reid of New South Wales, and registered as VH-USR in June 1935. Thyne Reid flew it mainly around the state but occasionally made longer trips, for example to Brisbane. With the outbreak of war, Thyne Reid handed his aircraft over to the military where it took part in hush-hush programs. It was used in the secret effort, laughable in hindsight, to create a flying jeep (known to the boffins on the inside as a fleep!).

In a letter to the museum dated 18 September 1992, R N Torrington of Victoria gives a vivid account of his sighting of VH68-USR 50 years earlier in a hangar at Essendon aerodrome. He writes: 'I do not know who owned the aircraft at that time. However, the war was in full swing and some unusual work was in progress in the hangar.

'For example, there was an American jeep – the small one – which it was proposed should fly like an autogiro, land and proceed on its way. I don't know what organisation was responsible for the project and in wartime, one does not ask too many questions of this nature, especially when one sees a project like this.

'I did, however, see VH-USR fly at Essendon a couple of times in about 1943 and in those days it was a most unusual sight – well before helicopters which are so commonplace today. It disappeared from the hangar about then or maybe 1944. Again, one does not enquire where it went to.'

AUTO**GIRO**

1934 Cierva C30A autogiro, developed by Juan de la Cierva in 1920, made by A V Roe (Avro) and Co Ltd, Southampton, England. Purchase funded by the Andrew Thyne Reid Charitable Trust, 1979; restoration funded by the Thyne Reid Education Trust No. 1, 1991.

By the early 1950s, the flying days of VH-USR were over and when this rare craft, the only one in Australia, entered the collection in 1979 its condition was lamentable. It was not until 1991 that the museum was in a position to comprehensively restore this treasure. In that year the Thyne Reid Education Trust No. 1 decided to provide the extensive funds necessary for the lengthy and painstaking restoration program. It was a strict condition of this generous donation that it remain anonymous. Lest it seem that I am breaking faith with the terms of the gift, I hasten to add that I earnestly sought and gained permission from the Trust to name it. I explained that it is in the interest of a museum to be able to state the source of its funds along with its expressions of profound gratitude. Our Cierva C30A autogiro VH-USR was hoisted into the air in one of the Powerhouse's cavernous galleries in September 1994. It will remain there, on proud display, indefinitely.

Model of Her Majesty's ship *Sirius*, on the list of the Royal Navy as a sixth-rater in 1786. The *Sirius* model was made by Geoffrey Ingleton R N in 1937. Scale 1:20. Presented, Australian Sesqui-centenary Committee, 1938.

Ship models are another special case. In the great days of full rigged sailing ships, a model would be presented to the monarch, or some other powerful patron, for approval before work began on the costly enterprise of building a ship. In this sense, ship models had a role or function in history rather similar to architectural models (see page 74). We can often find out about a famous ship, or marine design, from an authentic model. Real ships, however famous, rarely survive. If they are not overtaken by disasters of nature or of war, they are eventually broken up, and the materials from which they are made recycled. The *Victory*, flagship of Admiral Sir Horatio Nelson, is one of the rare exceptions.

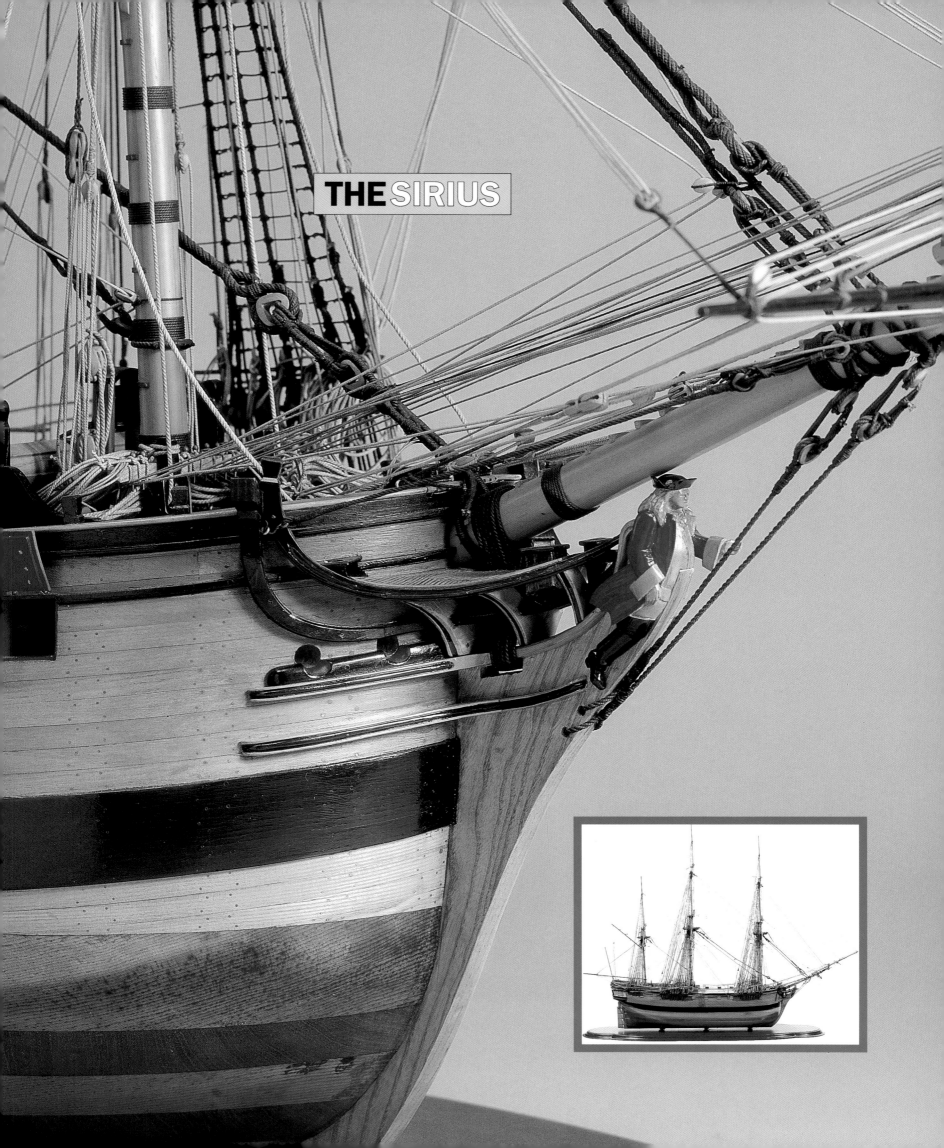

THE SIRIUS

Model of a brig (c1775).
Brigs-of-war escorted
larger ships and ran
despatches. Made in
1963 by Commander
S L Beeston RAN of
Newcastle.
Scale 1:48. Length
860 mm; width 350 mm;
height 750 mm.
Purchased 1963.

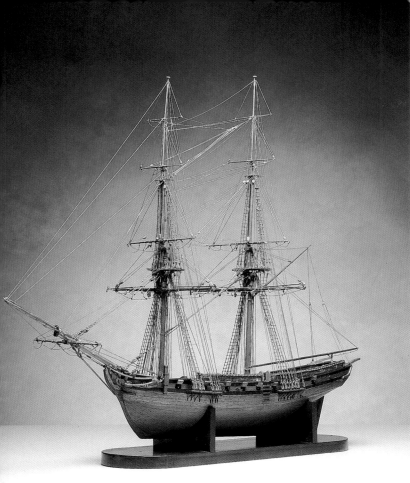
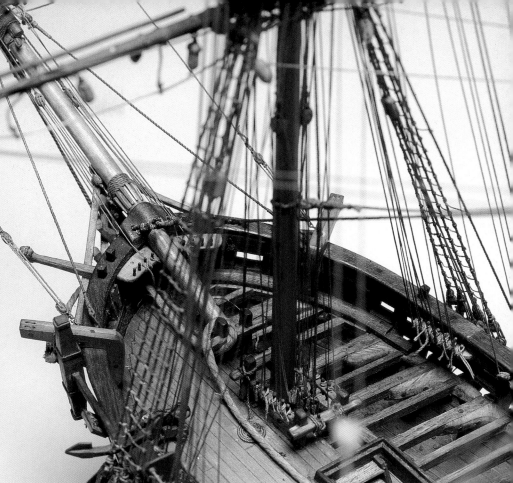
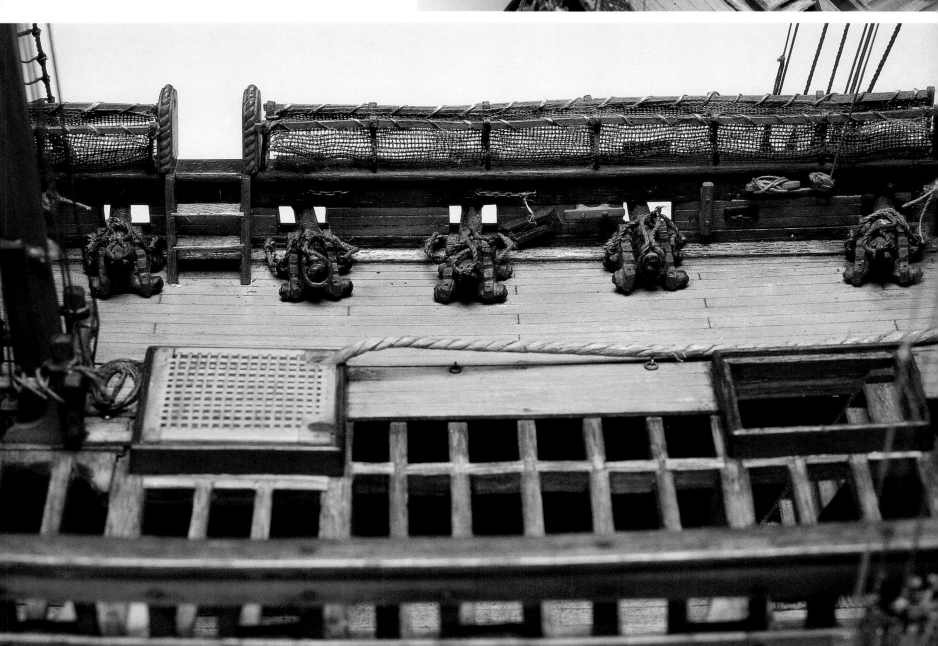

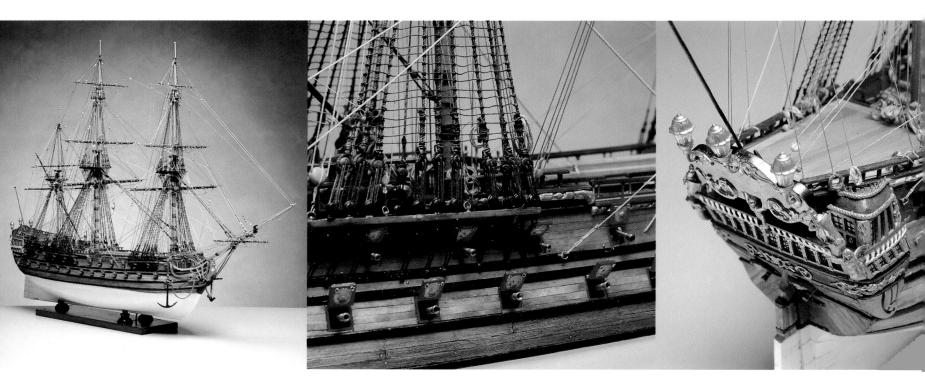

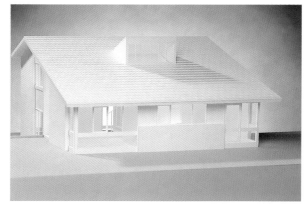

Acrylic architectural model, *Split level house*, designed by Ken Woolley and Michael Dysart in Sydney in 1962 for Pettit and Sevitt merchant builders; model made by R & F Modelmakers Pty Ltd. Scale 1:25. Width 835mm; depth 835 mm. Purchased 1992.

Perhaps more than any other kind of model, models of ships have the power to fascinate visitors in a museum. The Powerhouse has a large collection. There is a tradition in ship model making of providing accurate and minute detail. Ships' boats on their davits, anchors, companion-ways with tiny steps, miniature ropes and chains, minuscule cabins – all these fire the imagination and allow the viewer a picture of life aboard the real thing. Visitors also enjoy the gracious lines of ships, and with models they can admire a design from any angle, including from above. Exquisite decoration was lavished on the hulls and superstructure of sailing ships. The stern in particular was elaborately ornamented, with carving and gilding gracing the windows of the captain's and officers' cabins. At the bow stood the brightly painted figurehead. For the model-maker to render all this in miniature scale inspires admiration in the viewer, and this is particularly true of the skill and ingenuity which informs the complex, filigree patterns of rigging.

Model-makers strive conscientiously for authenticity. An excellent example of this is the work of Commander S L Beeston RAN of Newcastle. His model of an **eighteenth-century brig** (see pages 72–73), which he made in 1963, uses the same timbers as the original. To reveal the authentic construction of his model, he has left one side of the hull and a portion of the deck unplanked.

One of the treasures of the collection is the large model, almost

above and opposite
Model of an English warship (c1750) of the third rate. Ships of the line were rated in six classes, according to the number of guns. A first rate would have 100 or more guns; third raters had between 50 and 80 guns. Made by Captain S D Kirk of Sydney, 1975–78. Scale 1:75. Length 1410 mm; width 670 mm; height 1060 mm. Gift of Captain S D Kirk, 1978.

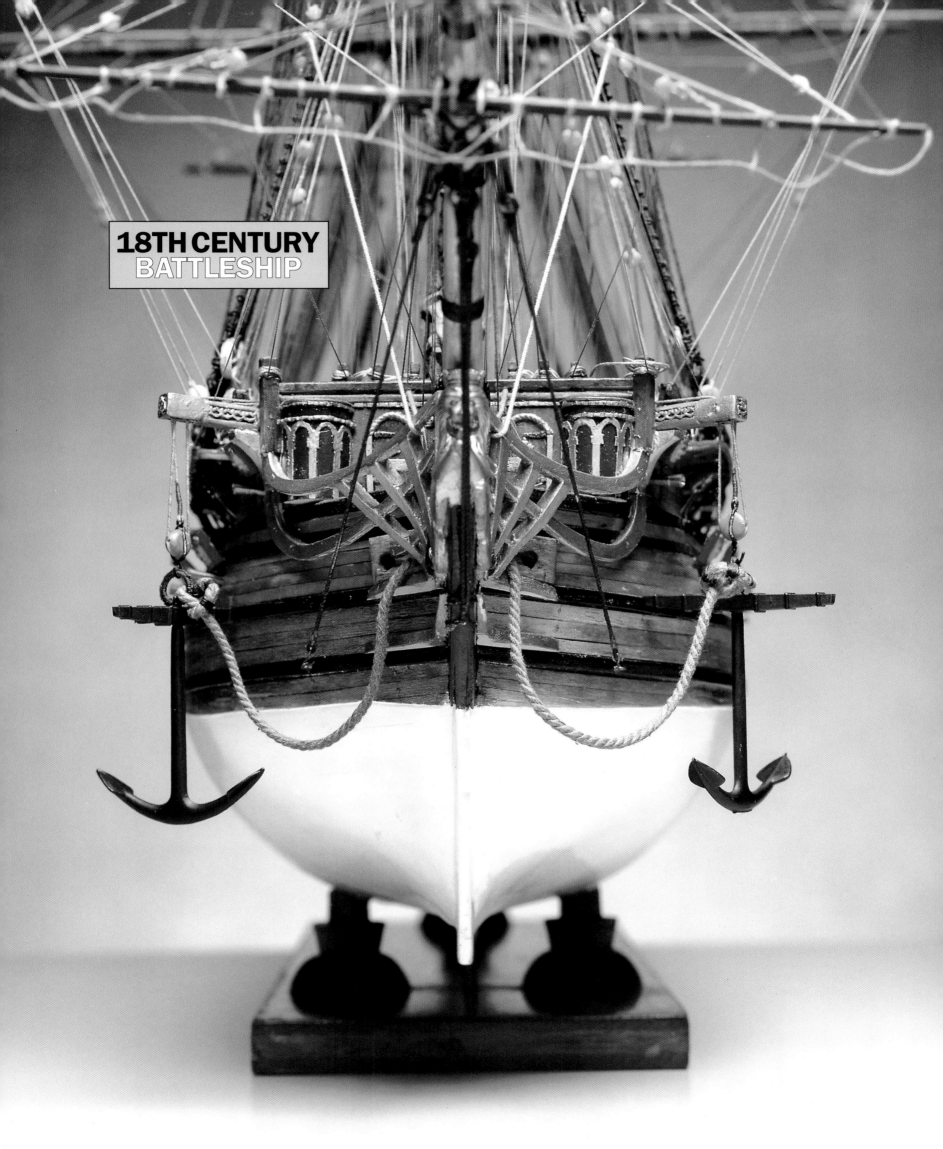

18TH CENTURY
BATTLESHIP

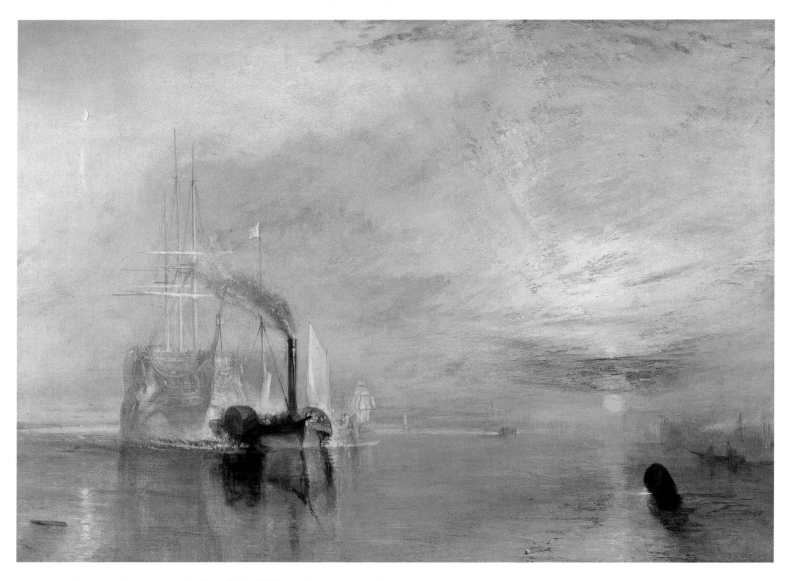

3 metres long and 3 metres high, of the **Sirius**, the command ship of the First Fleet. The *Sirius* was an armed store ship first registered under that name with the Royal Navy in 1786. It had been built a few years earlier at Rotherhythe on the Thames as a humble collier named the *Berwick*. As a naval vessel, the *Sirius* still kept an effigy of the Duke of Berwick as its figurehead. The poor old duke was knocked from his perch in raging seas in 1889. That was south of Van Diemen's Land, as Tasmania was then called. It was a bad omen. An age-old superstition states that when a ship loses its figurehead, the ship will lose its life. And, indeed, the *Sirius* was wrecked less than a year later off Norfolk Island.

The *Sirius* was lightly armed. It was a sixth-rater. Battle-ships of the line rated down from first-rate ships such as the *Victory*, or the *Fighting Temeraire*, made famous by Turner's great painting. Illustrated (see pages 74–75) is the museum's

JOSEPH MALLORD WILLIAM TURNER (1775–1851) *The Fighting Temeraire, tugged to her last berth to be broken up 1838* **1839 oil on canvas 90.8 x 121.9 cm. Collection of and reproduced courtesy of the Trustees, The National Gallery, London.**

very fine model of an eighteenth-century battleship of the third rate. With up to eighty guns, this size of ship was the most effective fighter in the fleet because of its greater manoeuvrability.

Like so many things in the museum's vast collection, ship models require their own special brand of care. They are fragile and vulnerable objects which are cleaned delicately, from time to time, with an artist's brush.

Ships and navigation are important to the Powerhouse Museum in a number of ways. We are a museum of astronomy and we run the historic Sydney Observatory (see page 82). Situated on Observatory Hill, a site of immense significance in the history of the colony of New South

As a young man, Robert Klippel was a frequent admirer of the museum's model collection. In wartime, he made ship models for the Navy's identification training sessions, as seen in this photograph from 1944. Models and model-making thus contributed to Klippel's eventual recognition as Australia's greatest sculptor.

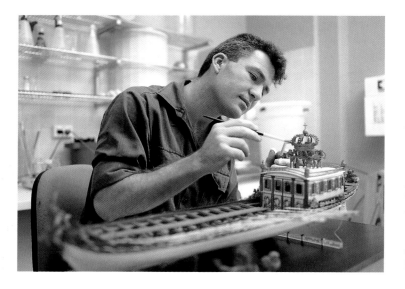

above Defensively equipped merchant ship model, made by Robert Klippel in 1942. Height 80 mm; width 55 mm; length 170 mm. Gift of Robert Klippel, 1972.
left The ship model being treated by Tim Morris, one of the museum's conservators, is Napoleon's imperial barge, *Le canot imperial*. It was made by Giovanni Scardinale, Australia, 1975–80. Gift of Giovanni Scardinale, 1982, as a token of his gratitude to his adopted country, Australia. Height 40 cm; length 93 cm; depth 32 cm (dimensions include base).

opposite top Minesweeper model, HMAS *Bombo*, made by Robert Klippel in 1941, set in painted plaster seascape by John Allcot, in three-sided wooden box. Width 260 mm; height 110 mm; length 290 mm. Gift of Robert Klippel, 1972.
opposite below Pilot ship model, made by Robert Klippel in 1940, set in a painted plaster seascape by John Allcot. Height 90 mm; width 120 mm; length 265 mm. Gift of Robert Klippel, 1972.

Wales, the Observatory was built from Sydney sandstone over the period 1857–1859. The architecture itself is impressive, an essay in Italianate classicism, restrained if not to the point of frugality then certainly in a style consistent with the pursuit of scholarly research.

Other masonry structures on the site are much older than the Observatory. The hill was fortified in the late 1700s and an extant wall is the oldest masonry built in Australia since

European occupation. In addition there are two cottages on the site. The so-called Messenger's Cottage has been restored by the museum and the Signal Master's Cottage, historically much more significant but in a worse state of dereliction, certainly needs to be restored when money can be found. From here, overlooking the harbour, a series of flags was used to exchange messages by semaphore with flags at South Head, as sailing ships entered Sydney Harbour from

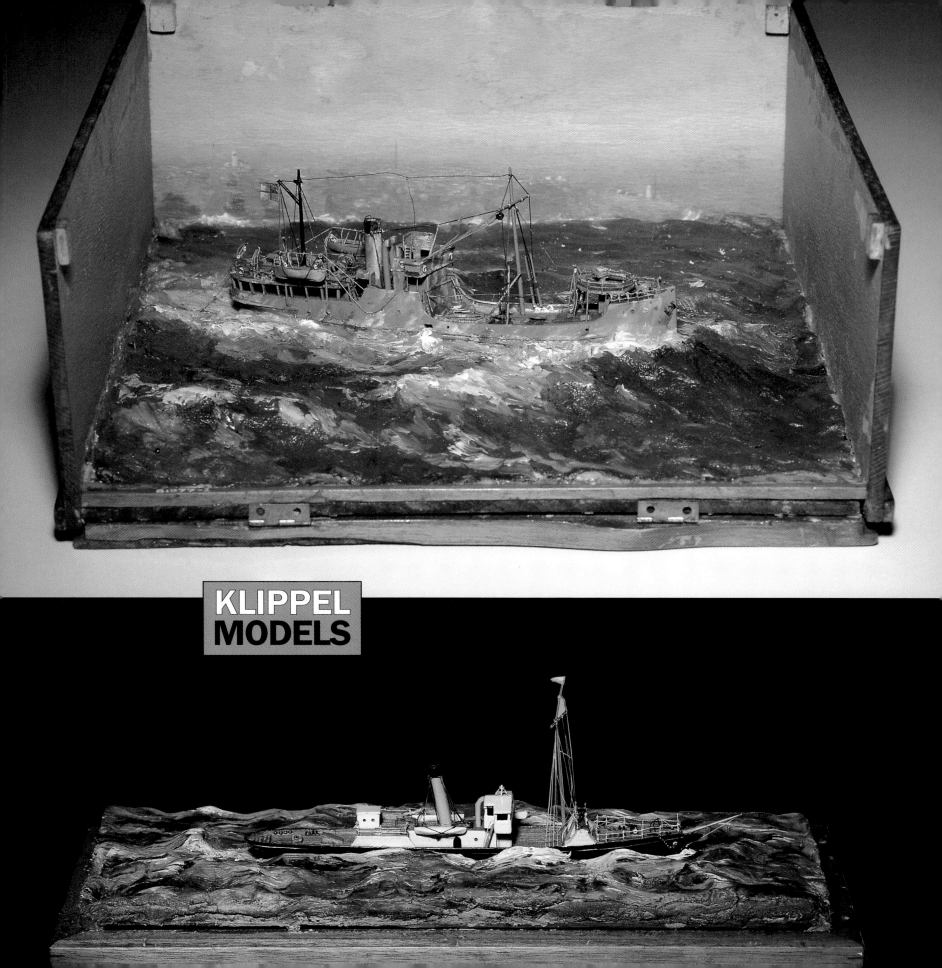

FROM NEIGHBOURING PLANETS TO DISTANT NEBULAE, THE UNIVERSE HAS PROVIDED UNLIMITED FASCINATION FOR HUMANKIND.

This is a 406 mm repeating circle mounted with two 38 mm refractor telescopes, by Reichenbach, Munich, Germany, c1820. It was used to minimise the error in measuring angles between stars in the 19th century. Acquired 1983.

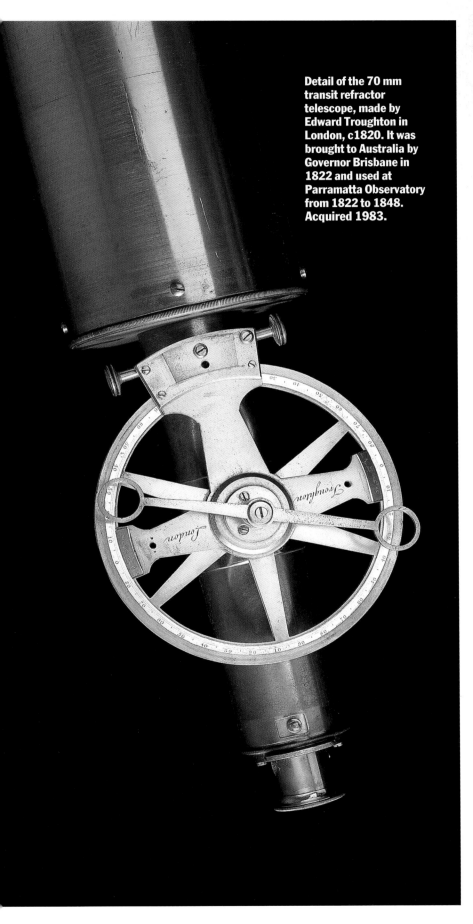

Detail of the 70 mm transit refractor telescope, made by Edward Troughton in London, c1820. It was brought to Australia by Governor Brisbane in 1822 and used at Parramatta Observatory from 1822 to 1848. Acquired 1983.

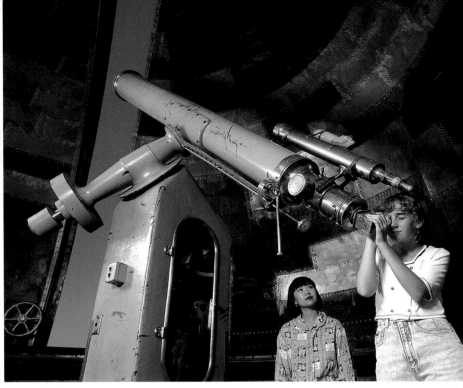

the ocean. Such messages from the Heads were relayed all the way up river to Parramatta, more than 20 kilometres west of Sydney. One of the staging posts in this process has given its name to what is now a large suburban district: Pennant Hills.

above This 29 cm refractor telescope, optics by Hugo Schroeder, Hamburg, Germany, in 1874, has been the main telescope for optical observation at Sydney Observatory since 1874.

The Astronomer Royal in London appointed a government astronomer for the Sydney Observatory, and the navigational function of the site was intensified. The Observatory's tower houses a time ball (see page 82) which was dropped at noon each day for the first few months in 1858, then switched to 1.00 pm. Captains of ships in the harbour, their telescopes trained on the Observatory, set their chronometers by its signal. A cannon echoed across the water, confirming the time – necessary in case sight lines were blocked.

The real business of the Observatory was with navigation of a different kind. The large telescopes in the domes were pointed at the heavens and plotted the course of stars. Astronomers made their observations here up until 1982 when the building and its contents were handed over to the museum. Today, its function is not radically changed as Dr Nick Lomb, curator of astronomy, and his talented staff conduct nightly sky viewings for the public. Visitors are voracious for information and soak up the lectures which are always provided before the exciting ascent into either the north or south dome.

From neighbouring planets to distant nebulae, the universe has provided unlimited fascination for humankind. But in

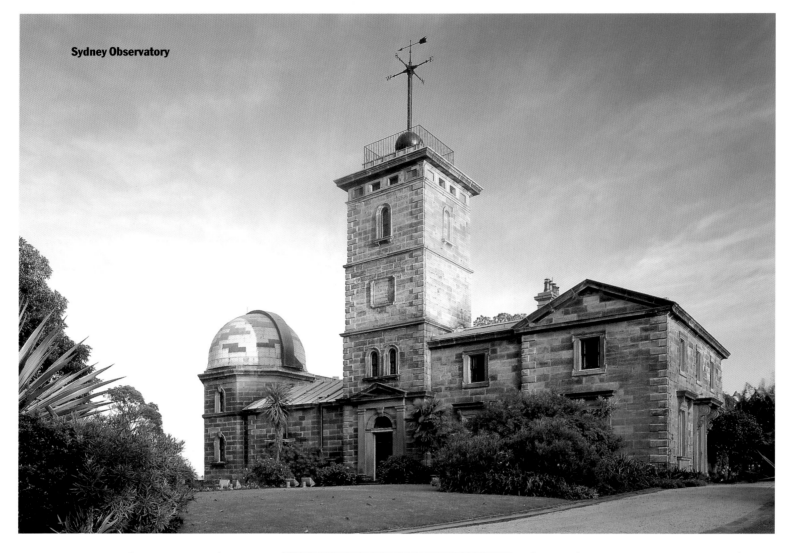

Sydney Observatory

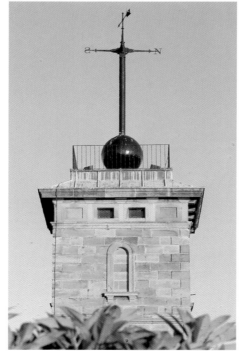

our own age, modern space exploration has meant that that fascination is more intense, more acute than ever. After Neil Armstrong stepped onto the Moon in 1969, people knew that it was real. Australians have watched the space race between the USA and the Soviets just as avidly as anyone else. And since the collapse of the USSR, we have continued to compare the different achievements of Russian space technology with those of America. And, indeed, to applaud their close cooperation.

Its position in the southern hemisphere has given Australia a unique role in astronomy since the eighteenth century. Indeed, Captain Cook's mission in sailing the southern seas in 1769 was to observe the transit of Venus. Then, in 1874, when Venus was passing our way again, an 11.5 inch (29 cm) refractor telescope was installed at Sydney Observatory to witness the event. (This is one of the telescopes still in use in our public night-time viewings, along with more modern and sophisticated instruments.)

In recent times, Australia has played integral roles in major astronautical

left The time ball at Sydney Observatory.
opposite Soviet spacecraft 'in orbit' above the exhibition *Space: beyond this world*. The 1:3 scale *Soyuz 4–5* model represents the world's first docking of two crewed spacecraft in 1969. The *Luna 9* replica, represents the first spacecraft to soft-land on the lunar surface in 1966. Purchased 1997.

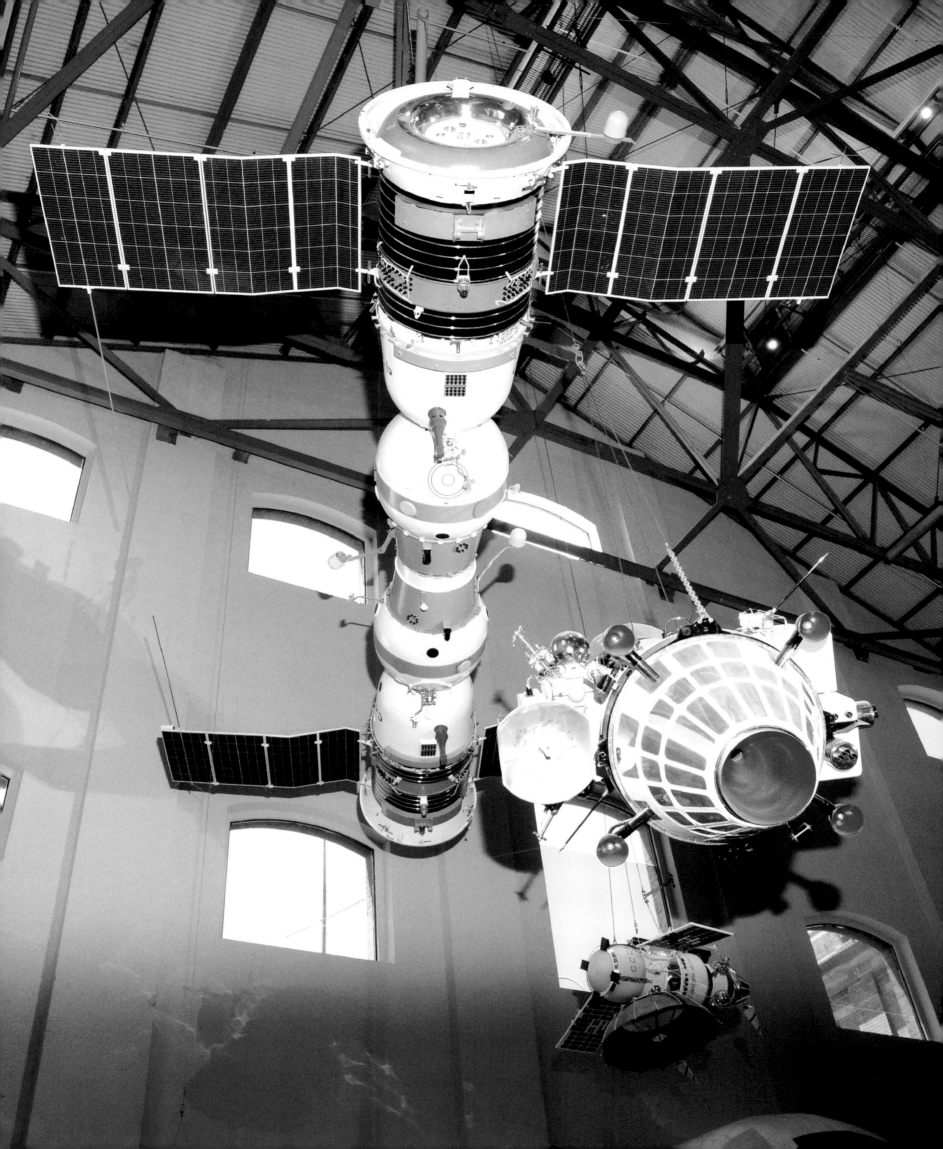

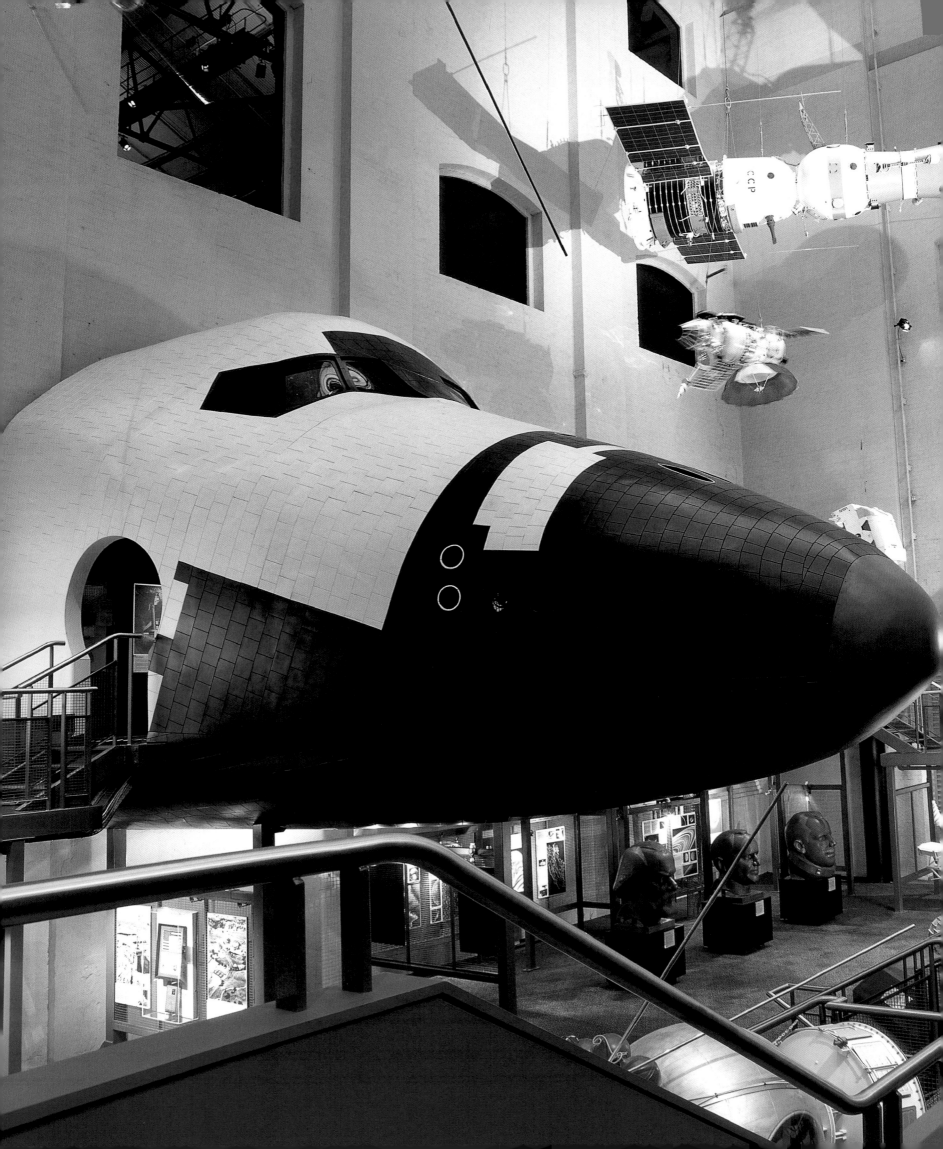

WHEN OUR SPACE EXHIBITION WAS LAUNCHED IN OCTOBER 1988, IT WAS THE FIRST IN THE WORLD TO BRING TOGETHER THE ACHIEVEMENTS OF THE USA, THE THEN USSR AND CHINA.

programs. The Tidbinbilla Space Tracking Station in the mountains outside Canberra is crucial in the United States National Aeronautics and Space Administration (NASA) programs. Opened in 1965, Tidbinbilla has monitored every NASA space probe since then. At Parkes, NSW, the Commonwealth Scientific and Industrial Research Organisation (CSIRO) radio telescope has played a role in a number of programs. For example, it tracked the *Voyager* 2 spacecraft as it encountered Uranus in 1986 and Neptune in 1989. From November 1995, the assignment was the *Galileo* spacecraft in orbit around Jupiter.

In several ways, Australia has played a leading role in the science of astronomy. Astronomy is an international science because it can't be carried out on a national basis. Observations made in one part of the world need to be checked and confirmed by observations made from some other vantage point. It is remarkable and highly creditable that astronomers in Australia, given our small population, participate in and, indeed, initiate some international projects. Perhaps because astronomy is still considered by some to be a 'pure' science, one that does not produce functional by-products, or spin-offs, its continued government support is vulnerable. Unimaginative finance departments in Canberra are reluctant to fund activities which do not appear to produce immediate and tangible returns. (The same old 'dry' approach constantly surfaces to threaten the existence of museums where current visitor numbers seem to be accepted as the only justification for our existence. As you read this you are one of many other kinds of museum clients that exist today; and future generations are also very much our concern.) Astronomers, for their part, are more and more excited by where their observations are taking them – seemingly beyond physics, beyond the physical laws that have hitherto defined the universe.

THE ORIGINAL LUNAKHOD, OR MOON BUGGY, OF WHICH OURS IS A COPY, IS STILL ON THE MOON.

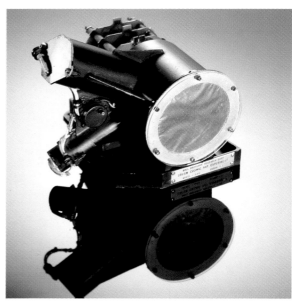

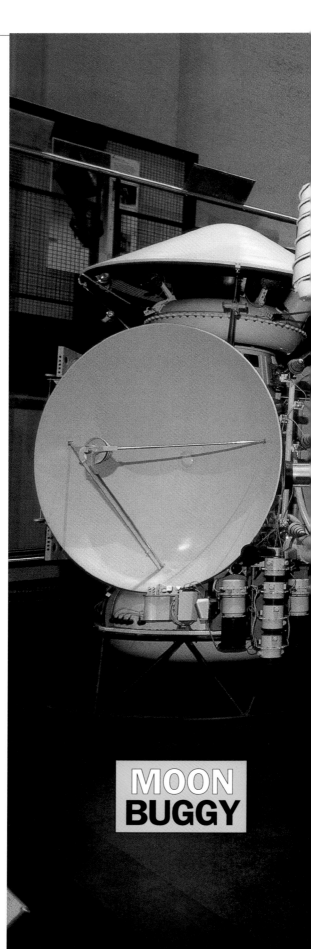

left Cosmic ray detector designed by Dr Ken McCracken, Australia, manufactured by Ball Brothers Research Corporation, USA, 1965, for flight on the *Pioneer 6 and 7* space flights to the vicinity of Venus and Mars (1965 and 1966). Lent for *Space: beyond this world* exhibition by Dr Ken McCracken.
below This space dinner went aboard the *Apollo 8* mission, which put the first crewed spacecraft into orbit around the Moon on 24 December 1968. Some of the techniques developed for space food were later transferred to the commercial processing industry. Purchased 1995.

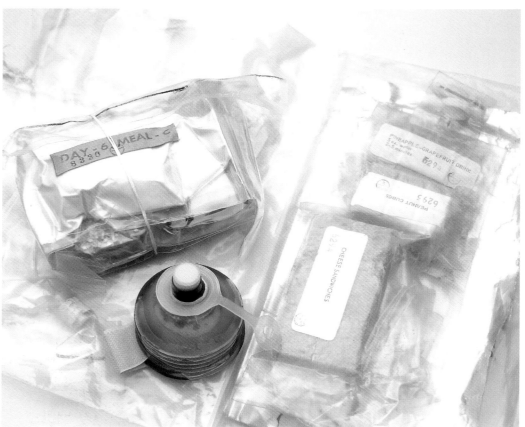

MOON
BUGGY

Full size replica of the *Lunakhod* remotely controlled Moon roving vehicle, used by the USSR to explore the lunar surface in 1970 and 1973. A replica of the Soviet *Mars 3* probe, which landed on Mars in 1971, can be seen in the background. Purchased 1997.

SPACE EXPLORATION
IS A STRONG SUIT IN THE
MUSEUM'S PROGRAMS…
THIS THEME IS THE MOST
POPULAR OF ALL THE
MUSEUM'S MANIFOLD
DISPLAYS.

The Space Shuttle *Endeavour* lifts off with the museum's commemorative *Resolution* and *Adventure* medal (see page 90) on board.

Nestling in the beautiful bushland of the Australian Capital Territory, the Tidbinbilla Space Tracking Station has given remarkable assistance to the space technology programs of the Powerhouse Museum. Much of this is due to the high regard in which our space curator, Kerrie Dougherty, is held by space scientists across several continents. Many of them stop by at the museum on their way to the ACT to give a talk or similar presentation to our visitors. Also, from time to time, Tidbinbilla relays programs into the museum from NASA Select Television, NASA's in-house network.

Space exploration is a strong suit in the museum's programs. In the Powerhouse itself there is an exhibition, **Space: beyond this world**, on this theme which is immensely popular with visitors, in fact, the most popular of all the museum's manifold displays. It is the museum's claim that when our space exhibition was launched in October 1988, it was the first in the world to bring together the achievements of such politically incompatible nations as the USA, the then USSR and China. Inevitably, most of the material on view consists of models or replicas. Indeed, taking the Soviet material, for example, ten out of a total of eleven items were described by the Russians themselves as models. Half of these were also described as full-scale replicas.

In fact, all this material was on loan from the Soviet Academy of Science, which reverted to its historical title, the Russian Academy of Science, after the disintegration of the USSR. The several year duration of the loan agreement expired and the Powerhouse had to decide whether to send this popular material back to Moscow, to extend the loan, if possible, or to attempt to buy the objects outright. The latter was the course adopted but not until after much agonising on the part of the Board of Trustees about the status of models and replicas and their place in a museum that places the highest value on authenticity.

One of the deciding factors was the difficulty in making such technology accessible to the public in any other form. The original **Lunakhod 1**, or moon buggy, of which ours is a copy, is still on the Moon. That's extremely inaccessible! (Although, in 1993, a bidder at Sotheby's, New York, bought it even though it is stranded on the Moon. The money he paid to the Russian agency representing the original manufacturers was real enough and so was the

SPACE DEBRIS

This is space debris from the oxygen tank of the *Skylab* space station, made of titanium / fibre-glass by McDonnell Douglas Astronautics Co, USA, 1970–72. *Skylab* was the first US space station and the largest such facility built at the time – as large as a three-bedroom house. Its three crews held a number of space endurance records during the 1970s. *Skylab* was the first large space object to make an uncontrolled re-entry, causing public recognition that space debris was a major international hazard. The *Skylab* space station crashed into the Indian Ocean, off the south-west coast of Western Australia on 12 July 1979. It broke up during its final descent, scattering debris along a wide path across the south east of Western Australia. Wild animals were drinking water out of this piece when it was found in 1993. Purchased from the Crome Bequest, 1994.

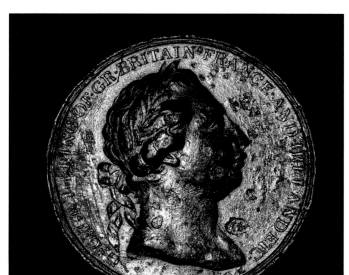

RESOLUTION AND ADVENTURE MEDAL

The *Resolution* and *Adventure* medal was conceived by Joseph Banks and struck by Matthew Boulton (manufacturer of the museum's famous Boulton and Watt engine) in 1772 to commemorate Captain Cook's second voyage to the Pacific. Two thousand were struck in brass alloy and purchased by the British Admiralty for presentation to the people of the lands visited on this voyage. Only a few of the brass alloy medals have ever been recovered. This example was gilded at a later date. In May 1996, this medal was sent into space aboard the NASA Space Shuttle, *Endeavour*. Purchased 1977.

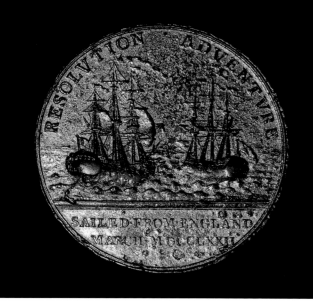

buyer's premium he paid to the auction house.)

Another persuasive factor in the decision to buy them was that our models and replicas had been produced by precisely the same Soviet agency responsible for producing the real things. Indeed, many of the components in the replicas are fully authentic. Why fabricate look-alikes when there is plenty of original componentry readily available?

With these attitudes I travelled to Moscow to meet our friends at the Academy, Dr Natalia Kotelnikova, Director of Exhibitions, and her deputy, Dr Ruslan Lavrenov to negotiate the terms of purchase.

More recently, in March 1996, the museum seized the opportunity to build on the strengths of its space collection by bidding at a Sotheby's auction in New York for some very real, albeit prototypic, objects in the space technology field. We bought authentic equipment that had actually been used on a mission in space. The most unusual items were a pair of waste management systems, one for a woman and one for a man (see pages 92–93). Our experience in the museum is that the most frequently posed question about space flights is: 'How do you go to the loo in space?'

The museum already had an American solution to this anxious problem. Our Boeing Space Habitation Unit is a serious design which looks very real even though it is a stage earlier even than a prototype. Built in the Powerhouse workshops by our own preparators, using photographs of the Boeing design, the Habitation Unit projects a very plausible picture of what living for extended periods in orbit would be like. Its toilet is a source of fascination for most visitors because they can see that our natural body rhythms could not be accommodated as easily without the assistance of gravity.

The acquisition of prototype collectors in March 1996 means that we have a definitive and proven answer to the common question about our most basic of needs. One waste management system was developed for the *Vostok 6* mission of June 1963, on which travelled the first woman in space, Valentina Tereshkova. The mission lasted for three days, far too long for cosmonaut Tereshkova to wait for a convenient loo. The waste management system for a man was used by the Cosmonaut Georgy Beregovoy on board the *Soyuz 3* mission of 1968.

How do these systems work? Fans help to create a partial vacuum which collects both kinds of waste matter. An air purifier then keeps everything clean. *Adieu ordure!*

MANY ASTRONAUTS AND SPACE SCIENTISTS STOP BY AT THE MUSEUM TO GIVE TALKS TO OUR VISITORS.

At the same auction in 1996, the museum also made successful bids for three further items: a pair of flight shoes with elastic gaiters; a complete survival kit for use in emergencies, such as faulty landings back on Earth; and a prototype space razor (see page 93). Purchased for sentimental reasons, the space razor had been used by Nicholai Rukavishnikov, the cosmonaut who had been present at a very different kind of launch – the official opening of the our exhibition, *Space: beyond this world* in

October 1988. On that occasion, Rukavishnikov gave a long and magisterial speech at the formal dinner which was so frank in its assessment of Soviet issues that we were convinced he would be sent to Siberia. However, I failed to take into account the hero status of a famous cosmonaut and the privileges that go with it. I also had not yet understood, like most people in the west, just how far-reaching and radical were the changes that were taking place in Russia. The collapse of Soviet communism took everyone by surprise.

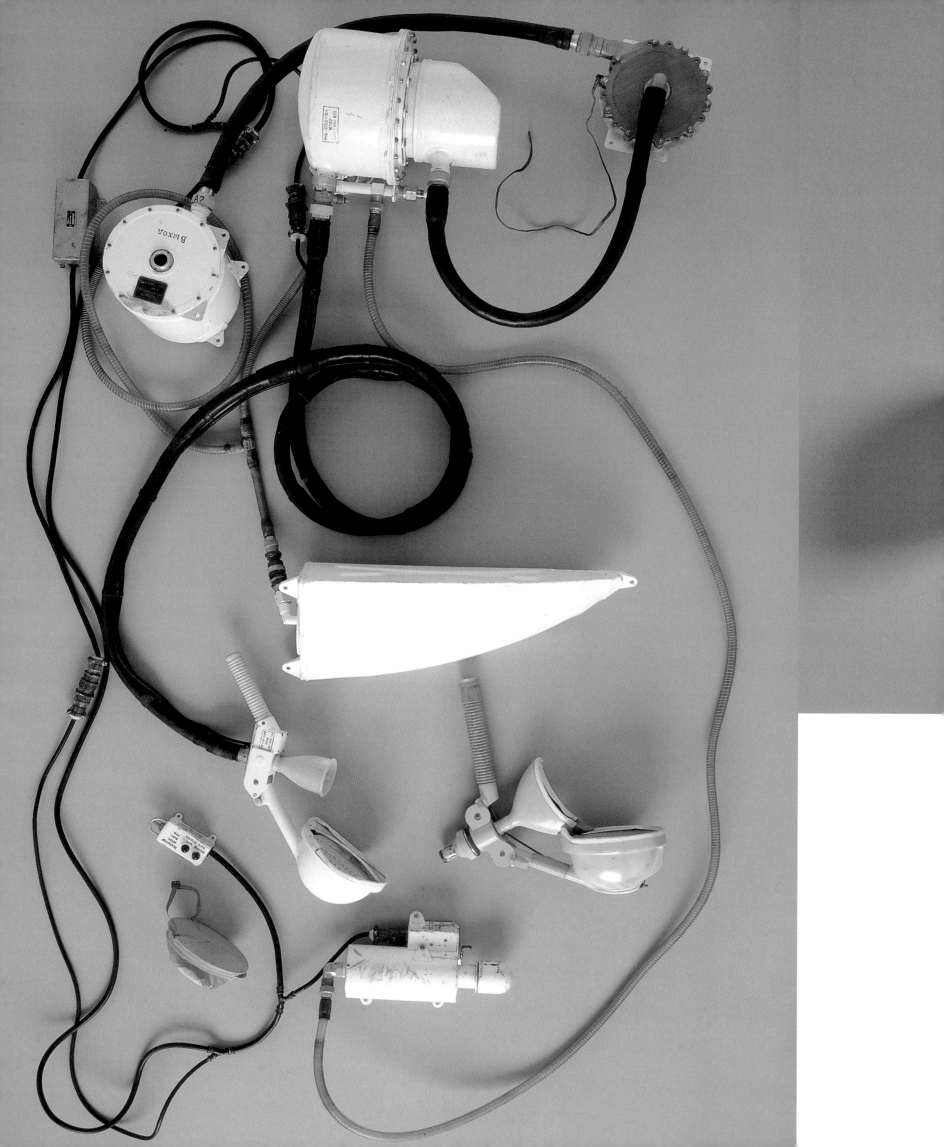

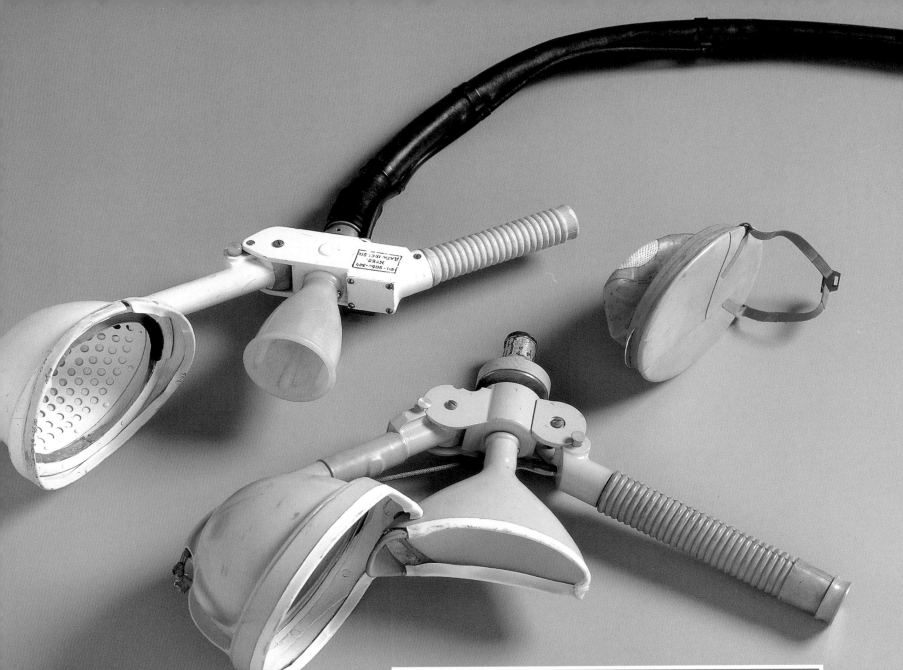

'How do you go to the loo in space?' is the most common question asked about space travel. These male and female 'waste management devices' represent a Soviet answer to the question. The male device was used on the *Soyuz 3* mission in 1968. The female collector is the prototype of the system designed for use on the *Vostok 6* mission in 1963, the flight of the first woman in space, Valentina Tereshkova. Purchased 1997.

right The Soviet space razor was designed to trap whiskers, so that they would not float about in the weightless environment of the spacecraft. This example was used by Cosmonaut Nicholai Rukavishnikov (a guest at the opening of the *Space* exhibition) during the *Soyuz 16* mission in 1974. Purchased 1997.

An astronaut model with a Manned Maneuvering Unit (MMU) backpack, also known as the 'Buck Rogers' backpack, hovers above visitors in the *Space: beyond this world* exhibition. NASA developed the MMU to enable astronauts to work freely in space without being directly tethered to a spacecraft. It is a loan from Lockheed Martin Astronautics, Denver, USA. The reproduction space suit is a gift of the US Information Agency.

A part from the specimen
piece of the Babbage
Difference Engine No. 1
during conservation.
Purchased 1995.

the
babbage
enigma

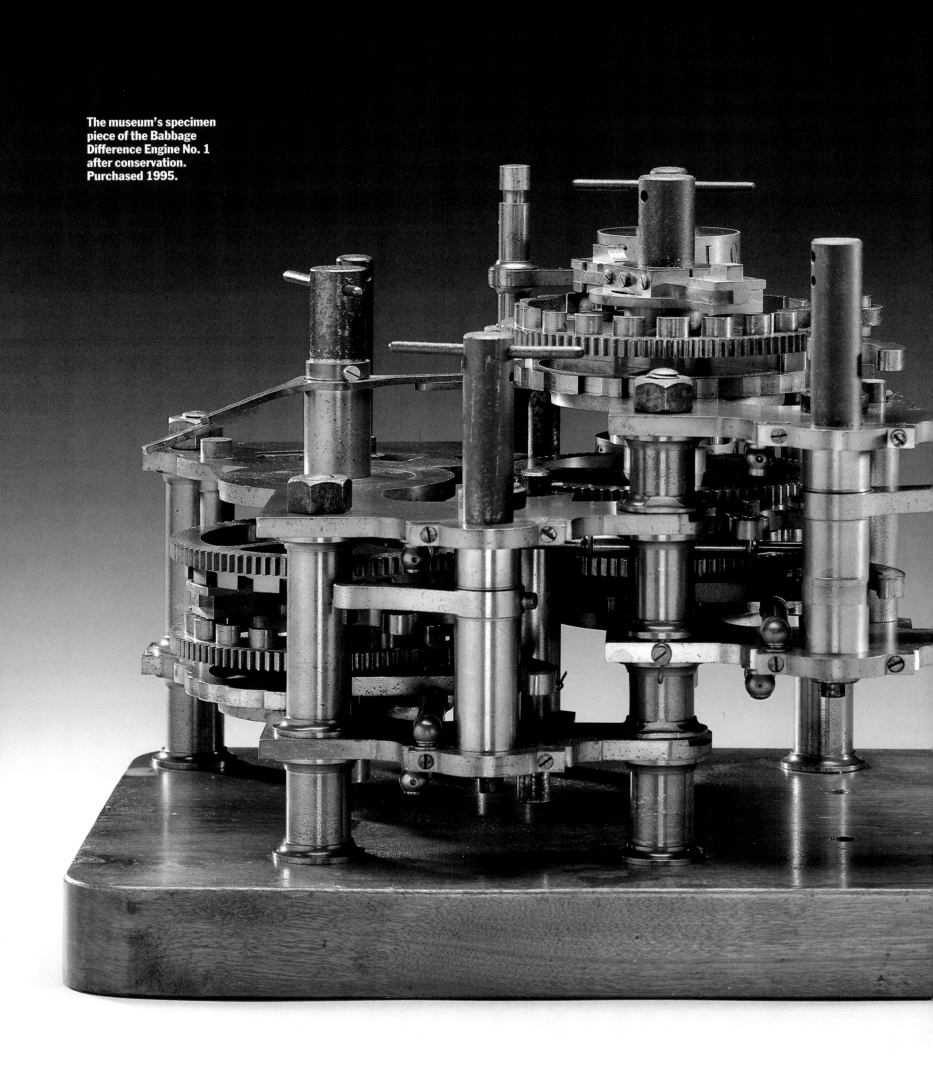

The museum's specimen piece of the Babbage Difference Engine No. 1 after conservation. Purchased 1995.

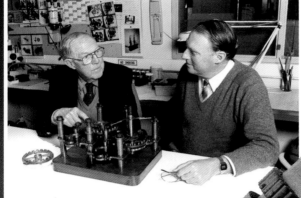

above left **Dr Neville Babbage, a descendant of Charles Babbage, with his son, Dr Michael Babbage.**
above **A component from the Babbage Difference Engine No. 1 during conservation.**

A s the last chapter has shown, museums routinely face refractory questions of definition and categorisation when it comes to scale models, real-size models and replicas. In October 1995, however, the Powerhouse was prominently successful in making a celebrated acquisition that defies all such categories. The specimen piece of **Difference Engine No. 1** by Charles Babbage is neither a model nor a replica. It is not a prototype. There is no doubt about its authenticity yet it is a part of something that never really existed.

Before attempting to determine its scientific significance we should situate it within the history and traditions of collecting. The phenomenon of the Babbage's appeal to museums or private collectors is reminiscent of the age of holy relics, perhaps, for some, uncomfortably so.

In the middle ages and earlier, cathedrals, abbeys and, later on, merchant towns, such as Venice, all searched for and jealously guarded religious relics, such as fragments of the true cross, or a bone from a saint's foot. Goldsmiths, silversmiths and jewellers lavished their craft skills on the creation of exquisite reliquaries in which to contain these legendary

fragments with their mystical properties. It was not uncommon for cities to go to war over possession of a particularly powerful relic. Such things were often the loot or booty carried off by raiding parties. Sometimes they were traded rather as collectors have always swapped items with other collectors. Holy relics were of enormous economic significance as large groups of people formed pilgrimages, undertaking perilous journeys across foreign lands and jurisdictions to view them. Wherever pilgrims travelled, needless to say, they needed food, accommodation, entertainment and some keepsakes to take back with them, perhaps to distribute among family and friends. Nothing's changed! Today's secular pilgrims are called tourists and it is a truism that museums are the cathedrals of our secular age (and certainly, the Powerhouse has the spaces of a giant basilica).

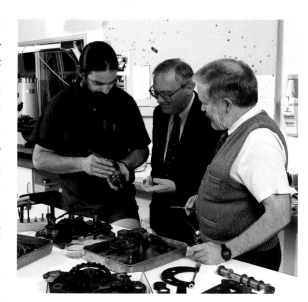

left to right: Carey Ward, museum conservator, Terence Measham and Allan G Bromley, Associate Professor, Computer Science, University of Sydney, study the Babbage's componentry.
below and opposite Components from the Babbage Difference Engine No. 1 during conservation.

It is also easy to recognise that many of the great cathedrals and abbeys now function as museums, with guided tours, audio tours, gift shops and, of course, admission charges.

Fragments of the Difference Engine No. 1 are regarded with reverence by computer historians who acknowledge the sanctity of the fragments as being similar to that of a holy relic. Such fragments are rarer than saints' bones. Until September 1995, four fragments were in captivity, that is, in collections. A portion of the Difference Engine, assembled under Charles Babbage's supervision in 1832, was in the collection of the Science Museum, London. Three specimen pieces, assembled after Charles

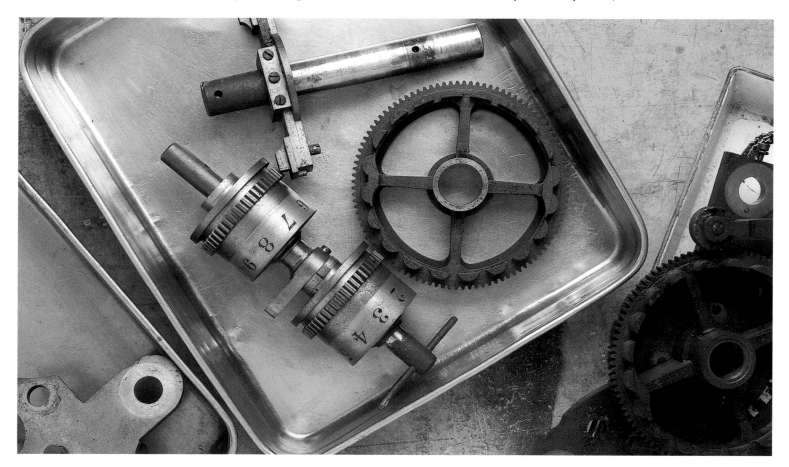

THERE IS A GENERAL NOTION THAT CHARLES BABBAGE
WAS THE INVENTOR OF THE FIRST COMPUTER...
MORE ACCURATELY, HE CONCEIVED OF THE
POSSIBILITY AND TRIED TO REALISE HIS CONCEPT.

Components from the Babbage Difference Engine No. 1 during conservation.

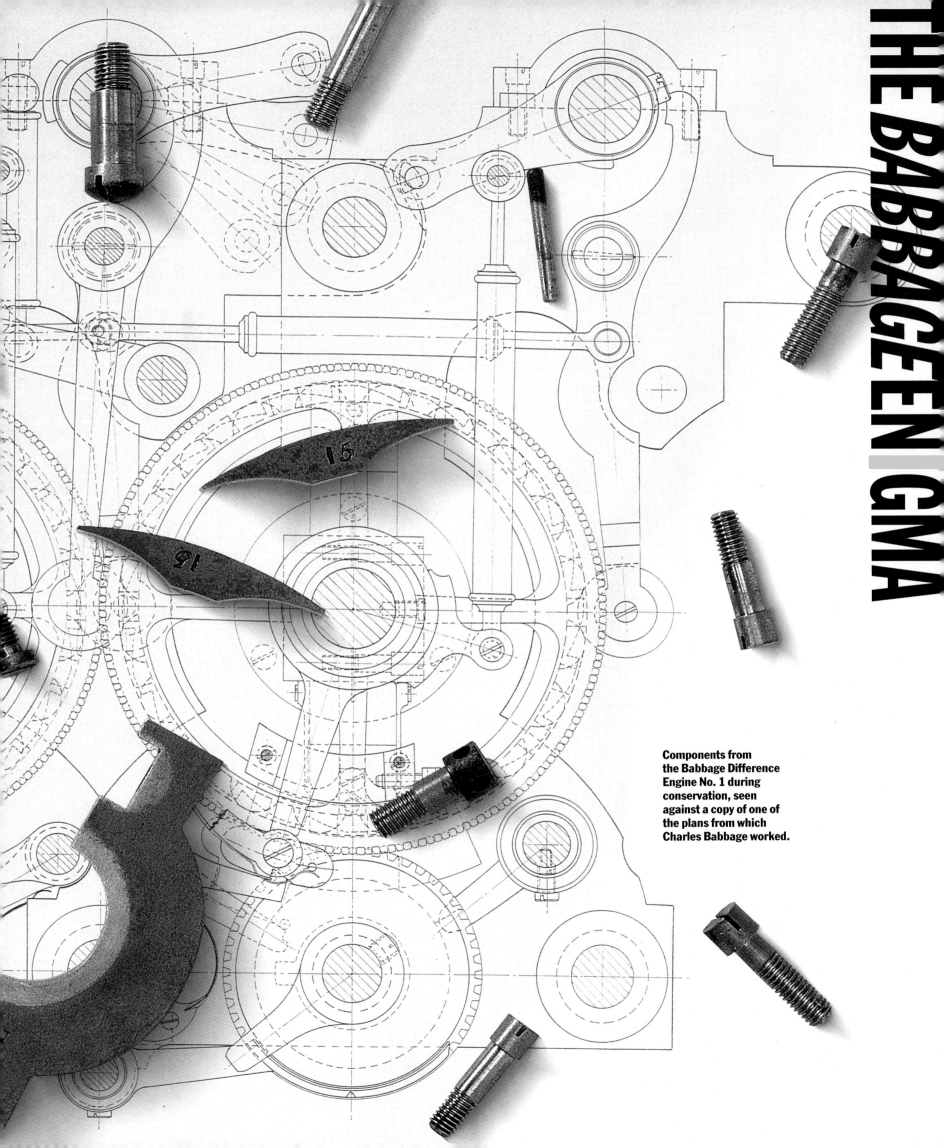

Components from
the Babbage Difference
Engine No. 1 during
conservation, seen
against a copy of one of
the plans from which
Charles Babbage worked.

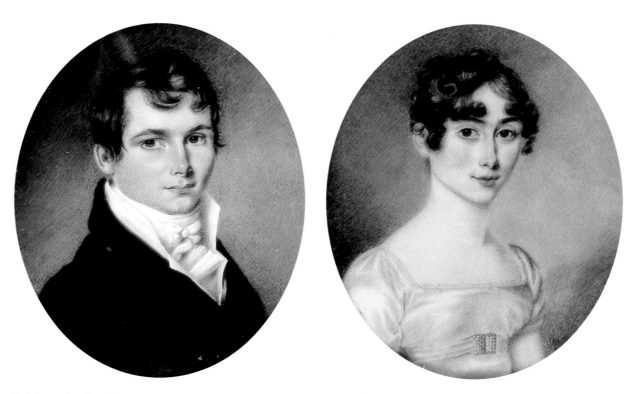

Charles Babbage and his fiancée, Georgiana Whitmore, portrayed in watercolour miniatures in 1813, when Babbage was a Cambridge undergraduate aged 21. They married in 1814. Lent by Dr N Babbage. **opposite** This portion of Charles Babbage's Difference Engine No. 1, assembled by Joseph Clement in 1832, is in the collection of the Science Museum, London.

Babbage's death in 1871, by his youngest son Henry Provost Babbage, were in museums: the Science Museum, London; the Whipple Museum, Cambridge, England; and in the Collection of Historical Scientific Instruments at Harvard University, Massachusetts, USA, respectively.

It was thought that a further three of Henry Provost Babbage's specimen assemblies had existed but were now lost to the world. So there was great excitement when one appeared in an auction catalogue at Christie's, London, in September 1995. Nineteen thousand kilometres away in Australia, the museum had very little time to decide on a bid. Fortunately, we had an extraordinary advantage in that the world's leading authority on the work of Babbage is an Australian and on the academic staff of the University of Sydney. Associate Professor Allan G Bromley quickly came to the museum's assistance with written advice which we could fax to the museum's Trustees, enabling them to authorise a substantial bid.

We needed a precision bid because a public museum does not have the spending flexibility of a private buyer. It is for this reason that we often lose to private collectors at auction because they can decide on the spot to commit more money by one extra bid or several. We, by contrast, have pre-set limits signed by a majority of our Board. In the event, our bid was as precise as Babbage's own componentry. We were

successful on our last throw. One more bid from rivals would have put us out of the game and left us empty-handed. Our triumph was witnessed by television cameras in the saleroom and shown on breakfast television in Australia within a few hours. There was a plethora of media attention. The *New York Times* ran a report and so did European papers.

There was much irony in all this. Most people would have great difficulty in describing what it was that we had bought at such great expense but nobody lingered on the question. There is a general notion that Charles Babbage was the inventor of the first computer. Or, more accurately, he conceived of the possibility and tried to realise his concept.

Charles Babbage was born in 1791 into a comfortably off family in the south of England. He lived most of his adult life in an affluent part of London, across the road from the town palace of the Marquess of Hertford. (That building is now a wonderful museum, housing the Wallace Collection which blends fine and decorative arts in a unique whole.)

Babbage was a scholar and an intellect who published prolifically. For a decade he was professor of mathematics at Cambridge University and he was made a Fellow of the Royal Society while still in his twenties. The Royal Society, founded in 1660, is the oldest scientific society in Britain and one of the oldest in Europe.

In the early 1800s, Charles Babbage was one of a number

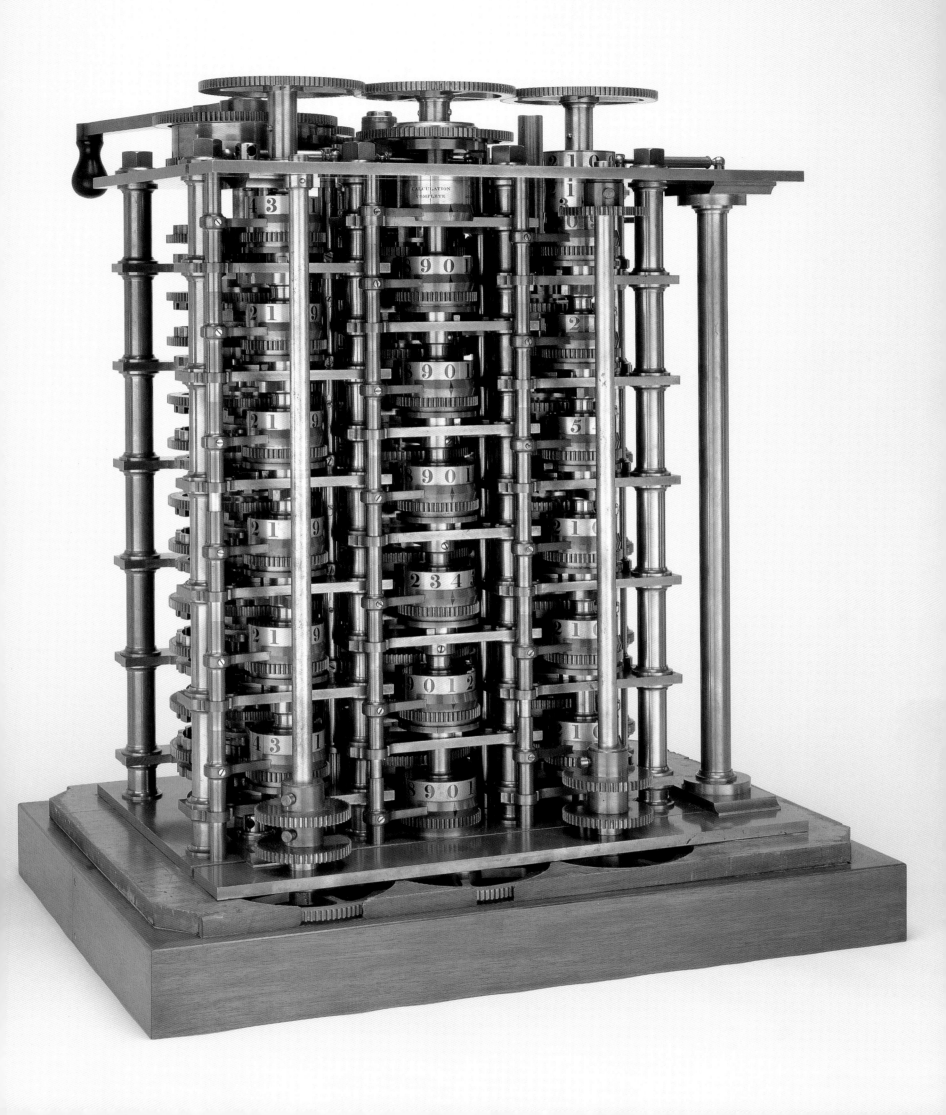

Babbage – Computer

opposite **This stamp featuring Charles Babbage is one of four British postage stamps celebrating scientific achievements, released in 1991. Purchased 1996.**
right **First day cover scientific achievements stamps (4), Royal Mail, UK, 1991: 22p stamp commemorating Michael Faraday (electricity); 22p Charles Babbage (computer); 37p Frank Whittle (jet engine); 31p Robert Watson-Watt (radar). Purchased 1996.**

BABBAGE'S CONTEMPORARY REPUTATION IN EUROPE WAS GREATER THAN AT HOME. HE WAS A PROPHET AND HE WAS MORE HONOURED ABROAD.

of people who were dissatisfied with the reliability of mathematical tables. All manner of professionals depended on printed tables for a variety of purposes such as scientific calculation, financial transactions and, most importantly, navigation. The importance of sea power in Babbage's time cannot be overestimated, yet British ships frequently lost their way or came to grief because charts were inaccurate. Babbage recognised that errors in tables resulted from all three stages in their production: human error in calculation, human error in transcription and mechanical and human error in typesetting and printing. In 1822, Babbage took on the mammoth challenge of producing a machine, his Difference Engine, which would eradicate errors in all three stages. He would be absorbed by this problem for the rest of his life and obsessed by his chronic failure to solve it.

Even though he was a man of substantial means, Babbage persuaded the government to fund his project. He made a careful study of industrial manufacturing processes and, polymath that he was, taught himself precision engineering to the point where he could make tools and run a workshop. This experience qualified Babbage to recruit a highly skilled

toolmaker and draughtsman, Joseph Clement, to manufacture and construct the components that he needed. Nobody knows for certain if all 25000 parts of the Difference Engine were completed. The machine was never assembled to its full size: 2.5 metres high, more than 2 metres long and about 1 metre thick. I would certainly not want so gigantic a contraption on the desk in front of me as I key in these words. Instead, I have a conveniently small machine which can perform vastly more functions than Babbage thought of, and can also exchange information with other like machines anywhere else in the world. But is my desk top computer a distant descendant of Babbage's concept?

Difference Engine No. 1 came to a stop. In 1834, after 12 years of intense effort, Babbage aborted the project. He fell out with Clement over money. In the 1830s, a good mechanic knew his value. And Clement was on to a good thing. He and Babbage had gone through a scarcely imaginable amount of government money. Seventeen thousand pounds might not seem much today but at that time it was enough to pay for about 25 of the new steam locomotives that were all the rage. With little or no result

for their investment, the government turned off the tap and the association between Babbage and Clement ended.

In an age that was increasingly industrial in character, Clement no doubt found ample scope to apply his talents profitably. For his part, Babbage went on to more doomed projects. He salvaged a working portion of Difference Engine No. 1, about 15 per cent of the whole, and this went on view 30 years afterwards at the Great Exhibition of 1862 in South Kensington. It is now a highly prized object in the collection of the Science Museum, London.

Despite a growing bitterness as he aged, Babbage was an engaging personality, a generous and magnetic host who

This gothic-revival walnut secretaire was designed by John Dibblee Crace for the international exhibition in London in 1862 – the same exhibition in which the specimen piece of the Difference Engine No. 1, pictured on page 107, was exhibited. Purchased 1992.

attracted the brilliant and the beautiful to gatherings at his West End house. One adherent was Countess Ada Lovelace, the daughter of Lord Byron. Her interest in his work was serious and her grasp of the mathematics involved was formidable, more impressive even than her ready ability to translate a continental commentary on Babbage from French to English. For Babbage's contemporary reputation in Europe was greater than his reputation at home. He was a prophet who was more honoured abroad.

Why do so many of today's computer historians see Charles Babbage as a great pioneer? There is no obvious connection between his aborted experiments and our present-day electronic computer technology, between cog wheels and microchips. Present technology has its origins in wartime Britain, with the boffins of Bletchley, – that generation of mathematical maestros like Alan Turing. Before them, Babbage had been the first to conceive of a fully automatic calculator that, once in motion, required no further input from a human brain to produce a result. That makes him the ancestor of today's techno-geniuses. In according reverence to a few metal components, albeit ones crafted with remarkable precision, we also honour a great mind, an intellect that ranged widely across too many nineteenth-century concerns to list.

Fields to which Charles Babbage made a contribution include astronomy, ophthalmoscopy, meteorology, linguistics, theories of mass production and allied research and development. In politics, Babbage was a radical, opposed to hereditary peerages. With great foresight, he proposed life peerages several decades before they were introduced into Westminster's upper house. His interests were by no means restricted to the esoteric: he invented the locomotive cowcatcher. Here in Australia, we can justifiably regard him as the father of bull-bars!

Bull-bars may be a facetious connection to make but since the subject of this book is the collection of Australia's largest and greatest museum I feel justified, on a more serious note, in adopting an Australian perspective on anything the book mentions. Indeed, the museum's collection is developed according to an Australian perspective. That is not parochial, it's plain commonsense.

It is a matter of interest and some irony that the specimen piece of the Difference Engine now lodged in the

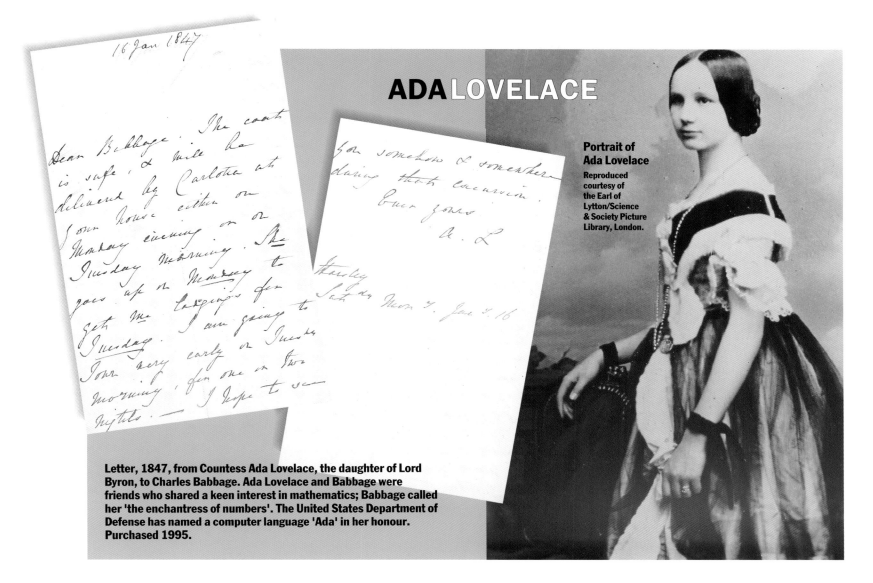

Letter, 1847, from Countess Ada Lovelace, the daughter of Lord Byron, to Charles Babbage. Ada Lovelace and Babbage were friends who shared a keen interest in mathematics; Babbage called her 'the enchantress of numbers'. The United States Department of Defense has named a computer language 'Ada' in her honour. Purchased 1995.

ADALOVELACE

Portrait of Ada Lovelace
Reproduced courtesy of the Earl of Lytton/Science & Society Picture Library, London.

Powerhouse Museum in perpetuity, after being auctioned in London, came from this part of the world.

The vendors were a New Zealand branch of the Babbage family. The piece's existence there was known to only a few experts in the world although, in another irony, our own curatorial staff had sniffed about for it in the past. In the period leading up to the sale it appears to have languished in a garden shed, gathering verdigris, having been relegated there from an earlier phase as a lounge room ornament.

This particular piece had been assembled by Charles' son, Henry Provost Babbage. Henry's two elder brothers both emigrated to Australia. One of them, Benjamin Herschel Babbage (1815–78), continued the family tradition of high achievement. The family's first born, he was named after Charles' close friend John Herschel, a distinguished astronomer and son of the famous discoverer of Herschel's Comet. Benjamin was a trained engineer who worked with Isambard Brunel. In 1851, he was sent to South Australia to carry out geological and mineralogical surveys. Benjamin Babbage became one of Australia's noted explorers. His skills were coopted in that great undertaking, the Australian overland telegraph project. Thus the father's achievements in information or communication technology continued with the son. Little or nothing seems to be known about the life in Australia of the remaining son, Dugald Bromhead Babbage. There are, however, many Babbage descendants now living in Australia. Dr Neville Babbage, a physician living in Sydney, has lent the exquisite miniatures of Charles and his wife Georgiana, painted shortly before they were married, for reproduction in this book. Neville, a descendant of Benjamin Herschel Babbage, has assisted the museum in countless other ways since the acquisition of the specimen piece of Difference Engine No. 1.

gilt by as

sociation

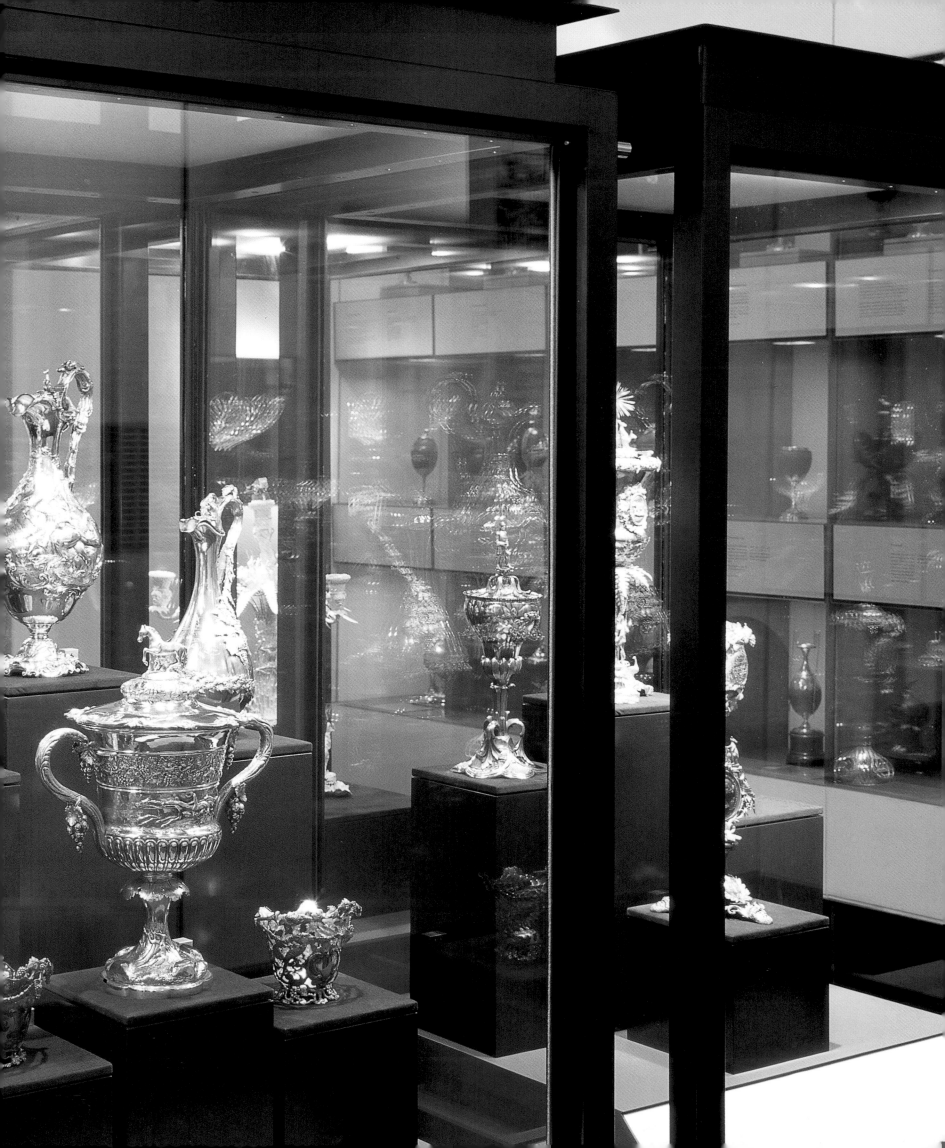

Views of the exhibition at the Sydney Mint.

Not long after coming down from Cambridge, Charles Babbage speaks of dining with Joseph Banks, the great botanist who accompanied Cook's 1770 voyage to Australia on the *Endeavour*. This dinner was some 25 years after New South Wales had become a penal colony. In January 1810, the fifth governor of New South Wales, Governor Lachlan Macquarie, was sworn in. He began to transform the young penal colony into a civilised, even stylish society, an ambition and a vision that exceeded his brief. Macquarie's unambiguous and visible success in developing the colony had two main consequences. The first was a quarrel with London's colonial administration, which treated him ignominiously at the end of his term, denying him his pension entitlement. This is one of the earliest examples of the tall poppy syndrome which has since become a famous Australian tradition, still very much alive. The departure of Joern Utzon from the Sydney Opera House, Australia's famous architectural masterpiece, is an example from the 1960s. Utzon's difficulties with the New South Wales government and bureaucracy parallels Macquarie's

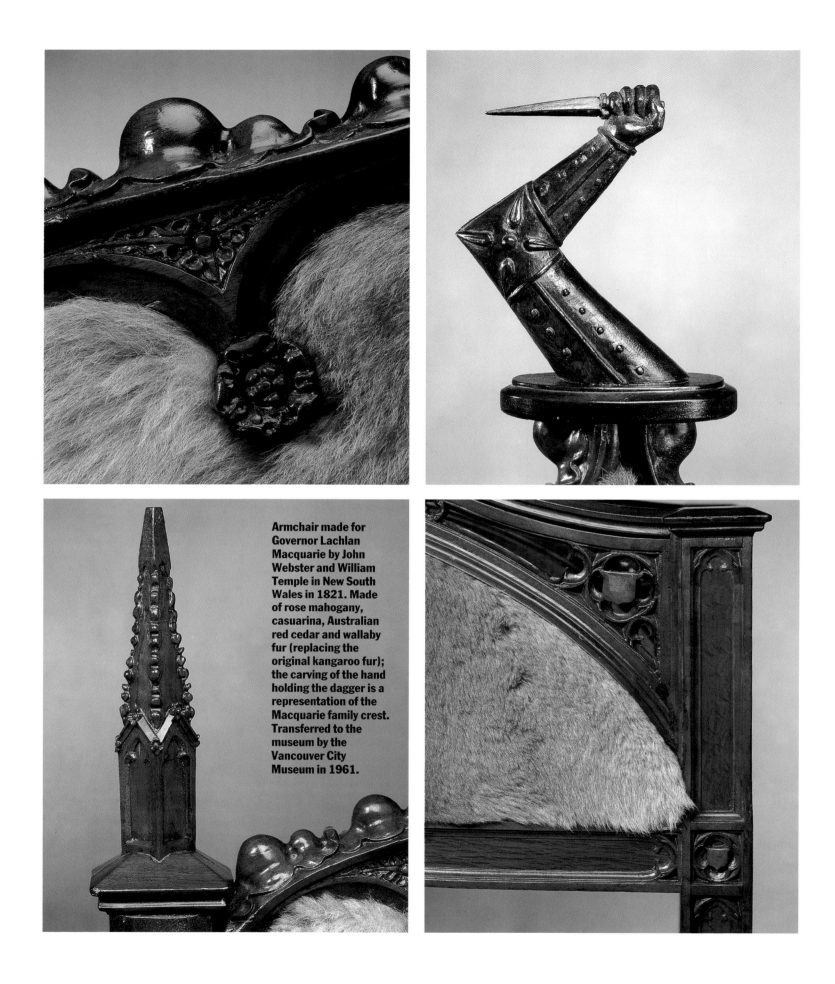

Armchair made for Governor Lachlan Macquarie by John Webster and William Temple in New South Wales in 1821. Made of rose mahogany, casuarina, Australian red cedar and wallaby fur (replacing the original kangaroo fur); the carving of the hand holding the dagger is a representation of the Macquarie family crest. Transferred to the museum by the Vancouver City Museum in 1961.

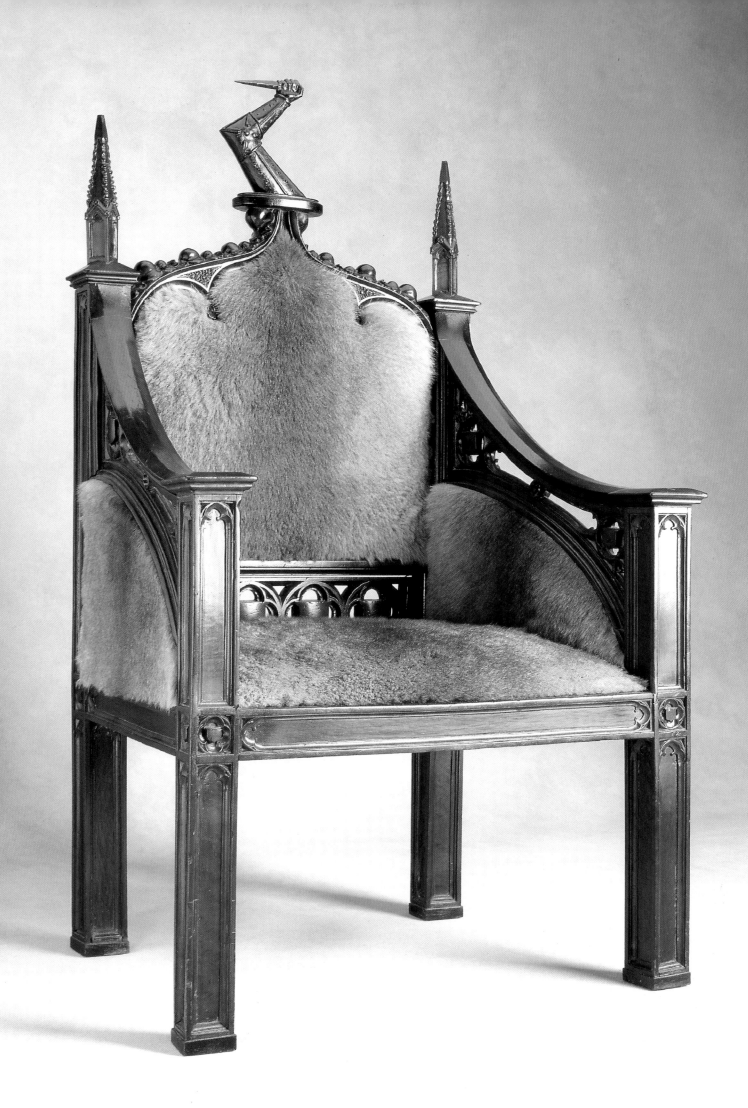

...A GLORIOUS PERIOD IN THE HISTORY OF AUSTRALIA. 'THE AGE OF MACQUARIE' IS NOW A COMMONPLACE LABEL FOR HIS ACHIEVEMENTS.

This watercolour painting of *Honeysuckle banksia* is one of many in the museum's collection by Australian artist, naturalist and explorer, Ellis Rowan (1848–1922). Gift of Sydney Technical College, 1922.

problems a century and a half earlier. The second consequence of Macquarie's vision is our recognition of his term of office as a glorious period in the history of Australia. 'The age of Macquarie' is now a commonplace label for his achievements. Sydney's most historic street is named after him and so is one of the more recent universities.

Charles Babbage began his work on computers just as the age of Macquarie in Australia was coming to an end. One of the museum's greatest treasures, the **Macquarie Chair**, was made in 1821. In the history of Australian colonial furniture, it is a masterpiece. It is one of a pair made for Governor Macquarie by two convicts, William Temple, a carpenter, and John Webster, a carver and gilder. Temple, sentenced to life, was transported to the penal colony in 1814, the year Babbage came down from Cambridge, got married, and listened to Sir Joseph Banks (who was then President of the Royal Society) at Royal Society Club dinners. Webster began a 14-year stretch in 1820. Macquarie must have been highly satisfied with his new chairs because one of his last acts as Governor was to grant pardons to both craftsmen. That was in November 1821, days before he handed the colony over to his replacement, Sir Thomas Brisbane.

The chairs were stylish and sophisticated by the standards of the day. They were in the newish and fashionable gothic revival style, with trefoiling,

above Infantry officer's dress sword, c1850. It belonged to Sir Thomas Brisbane, Governor of New South Wales from 1821 to 1825. Gift from the estate of Miss Margaret Swann, 1989.

ogee arches, carved pinnacles and crockets. All this was topped with the Macquarie family crest, a carved arm wearing medieval armour, gripping a wicked-looking dagger. The materials are all Australian. The chairs were constructed in Australian rose mahogany which was in vogue in the early days of the colony. It was also the preferred timber of William Temple and his mate Patrick Riley, who worked in the government lumber yard. The legs and seat rails are inset with casuarina and the chairs were upholstered with kangaroo fur. When Governor and Mrs Macquarie sailed away to England in February 1822, they took both chairs with them, along with the family's favourite cow.

The story of how the museum acquired one of these chairs is extremely interesting. One of Lachlan Macquarie's descendants emigrated from Scotland to Canada, taking the chair with him. Probably in the early 1930s, it was deposited in the Vancouver City Museum where it remained in obscurity for a quarter of a century. There were rare sightings which resulted in exchanges of correspondence with Vancouver. In February 1945, the chief librarian of Victoria wrote to the Vancouver City Museum:

'I have been advised by an airman who has just returned from Canada that whilst in Vancouver he saw in your museum a chair which was understood to have been used officially by the first [sic] Governor of Australia.'

Two months later, the reply came from a Vancouver curator acknowledging the existence of the chair, the property of Mrs Mcquarrie [sic], not heard of since 1937. So the chair was found but its owner lost. The next exchange occurred 14 years later. In July 1959, one of my predecessors,

Mr F R Morrison, fifth director of the Museum of Applied Arts and Sciences, writes to Vancouver that:

'A Mrs Ashby, who has recently returned from Canada, has informed me that you have in your Museum an antique chair thought to have belonged to Governor Macquarie…'

Mrs Ashby had a good eye and a strong will because the director wrote his letter at her prompting. In Vancouver, the current curator was responsive. Replying a month later, he says he had failed to locate Mrs Macquarie despite many efforts. He had also put in repeated calls to the Australian Trade Commissioner, explaining about the chair, but had drawn a blank. Therefore '…the absence of any response led me to believe there was a lack of interest'. *Plus ça change!*

Now things really started to move. After only two years of negotiations, the chair was generously transferred by the Vancouver City Museum to the Museum of Applied Arts and Sciences, Sydney, in July 1961. This success appears to have stimulated interest in the companion chair which had remained in Scotland, in the possession of the Macquarie family. In 1968, the second chair was donated to the newly founded Macquarie University, where it serves to this day as the throne for the Chancellor on official occasions.

Governor Macquarie and his wife Elizabeth dictated the taste of the colony through public works, particularly buildings. Today, there still exist many of those proud, urbane monuments by which Macquarie attempted to change a rough seaport and penal colony into a gracious, if provincial, city. His General Hospital with its 87.5 metres of double-decker colonnade has gone but at the south end of Macquarie Street there is still a building, a detached pavilion, that was part of the hospital. That building is now known as the Sydney Mint. A matching building or, rather, facade, at the northern end of the hospital site, survives as

the frontispiece of the New South Wales House of Parliament.

The architectural style of the Mint has been the subject of much critical comment. It has generally been compared unfavourably with neighbouring Macquarie period buildings designed by the celebrated convict architect Francis Greenway: St James Church and the Hyde Park Barracks. Comparison between the Barracks and the Mint is unavoidable; they are cheek by jowl. Greenway's work undoubtedly shows more erudition in terms of classical style. The Mint, by contrast, has a naive quality but, for me, it is the more interesting and attractive building. The Barracks building makes a strong but unelaborate statement, its massive walls appropriate for the security it needed for its function as a virtual gaol. Its appearance has been likened to that of a factory. The architect for the Mint, if it had one, is anonymous. Nevertheless, it is a gracious building. Its two-tiered colonnade has an appealing rhythm and the depth of its balcony creates a marked sense of plasticity, of light and shade. It offers more potential as theatre, as stage set, than the Barracks. Its columns are of no special order but the world is full of buildings that are grammatically correct but remain,

SIR RALPH DARLING

Watercolour portrait miniature on ivory in gold frame, *General Sir Ralph Darling* by Henry Edridge, England, c1805. Darling was appointed Governor of New South Wales in 1824. Height of miniature 64 mm. Purchased 1995.

nonetheless, boring. Correct corinthian or faultless ionic can be taught at the academy but they do not automatically confer distinction on a building, any more than anatomy and perspective can make a great artist. No aesthetic philosopher has yet identified what it is that makes a few classical architects breathtakingly good while the rest are tedious even if correct. Why is it that a single bay by Palladio or Sullivan is instantly recognisable as inspired? Whatever the answer, I'm certain it has to do with plasticity, with contrast, and, I guess, with rhythm. It is not a matter of rhetoric.

From Macquarie's time, the building now known as the the Sydney Mint has been put to a succession of government uses but its name derives from its function as the first branch of the Royal Mint to be created anywhere in the British Empire. The building assumed this function in 1855, soon after the New South Wales and Victorian gold discoveries, and continued as a working mint until 1927. From 1982 to 1997 it was used for exhibitions by the Museum of Applied Arts and Sciences. From 1982 until 1994 it was the showplace for our collection of colonial decorative arts. The Macquarie Chair was on view there, of course, and so were many other fine examples of nineteenth-century Australian furniture.

But late twentieth-century audiences need change in their museums and so we recast the Sydney Mint to tell the story of the gold discovery years and the Mint's own significance in the development of Sydney as a financial centre. Throughout the second half of the nineteenth century, the Mint complex was an institution of immeasurable influence and scientific and economic significance. With so much gold being found in New South Wales, the Mint led the world in the extraction of precious metals from ores. In mineralogical and metallurgical research, Mint staff were immensely sophisticated. In the

This Queen Victoria gold half sovereign is extremely rare because of the significant minting error ('sovereign' incorrectly spelled as 'sovrreign'). Sydney Mint, Australia, 1858. Diameter 19 mm. Purchased 1995.

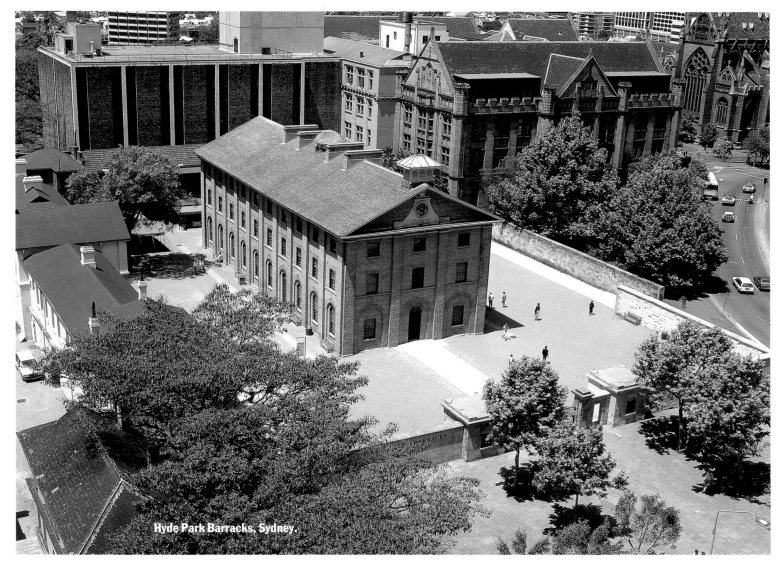

Hyde Park Barracks, Sydney.

course of sharing their expertise with the world, Mint boffins became highly experienced in international communication. And they were visionaries. They planned Australia's first International Exhibition which took place in 1879, beating the rival Melbourne show by a year. It was a courageous initiative on the part of both Australian cities since neither had the population base of London, Paris or New York. The Sydney exhibition was staged on the Governor's Domain, in the specially constructed Garden Palace. In 1880, when the exhibition was over, the Technological, Industrial and Sanitary Museum, newly founded as a result of the lobbying of those same Mint people, moved in and occupied some of the Garden Palace's vast spaces – until the inferno of 1882 destroyed it. After several name changes, the present Museum of Applied Arts and Sciences, the Powerhouse Museum, is that self-same

organisation that, for a time, included the Mint from which it was founded.

At the rear of the Mint premises was a sandstone-clad coining factory with a prefabricated modular metal frame shipped from Britain in 1854. It was manufactured by Walker & Co, to a design virtually identical with Paxton's Crystal Palace. Indeed, the team of Sappers and Miners (now the Royal Engineers) appointed to build and run the Mint had been involved in the Crystal Palace construction in 1851, and were shipped out on the *Maid of Judah* along with their kit factory. Recently, the metal frame came to light, quite literally, as a result of our efforts to restore a derelict section of the old coining factory. The remainder of the site has been used as temporary-looking courtrooms for many years. It is vital that their utility cladding and other cheap excrescences be stripped back as soon as possible to

reveal the original fabric of the coining factory. The site in its entirety is of incomparable Australian archaeological and historical significance.

The museum has a large numismatics collection and the Mint was an ideal place to show selections from it. Sydney Mint sovereigns and half-sovereigns are particularly appropriate for obvious reasons. In the early days of the Mint, gold sovereigns and half-sovs carried the printed legend 'Sydney Mint Australia'. Though the Royal Mint in London put a stop to this proud boast, later Sydney coins have maintained their desirability among collectors. A gold sovereign minted in Sydney in 1920 has become the most expensive Australian coin in history. In 1992 it was knocked down at auction at the London office of Spink and Sons Ltd for more than $250 000. This record is unlikely to be surpassed in the foreseeable future since the previous record, set in 1989, also for a Sydney Mint product, was a mere $81 000. The Mint was a treasure casket in which the

museum exhibited many other fine products of gold rush days and beyond, many of them made in Sydney.

During the lead-up to our first exhibition on the theme of gold and silver, an exquisite bracelet came up for auction at Sotheby's in Melbourne. It was by Hogarth, Erichsen & Co., jewellers and medallists, who set up shop in George Street in 1854. Place and period were perfect for us and the Board of Trustees authorised a hefty bid of $60 000. The museum was represented at the Melbourne auction by Mrs Anne Schofield, an honorary associate and a great supporter. (Our twenty-five honorary associates are experts in various fields who give valuable advice out of the goodness of their hearts.) Bidding thinned out to a duel between the museum and a mysterious telephone bidder. The latter slowed down and, just as our maximum was reached, triumph was a second away. The auctioneer's mallet was poised high in the air for its downward strike. Then — no! Surely it's too late! One extra telephone bid beyond our authorised limit shattered our

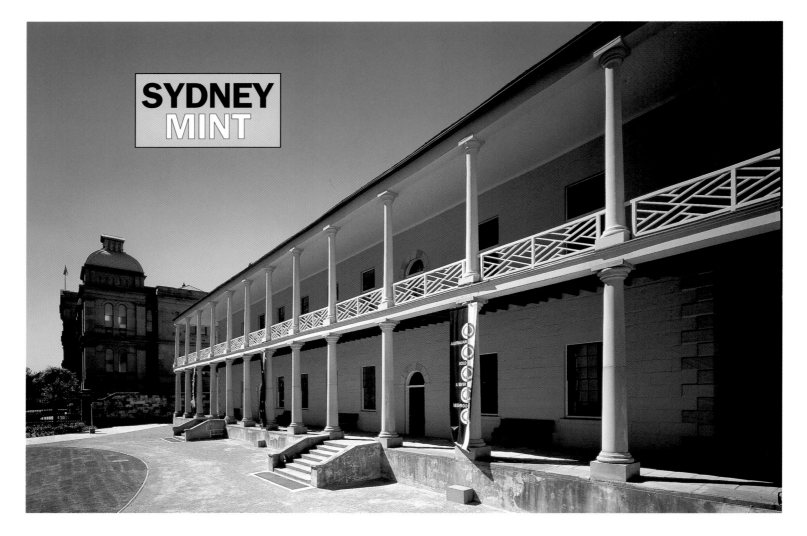

The Sydney Mint on Macquarie Street.

IN THE SECOND HALF OF THE NINETEENTH CENTURY, THE MINT WAS AN INSTITUTION OF IMMEASURABLE INFLUENCE.

dreams! It took some time for the museum to find out that the successful bidder was a West Australian collector who now wishes to remain anonymous. Business trips brought him through Sydney from time to time and on one such occasion he came to the museum to lunch and then and there consented to lend his recently acquired bracelet for display at the Mint. Its delicate design features Australian fauna with an emu and a kangaroo at the centre, flanked by a kookaburra and a dingo, all these surrounded by images of various Australian flora (see page 129).

A treasure that didn't get away was the **Sydney Cup**. Christian Ludwig Qwist (1818–77) was a Dane, one of the many European craftspeople who came to Australia to make their fortune, one way or another, from the gold discoveries. For a goldsmith, Australia was the ideal place to be. After trying his luck in Bendigo, Qwist joined the firm of Hogarth, Erichsen and Co. in Sydney in 1860 and then set up on his own account. By the late 1860s, his reputation was sufficient for him to gain at least three prominent commissions: the gold trophies for the Sydney Cup event at

A selection of coins from the collection. The rear courtyard of the Sydney Mint.

This is where the museum began: the Garden Palace, built on the Domain in 1879 for Australia's first International Exhibition. It was destroyed by fire in 1882.

Randwick racecourse in 1869, 1870 and 1871.

The 1871 trophy was included in a Christie's auction in 1994. It was important to secure the cup for public owner-ship in Australia. Of fifty-one secular gold presentation cups known to have been made in Australia, only fourteen survive in the world. The majority have gone overseas or simply disappeared. Indeed, many have been melted down simply for their gold value.

Knowing this and realising that the Sydney Qwist Cup would be a spectacular acquisition, the Trust decided to dig deep into reserve funds to mount an unassailable bid. Another of our honorary associates, Mr John Hawkins, who is an expert on gold cups in particular, agreed to bid for us. His

generous assistance and advice on this and many other matters has been invaluable.

The auction was held at the Ritz-Carlton Hotel, Double Bay, Sydney, on Monday 15 August 1994. Competition was fierce, with both Australian and overseas collectors making their invisible onslaught by telephone. But not fierce enough. For $170000 plus buyer's premium, we had purchased the rarest and most significant treasure of nineteenth-century goldsmithy in the museum's

The Jubilee Nugget (also known as the Maitland Bar nugget) was found in 1887, Queen Victoria's Golden Jubilee Year. Weighing 10.7 kg, it contains 8.87 kg of gold, worth about $155000 on today's market. Its rarity and historic importance, however, more than double its value. Lent to the Sydney Mint by the NSW Department of Mineral Resources.

A display in the *Gods, gowns and dental crowns* exhibition at the Sydney Mint.

**main picture Interiors, Sydney Mint.
inset top This brooch depicts a
bouquet of Australian flora including
native pear, fern leaves and banksia.
Made from gold and gold-flecked milky
quartz, it was produced by Hogarth,
Erichsen & Co in Sydney c1858.
Purchased 1976.**

**Gold bracelet, c1858, by Hogarth, Erichsen & Co.,
Sydney. The design includes an emu and
kangaroo, a kookaburra, dingo and examples of
native flora. Lent anonymously for exhibition at
the Sydney Mint.**

A Sydney Mint display of harp and mirror featuring decorative uses of gold.

and paterae, the plain body applied with leaves and scrolls supporting two leaf and flowerhead drops forming cartouches, two rising chased handles with Bacchus mask terminals and applied vine leaves, the slender neck with further bands of decoration, removable lid with bud finial, the cup engraved:

"The Sydney Cup Handicap Two Miles Won by Mr Twomey's 'Mermaid' Four yrs. Carrying 7st. 5lb. In 3'40" Randwick Autumn Meeting 1871"'.

Lot 692 included another item, in addition to the Qwist Cup. This was a fine painting (see page 132) showing the filly Mermaid that won the cup. The choice of the filly's name was significant. By King Alfred out of Milksop, she was foaled on the bed of a creek and had to be rescued from possible drowning. After some modest successes in Victoria, she was shipped (literally) to Sydney for Easter racing in 1871. It was here that Mermaid really made herself famous. She won five races, beating some of the best, and entered the Sydney Cup favourite at 5 to 2. Mermaid finished first after a slog on a track made slow by much pre-race rain. Romulus was second, no doubt lacking the advantage of starting life in a creek!

The painting shows Mermaid with her jockey, J Wilson Jr. At far left stands the jockey's father, trainer James Wilson, and next to him, the owner, Edward Twomey of Penshurst near Hamilton in the west of Victoria.

The museum rarely acquires paintings. Too rarely, in my view. And when it does so, the criteria for acquisition have little to do with aesthetics and much more to do with content. Of course, it is only since the advent of modernism that content became so divorced from the worthiness of a picture. Whistler was among the first to attack the importance of subject matter and to usher in abstraction. Beforehand, and throughout the history of art, painters chose their subject matter with great care. You could not have a great painting without great subject matter. This attitude survives, but barely, in portraiture, an artform that has deteriorated severely during the modernist period. Previously, almost all artists, whether famous or run-of-the-mill, accepted as a basic skill the ability to paint a face accurately. Turner might be a prominent exception. He would be the last person to win a portrait prize. In the

history. And treasure, on this occasion, is the right word. The cup had been stored in a bank vault for most of this century. The vendors decided that it was time someone 'may as well get some pleasure from it'.

The style of the Qwist Cup is classical revival. The Danish goldsmith was a leader in the move away from the heavy rococo, ornate naturalism typical of the mid-Victorian era. Christie's catalogue note for lot 692 describes the cup in minute detail:

'…in the form of a Grecian lidded cup, on circular foot with bands of ovolo and beaded decoration rising to a knopped stem with band of laurel decoration, the lower body with band of stiff acanthus leaves on a matt ground, a band of rope decoration, chased Greek key, floral scroll

twentieth century, very few artists have been able to manage a good likeness. There is virtually no training in the skill and most artists wouldn't want it anyhow.

Equestrian painting is a different matter, a special case. It is a genre all to itself, separate from the mainstream of art. Very few art historians, trained in university departments, can cope with it. Its collectors want an exact likeness, phenomenal accuracy, or the painting is no good to them. They are not interested in style, 'isms', or self-expression. Connoisseurs of horse painting have first to be connoisseurs of horses. Quite refreshing!

The reason why the Powerhouse Museum should not be afraid to collect more paintings is simple. The museum

Silver figure by Julius Hogarth, c1854–60, inspired by an Aboriginal man known as Ricketty Dick. Height 150 mm; diameter 75 mm. Purchased 1996.

131

collects the 'material culture' of society. This is an inelegant term used by the museological profession for want of a better one to mean all things that people have made, as opposed to things that have grown naturally, such as snakes, polar bears, chimpanzees etc. The latter are things you see at a museum of natural history or, if still alive, at a zoo.

But paintings are material culture and can well be seen in the context of other society products as happens in so many great museums, such as the Metropolitan Museum of Art in New York. The Met's diverse holdings include a collection of some 4500 musical instruments – including the only Stradivari violin to have been restored to baroque specifications approximating the artist's intentions. The Frick Collection in New York, the Victoria and Albert Museum in London and the Wallace Collection in London are further notable examples of mixed collections which show paintings in the context of other objects. In Australia, it happens at the *soi-disant* National Gallery of Victoria and to a limited extent at the National Gallery of Australia in

Canberra. Of course, none of the above is associated with technology, but there is no good reason why *la belle peinture* should not be shown under the same roof as machines. Leonardo da Vinci is a famous example of a great artist who absorbed himself in the problems of technology, both on an esoteric plane and, when it came to the city's defences, on a

above **Painting, *Mermaid, the owner and the trainer,*** by Frederick Woodhouse Snr, Australia, 1871, depicting the 1871 Sydney Gold Cup winner. left and opposite **The 1871 Sydney Gold Cup,** by Sydney silversmith, Christian Ludwig Qwist (1818–77). The cup is stamped to the base '18ct Qwist/18' with further maker's mark engraved and stamped twice to the body. 25 cm high; 458 grams. Purchased 1994.

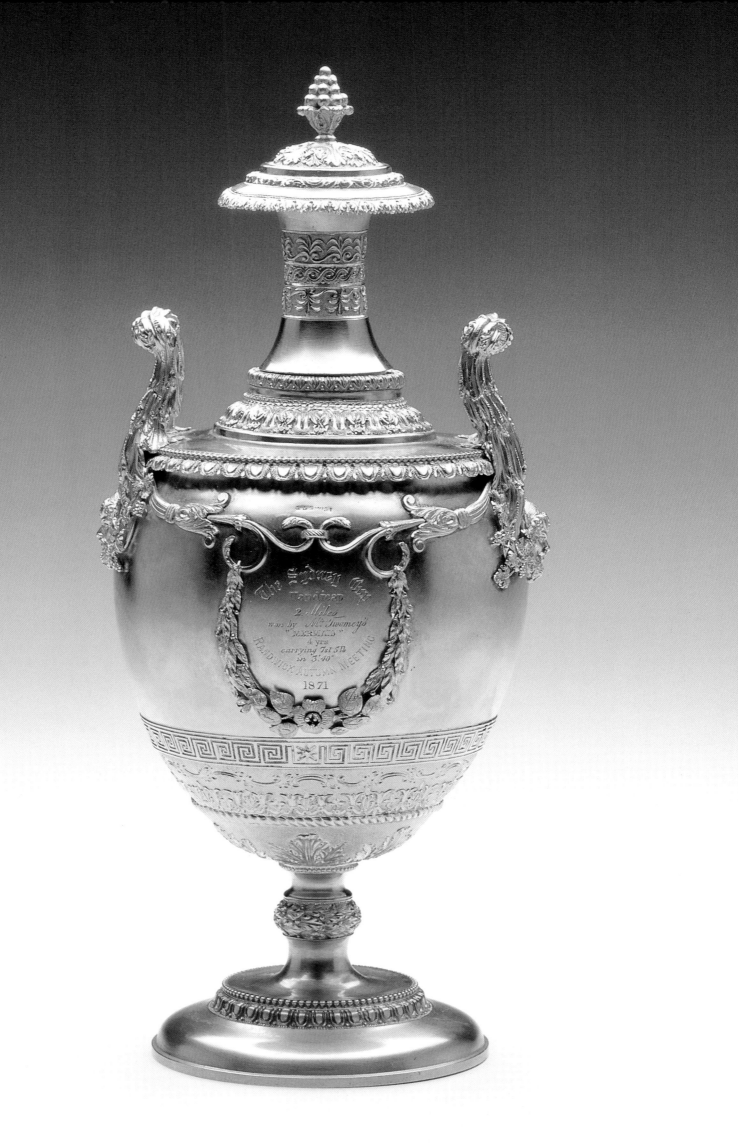

The Sydney Cup
Handicap
2 Miles
won by Mr Twomeys
"MERMAID"
4 yrs
carrying 7st 5lb
in 3'40"
RANDWICK AUTUMN MEETING
1871

Windscreen of Boeing 747 aircraft made of glass, aluminium and gold by PPG Industries and The Boeing Company, USA, 1960–80. Gift of Qantas Airways, 1996.

practical one. Raphael was a great architect. Bernini, the greatest sculptor of the baroque period, could paint brilliantly, like his predecessor, Michelangelo. We now classify these great figures as renaissance men.

Gold, to return to the principal theme of this chapter, has been synonymous with wealth throughout history. An inert metal, it has also symbolised incorruptibility; hence its appearance as haloes over the heads of saints in medieval and renaissance paintings. Beyond its symbolic power, gold has generally not been good for much, other than decoration and ornament. Its decorative power is as strong today as it ever was.

There is still scope for innovation in decoration using this age-old medium. An artist or craftsperson who has demonstrated a unique approach in his use of gold is Alan Peascod, one of Australia's leading ceramists. Peascod has made a special study, over a long period, of Islamic ceramics. His mastery over lustre techniques and glazes has put a uniquely expressive means at his disposal as we see in this

gold decorated flask. The black calligraphic marks across the surface are reminiscent of Arabic script. They contrast with the highly reflective, sumptuous gold lustre. An Arabian treasure indeed, evocative of genies and magic. Its gleaming mirror-like surface belies the stoneware body of this bottle, suggesting that it is made not of clay, but of glass.

Today, gold is not always limited to symbolic and decorative or ornamental roles. In recent times in particular, technology has found important uses for its unique characteristics. One of these is its efficiency as a conductor of heat. Few people realise that the pilot of a Jumbo jet looks

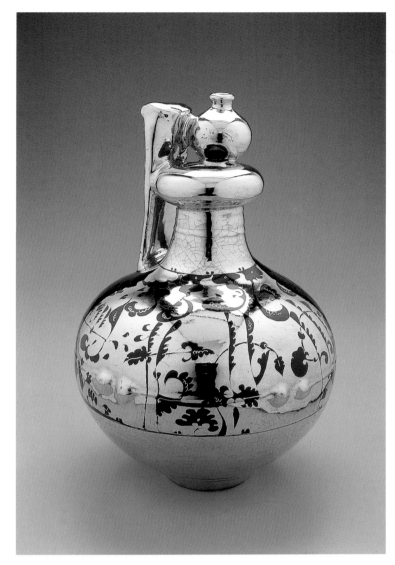

Stoneware, wheel-thrown bottle, glazed with 24 carat gold lustre, crazed, by Alan Peascod, Canberra, Australia, 1984. Height 390 mm; width 260 mm. Purchased 1984 with the assistance of the Crafts Board of the Australia Council.

out into the clouds through a filter of gold. The gold sandwiched between the other laminates of the windscreen is so thin that it looks slightly greenish. It is the essential element in the anti-fogging and anti-icing system in the flight compartment of the Boeing 747, that ubiquitous carrier of passengers across continents. The Museum of Applied Arts and Sciences, Sydney, is one of the few places, perhaps the only one in the world, where you can find a piece of pure poetry like an Alan Peascod bottle under the same roof as the highly functional windscreen of a Boeing 747. The perspective is an unusual one but it is fully consistent with the museum's aim, which is to present Australian material culture in an international context.

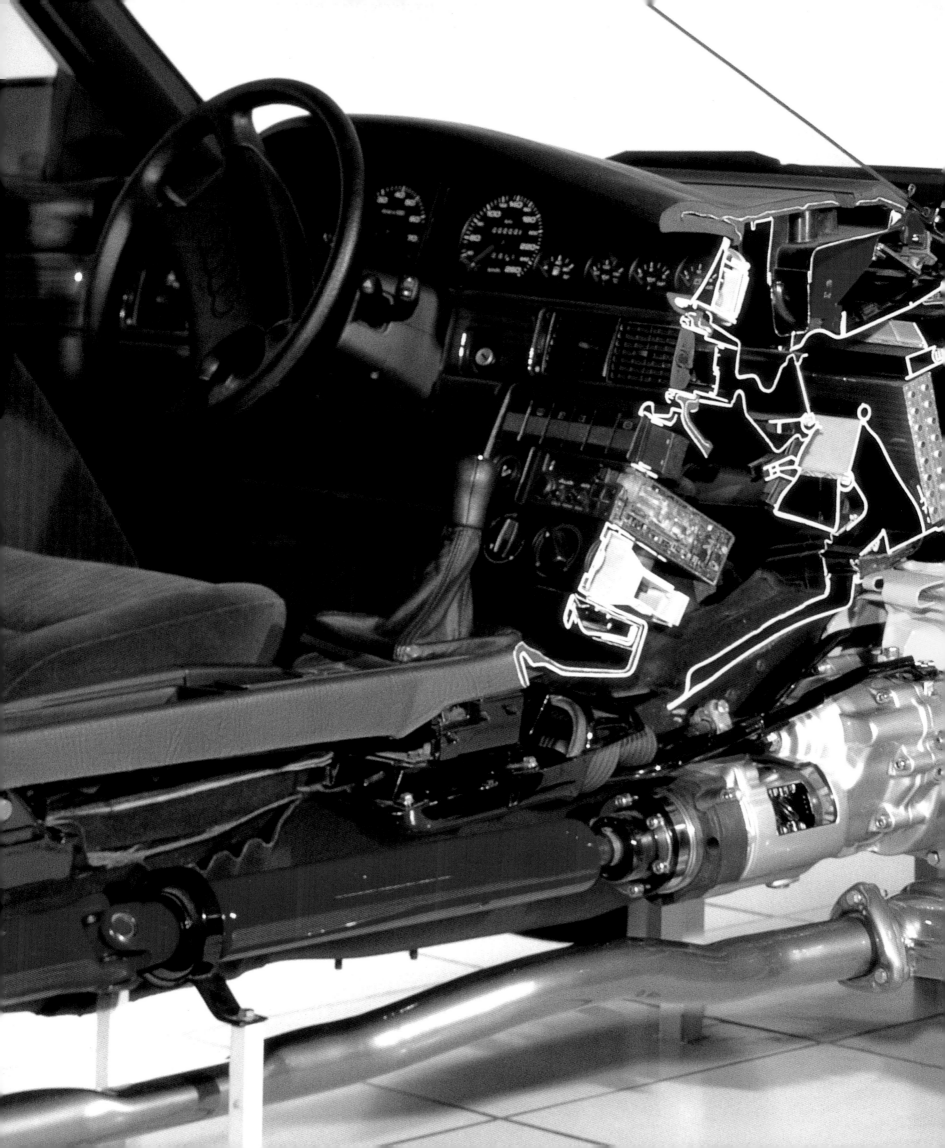

truth
and
transparency

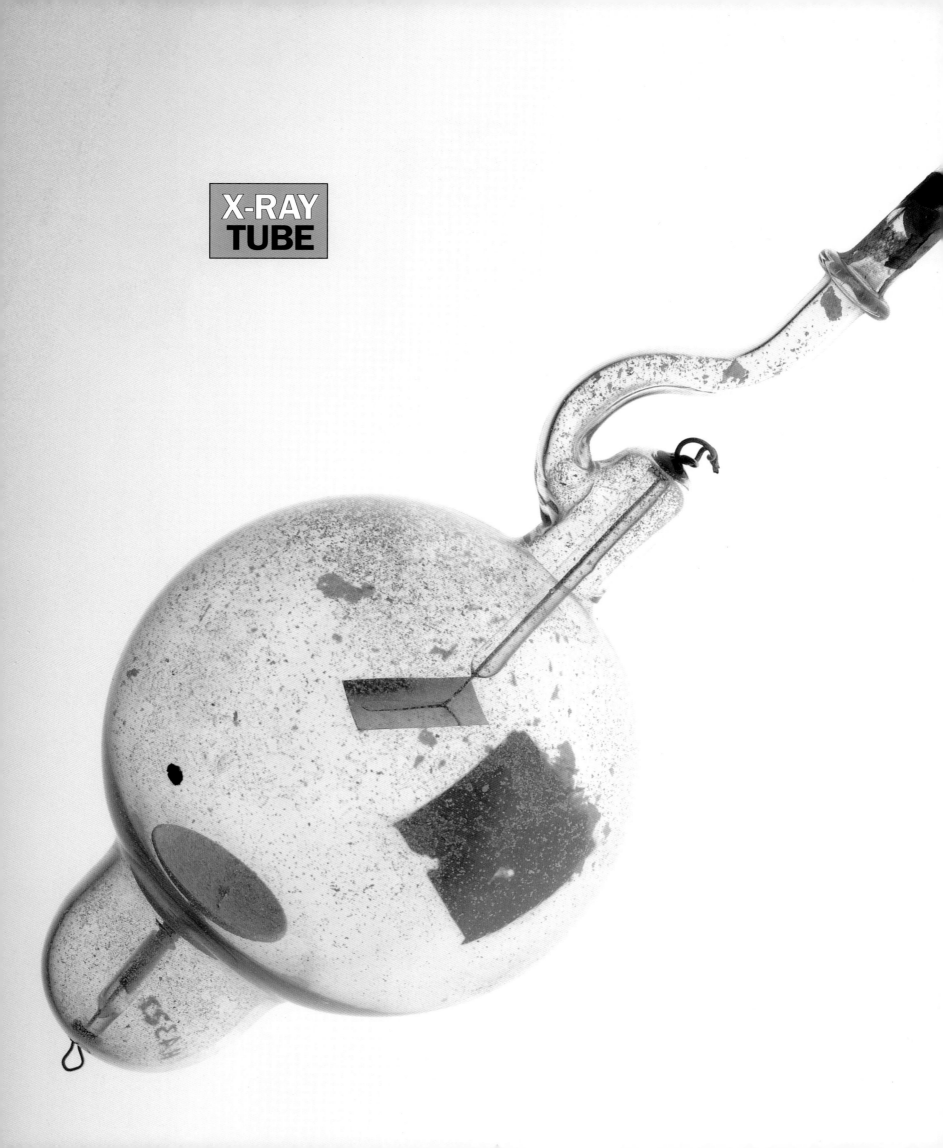

X-RAY
TUBE

left **Possibly the first X-ray tube used in Australia, 1896. Gift of the Hon. H M Doyle, MLC, 1941.**

Opacity puts people off. They want to see through things. Recently, during an exercise to evaluate the effectiveness of our planned new exhibition on motoring, women in our focus groups expressed a desire to see through the dashboard of a car. They wanted the dashboards of the cars in the exhibition to be made of translucent material so that when they pressed the brake, or moved the gear stick, they would be able to see something happening beyond the barrier immediately in front of them. Men who visit the museum invariably like to look at cutaway models which show working parts. It is all part of the same human need to see what's going on, a disliking of visual barriers.

There is a paradox at work here because motor car design is moving inexorably to 'black box' status. We take automobiles for granted and expect them to perform, just as we do light switches or water taps. Already automobiles have passed the point when home mechanics could safely tinker with their cars, and adjust settings or the timing. Nowadays, we have to leave it all to computer diagnostics. We no longer romantically expect to fix a broken fan belt with a nylon stocking. With modern cars, it is considered unwise or risky to behave like a good

samaritan and offer a jump-start to an unfortunate motorist who has broken down. An automobile engine is now so complicated that jump leads can crash the computer that governs it. Cars are becoming more and more like fridges, pieces of equipment we all depend on but in which we invest less and less fantasy and imagining. There are large fridges and small fridges but little status is invested in the difference. Similarly with cars. It probably started when they made cars with lights that come on when you open the door, just like fridges. That was the beginning of the end for car fetishes and Freudian interpretations of Porsches or E-type Jags. Cars are becoming white goods, appliances. Fridge lights and opaque doors remind me of great philosophic questions. In this age of sophistication we still wonder about the existence of things we cannot see.

Empiricism and scepticism were the principal philosophic issues for those great seventeenth- and eighteenth-century British thinkers, Thomas Hobbes, John Locke and David Hume. Hume's Irish contemporary, Bishop Berkeley, believed that everything outside himself was an illusion. Such questions seem to me to retain their validity in our own times.

As a student I irritated my professors with doubts about the truth of the phenomenal world only to be roundly rebuffed by them for being in the wrong century. They saw no point in posing questions that had been exhaustively explored two or three centuries ago. I was passé, a flat earther! Yet it seemed to me that each psyche, each individual, can rely still only on their own perceptual systems. You cannot physically see through another's eyes, hear through another's ears. Still less can you filter those experiences through another's memory. Empathy and

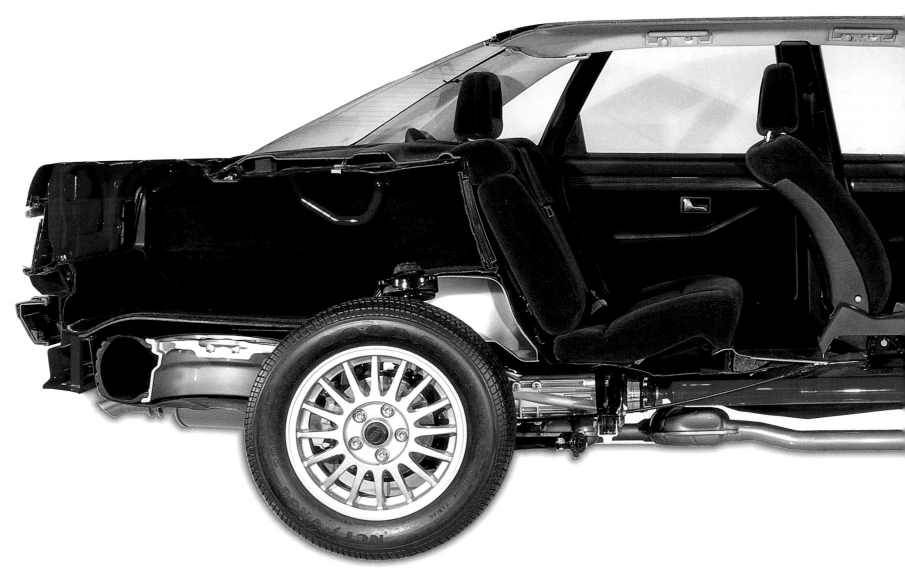

right Full-size, sectioned 7M-GTE Toyota Supra, Toyota Motor Corporation, Japan, 1986. Gift of Toyota Motor Corporation, 1988. below Full-size, sectioned Audi 200 Turbo automobile, designed and manufactured by Audi AG, Germany, in 1986. Gift of TKM Automotive Australia Pty Ltd, 1996.

left Booklet published by the museum in the 1950s to accompany the exhibition of the Transparent Woman.
above Porcelain nude figure, *Bather surprised*, Royal Worcester, 1882. A photograph of the *Bather* was included in the booklet to add the high moral tone of art. Purchased 1883.
opposite This full size, plastic anatomical figure of a woman has been used in museum demonstrations since the 1950s. Purchased 1954.

imagination go some way to allow one to sense another's pain or joy but the nervous systems of human beings are separate and individual, not physically connected, as far as we know, twins and ESP notwithstanding. All those implements, such as telescopes, microscopes, cameras, and much more recent and sophisticated scanning technologies are, as Marshall McLuhan pointed out, extensions of our senses, nothing more. Our psyches remain separate although we easily forget such solitariness at concerts, footy games and other tribal rituals.

One wonders if Professor Roentgen's discovery of X-rays in 1895 made any impact on all this. Does X-ray technology illuminate the mystery of the fridge light? Does it change our grasp of the mystery of being? From the *fin de siècle* onwards, X-rays and the ability to use them gripped the public's imagination. Now, it seemed, vision could really penetrate the surface, the cover of things. Did modesty require extra protection, extra cover? Such drama was forgotten at the museum until, a century later, our curators and registrars, engaged on a five-year project of sifting through our 380 000 strong collection, came across a

THE MUSEUM PRODUCED AN EDUCATIONAL BOOKLET, BUT ATTEMPTED TO MARKET IT BY PRINTING A RAUNCHY NUDE ON THE COVER.

treasure trove of X-ray equipment. They discovered a number of X-ray tubes dating from the turn of the century or before. One of them is possibly the first X-ray tube used in Australia, dating from 1896. It was used in Newcastle and was presented to the Newcastle Museum in 1917. Newcastle then had one of five branches of this museum which were scattered across NSW in such places as Goulburn, Broken Hill and Bathurst. These country annexes all died for lack of resources, atrophied for lack of interest. The present museum in Newcastle is a fine and vigorous one, independent of us; I'm sure we would be delighted to lend them some of our X-ray material that came from Newcastle even though we are extremely glad to have it in our collection.

In 1989–90 the Trustees, working with staff, expended much effort and thought on rationalising our collection fields and drawing up a substantial policy document on the scope of collection development. Medical technology is a field that we identified as important for the museum. A recent consequence of that decision was the

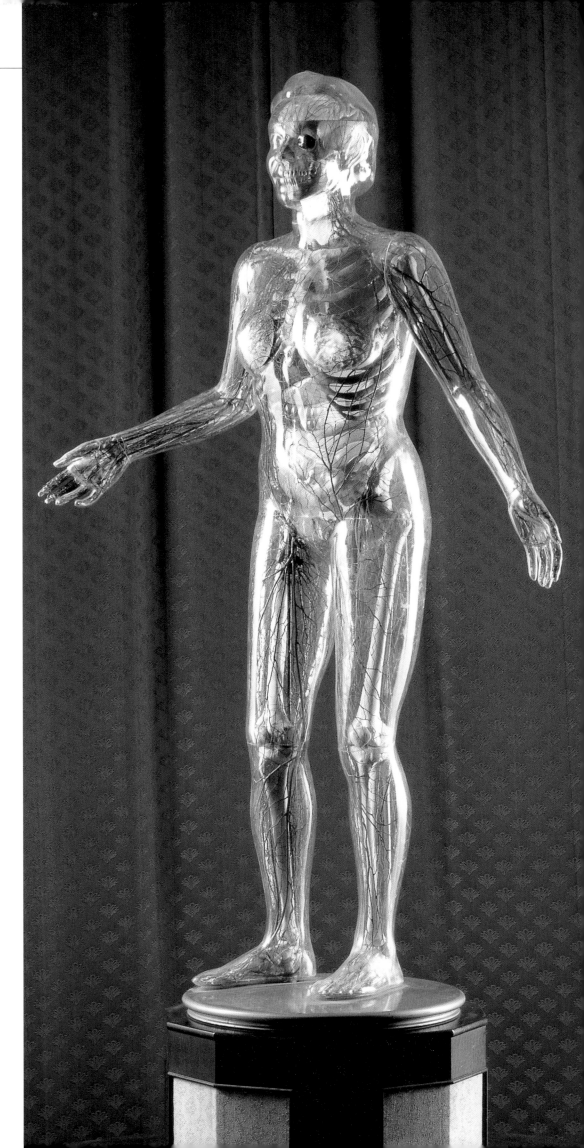

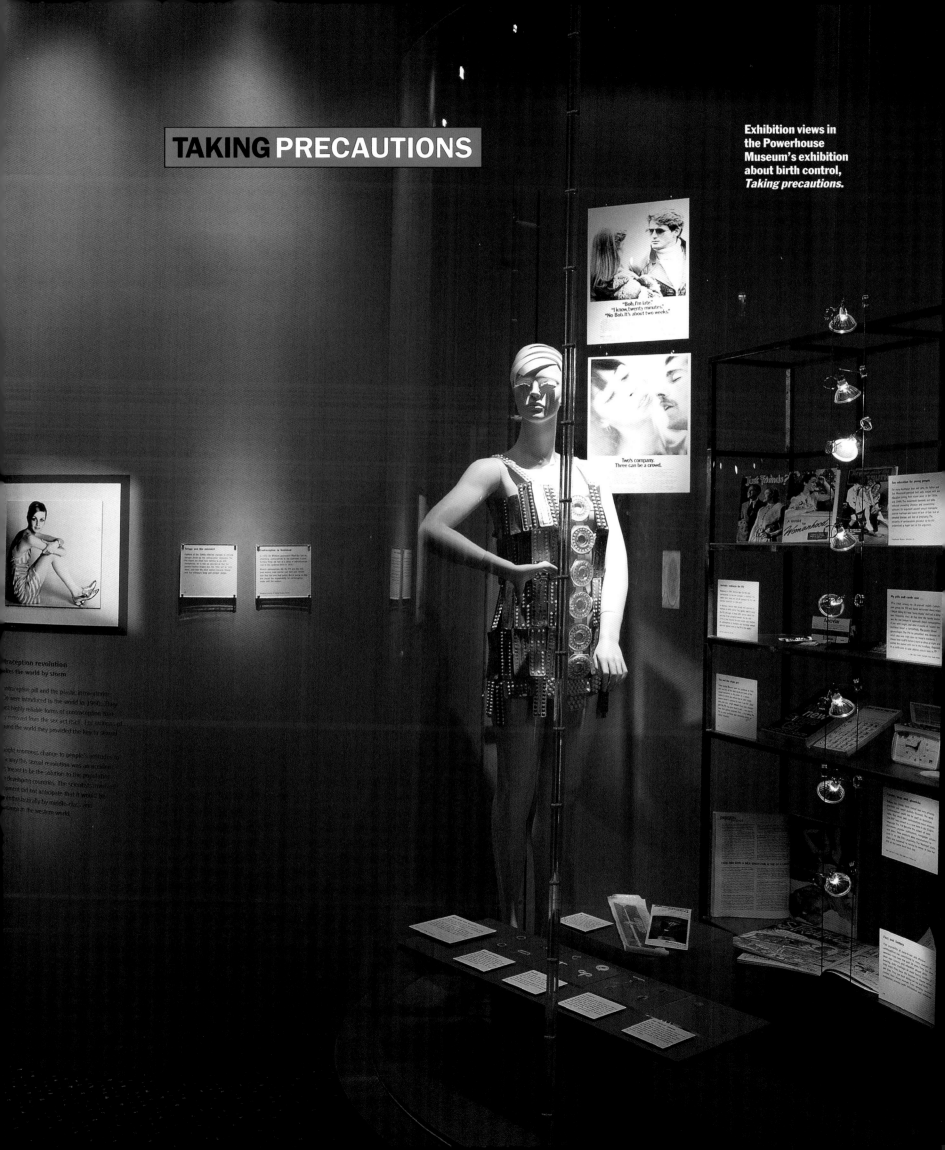

TAKING PRECAUTIONS

Exhibition views in the Powerhouse Museum's exhibition about birth control, *Taking precautions.*

opening in December 1995 of a long-term exhibition on the control of human fertility called **Taking precautions**, curated by Megan Hicks. In the exhibition, we show a museum favourite, the **Plastic Woman**.

In 1954, to teach basic anatomy, the museum imported the Transparent Plastic Woman from Germany. You don't need an X-ray to see everything she's got. All her organs are visible in accurate and complete biological detail. Before her arrival at the museum she was placed on show in the foyer of the State Theatre ballroom in Market Street, Sydney, rather like a freak show. Viewing sessions were organised on a segregated basis, men and women not being allowed in together. One can't imagine anyone being aroused by the spectacle but our Transparent Woman must

Petrological microscope, made by Watson & Sons, London, England, in the early 20th century, was used by the Technological Museum Laboratory. Acquired 1956.

have been something of a sensation in the 1950s, that decade of suffocating inhibitions and restraints. At the State Theatre, a trained nurse was in attendance in case anyone was overcome by the experience. When the museum acquired her, children under sixteen were banned from her presence. At the museum, regular demonstrations were organised. This simply meant that an attendant would press switches which lit up various organs sequentially for the princely sum of two shillings per adult – more than we'd dare charge now for a single object viewing. The museum also produced an educational booklet describing the colon, the pancreas and so on, but attempted to market all this earnest effort by printing a raunchy nude on the cover. The cover graphic betrays the designer's transparent enthusiasm for 1950s Hollywood, for a naked Marilyn Monroe or Jane Russell. To keep things on a high moral plane, the museum included at the back of the booklet a photograph of an 1882 porcelain statuette by Royal Worcester, *Bather surprised*.

Today, our Gläserne Frau is the subject of less dramatic attention. Although medical technology is a field to which we are still committed, a see-through model of a human would now scarcely qualify as a priority on our list of *desiderata*. Nonetheless, our Plastic Woman is assured of her continued position in the collection. She has become an old favourite with long-time visitors and takes her place with the 'Strasburg' clock model, and the Boulton and Watt steam engine, as one of those defining objects in the museum.

Some weeks before the exhibition *Taking precautions* opened, we staged training sessions for staff, particularly those who meet the public face to face. We knew that for some our topic would be controversial and, indeed, we did not presume to know the attitudes of

our own colleagues. The idea was that should any staff feel that issues covered by the exhibition were unduly problematic, then we would face such issues before confronting visitors. This foresight seems to have been well placed because no controversies arose in the first few months after opening and, at the time of writing, none has, even though the exhibition is popular and well-visited. Another device used to forestall problems was the angled design of the entrance. It is not uninviting but each visitor has to make a conscious decision to enter. You cannot just stray inside without realising it.

The preparation of this exemplary exhibition took Megan about three years, in the course of which she scoured the world for material. Once, when I was in Tokyo, she sent me a fax directing me to a famous shop called *Condomania* to purchase a selection of its wares. I entered it, somewhat red-faced, and discovered its striking packaging. Condoms there look like anything but what they are: Smarties, chocolates, lollipops and lots more. It is as much a novelty shop as anything. Such an approach diffuses the embarrassment that still accompanies the purchase of contraceptives for many people. One unplanned consequence of my visit is the acknowledgement that will survive in perpetuity in the museum's computerised records, of a large poster depicting dozens of colourful and comically drawn condoms, all at full stretch: 'Gift of Terence Measham'.

Fused glass bowl-form, by
Klaus Moje, Canberra, ACT,
1990. Purchased 1991.

crystal clear

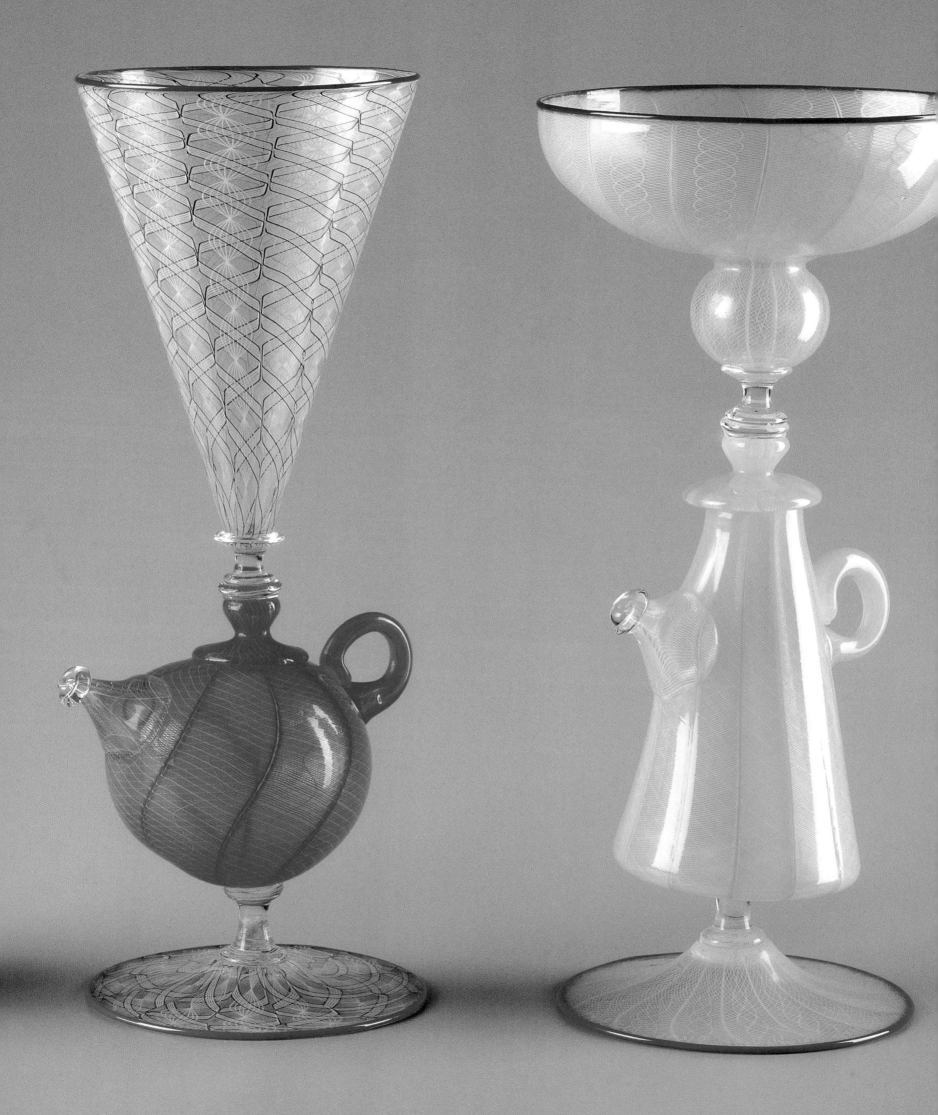

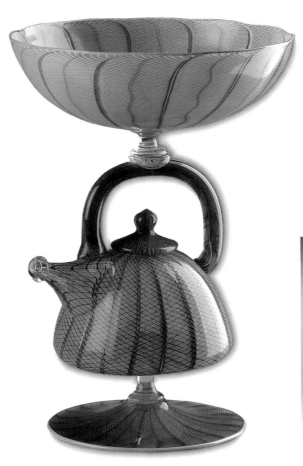

left Three glass goblets, with teapot-shaped stems, by Richard Marquis and Dante Marioni, 1994. This collaborative work by visiting USA glass artists was produced in Canberra, Australia, February 1994. Purchased 1994.

. . . she knew already the lovely contradictory nature of glass. . . that glass is a thing in disguise, an actor, is not solid at all, but a liquid. . . that even while it is as frail as the ice on a Parramatta puddle, it is stronger under compression than Sydney sandstone; that it is invisible, solid; in short, a joyous and paradoxical thing, as good a material as any to build a life from. From Oscar and Lucinda *by Peter Carey.*

Light and its passage through objects produces glamorous effects in exhibition design. As a museum of craftwork, the Powerhouse collects studio glass. This medium produces spectacular effects of light and colour. An example was an exhibition of the work of glass artist Klaus Moje (pronounced Moya) which the museum staged in 1995. Klaus Moje, born in 1936 in Hamburg, is a senior glass artist who built up a worldwide reputation before being head-hunted to Australia in 1982, by Udo Sellbach, the enterprising director of the Canberra School of Art. At about that time, Sellbach recruited craft specialists from a number of different countries and so put the Canberra School on the map as a centre of excellence in the crafts. Wood, ceramics, leather, glass, all these were media in which Sellbach's staff offered the best possible teaching.

The Klaus Moje exhibition was put together by the National

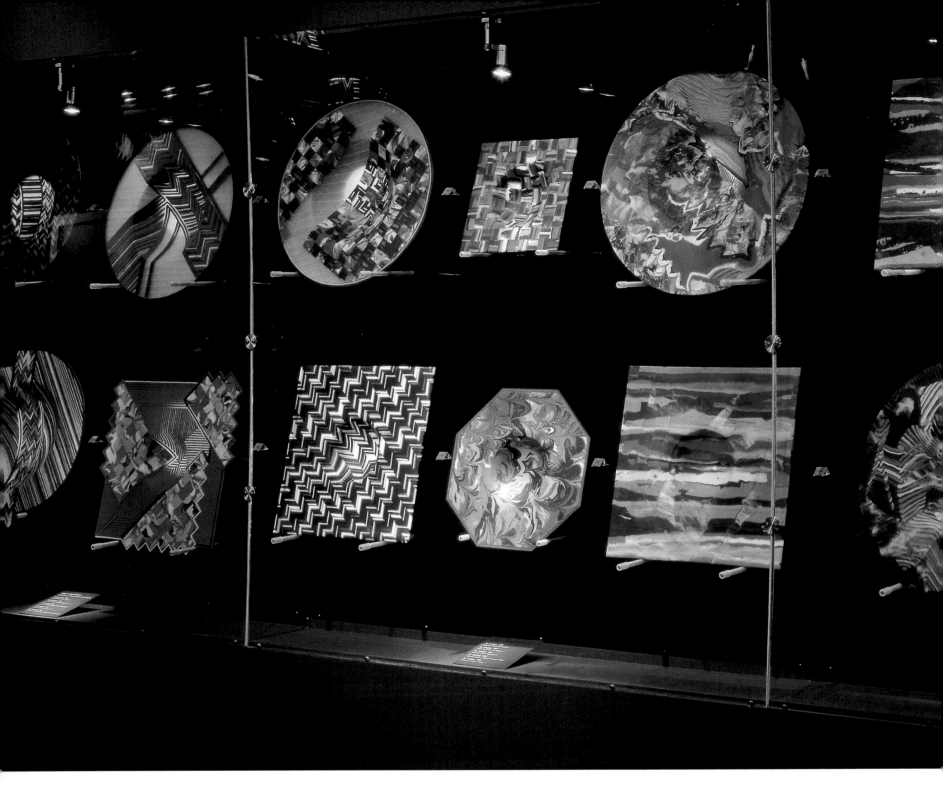

Gallery of Victoria in Melbourne, and included a number of items from our collection. After its Melbourne showing, this admirable exhibition with its very professionally produced catalogue came to Sydney. We enhanced the exhibition in three distinct ways.

First, Kathleen Phillips, a Powerhouse audiovisual specialist, produced an excellent video of Klaus Moje at work. Seeing Moje manipulating hot glass is a highly effective way of giving information about his exquisite but static products. On a large screen, viewers could watch the artist fuse rods of glass, slice the resulting slab or plane into fragments, re-fuse these, score the hot results with a sharp tool and then slump the semiliquid glass into a plaster mould before grinding and polishing the results to a spectacular finish. With great control over her lens, Kath Phillips followed his every move.

Second, Grace Cochrane, our own curator of Australian contemporary craft (and Australia's greatest expert in that field) produced an additional section in the exhibition showing Moje's technique of using glass rods to produce his mosaic of colours.

Third, our designers redesigned the show from sgraffito

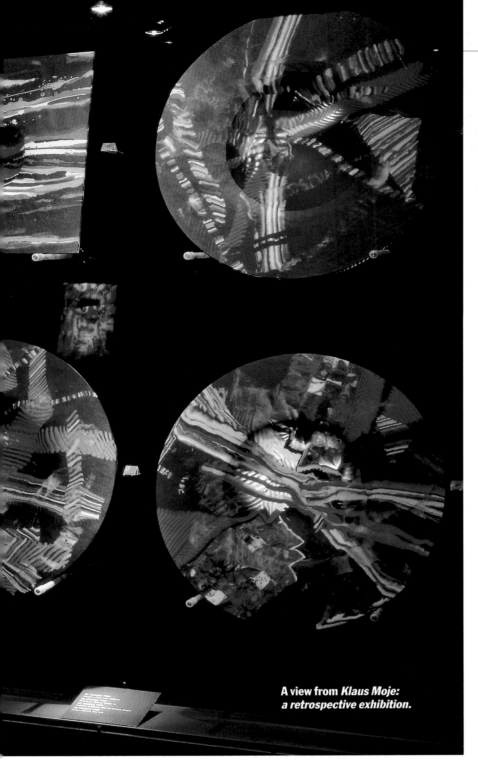

A view from *Klaus Moje: a retrospective exhibition.*

of the outback set against the vivid blue of Australia's clear and vast sky. He has also, out of his admiration for the art of the Aborigines, taken on their traditional ochres, yellows and blacks.

Klaus Moje has defied tradition in his working process. At the centre of the worldwide renaissance in studio glass has been the centuries-old art of glass blowing. Though Moje has played a leading role in the glass movement he has eschewed blowing in favour of the rarer and ancient technique of fusing glass, as we have seen.

The resurgence of studio glass began on the west coast of America, some time in the 1950s or early 1960s, when glass blowers globetrotted to centres across the earth, teaching their skills and stimulating the growth of local traditions. They came to Stourbridge, the age-old centre of the glass industry in England, when I was teaching there. We all liked them for the flamboyant confidence of their work and the generosity and openness with which they were keen to share experiences and learn from the locals.

I am bold enough to state that such generosity of spirit in art is an American phenomenon of the mid-twentieth century. Anyone visiting New York, for instance, in the 1960s or 1970s, could gain virtually instant access to the best and leading artists and their work. American artists have been neither reclusive nor secretive, unlike their European or British counterparts. In Britain, you would have to know someone who knew someone to establish contact with the art scene which has always been invisible to innocent visitors. The galleries of Cork Street, London, with their svelte but silent attendants distantly working at desks, are off-putting to strangers. Art is really only for those in the know. (Do not be unduly discouraged – a firm tone of voice and a bright smile can crash through that famous reserve.) In New York, the situation has generally been dramatically different. In galleries piled on galleries, dealers and their staff are enthusiastic and ready to give the enquirer, the student, a conveyor-belt ride to rival galleries and into the loft studios of artists themselves. And the latter also tend to be warm, welcoming and informative. All without the slightest cynicism – it is not your dollar they are after, at least, not in the first instance. Rather, it is a sense of community and the idealistic exchange of ideas that is more important.

with one very important innovation. They persuaded Moje to allow his glassworks to be back-lit. This may not seem such a remarkable step but to a serious artist like Moje, there could be the risk of introducing a stagy element. With the artist's cooperation, trials were undertaken until he was confident that his work was not compromised in any way by adventitious or gratuitous effects. When the exhibition was finally staged, Moje was utterly pleased by the approach, one which allowed all viewers of his work to derive the maximum benefit from his colours. Since living in Australia, Moje has changed his palette to incorporate the intense reds

Wandering glass artists put me in mind of medieval masons who infected city after city in the world they knew with the gothic virus. Just as the language of gothic became universal, with separate regional accents and variations, so now there are impressive glass traditions in widely dispersed places, linked by the international craft press with its increasingly attractive photography of the artists' work, but also linked by peripatetic artists. Two artists who have exercised a marked influence in Australia are Richard Marquis and Dante Marioni, both from Seattle. Marquis in particular has made several visits over a period of more than 20 years. As early as 1974 he was teaching Australians glassblowing techniques and creating opportunities for them to work in the United States. Marioni, a virtuoso who uses Venetian methods, has been visiting Australia more recently; he's younger but his impact on local artists is widely acknowledged and appreciated.

In recent years, Richard Marquis and Dante Marioni have combined their skills and produced a body of work collaboratively. In 1994, they took part in a workshop at the Canberra School of Art, now part of the Australian National University. Here they demonstrated delicate and sophisticated blowing techniques, producing witty assemblages of separate glass forms in which goblets surmount teapots. The patterning of the glass is Venetian; the perky spouts of the teapots gently mock eighteenth century preciosity while still offering the delights of rococo delicacy in their pale green and faded lemon. Seen together, as they should be, these three little creations set up the rhythm of a whimsical, if slightly comic, courtly dance.

Glass has many properties, many different types of appeal, many different visual characteristics. One of them is that glass can look like ice. It is this quality that Richard Morrell projects in a work such as **Bowl of choices**, made in 1993 and acquired by the museum in the same year. Morrell, born in 1953, grew up in the west midlands of England, west of Birmingham, near Stourbridge. Stourbridge College of Art, when Morrell

was an undergraduate there, had the best glass department in the United Kingdom, better even than that of the Royal College of Art in London.

I am familiar with the fumes, the heat, the glowing coals, the iridescent balloons of molten glass, the long metal blowing tubes that were a feature of everyday life at the Stourbridge College because I was head of 'academic' studies there, teaching all students, whether ceramists, painters or

left Circular, fused glass bowl-form, by Klaus Moje, Canberra, Australia, 1990. Purchased 1991.
below Glass dish by Klaus Moje, Canberra, Australia, 1985. Purchased with the assistance of the Crafts Board of the Australia Council and Mojo MDA Pty Ltd, 1985.
opposite *Bowl of choices*, glass, by Richard Morrell, Melbourne, Australia, 1993. Purchased 1993.

glass artists, their obligatory art history. Richard Morrell arrived at the college after I had departed to a career in museums, but it is clear that Morrell has a penchant for history, and that a sense of the magic of the past informs the poetry of his oeuvre. *Bowl of choices* is the culminating work of a series, made over the previous five years, with an Atlantis theme. The term, in this case, simply indicates a notion of ancient cultures with their mystical rituals. The work, with its heavy base and almost opaque blue middle, looks as though it belongs on the centre of a high altar. It could be a font or container of holy liquid. Yet it has a more raw and rugged quality, like a miniature iceberg.

This work marks a new departure from the rest of the Atlantis series. 'Choices' in the title refers to a structural ambivalence in the work. It looks as though it should be symmetrical, rather like a Mayan pyramid, but instead, its buttresses are set at an angle. By such simple means, by setting up an expectation of inert or static symmetry and then denying it, Morrell unsettles the viewer's mind a little. Perhaps such ambivalence mirrors the chancy and unpredictable nature of Morrell's complicated techniques. The blue bowl form at the centre of the work is the result of both blowing and moulding. The rest of the process is one

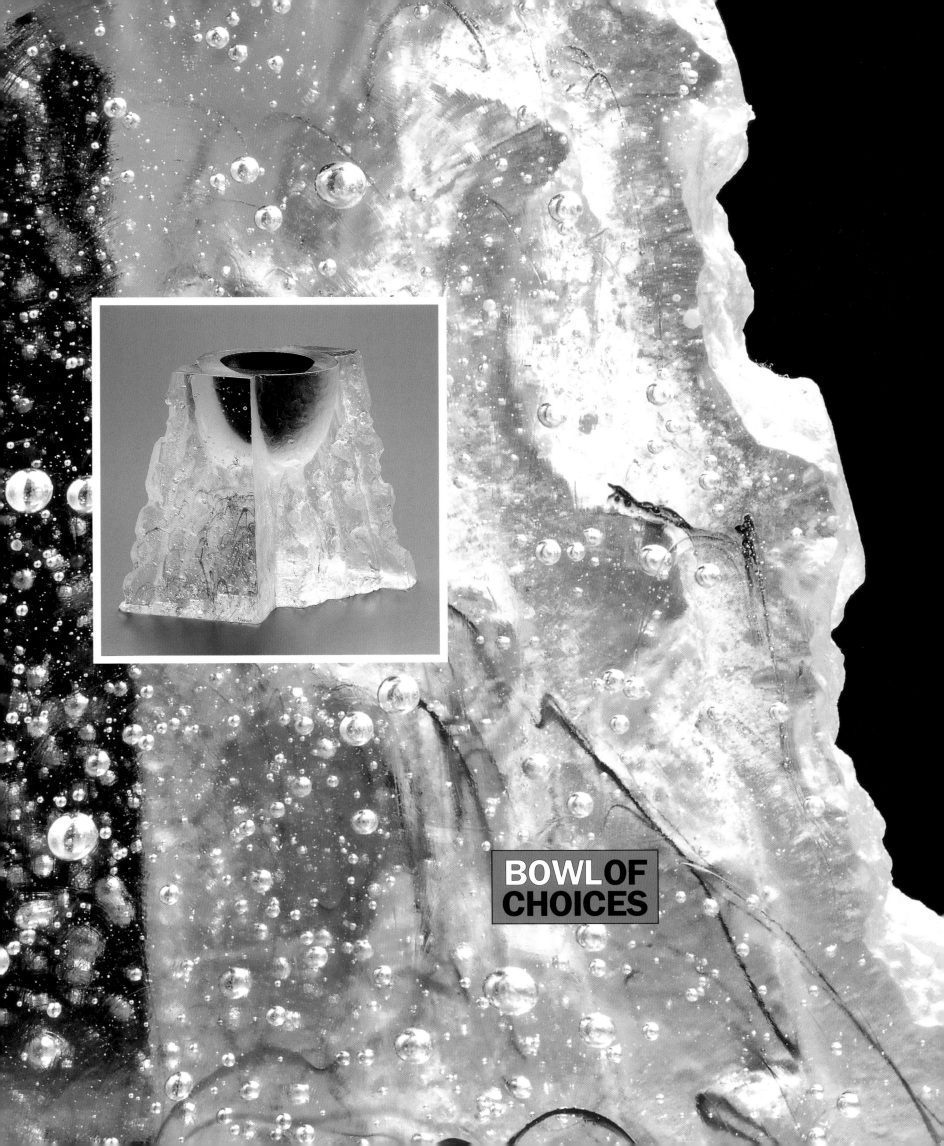

BOWL **OF**
CHOICES

Glass *Strawberry goblet*, with separate glass strawberry, by Richard Clements, Tasmania, Australia, 1994. Purchased 1995.

of cutting, grinding, polishing and, of course, casting. When the whole procedure succeeds, we have a powerful product, all the stronger for being highly wrought. When it doesn't, he has to begin again.

It is perhaps not surprising that glass can be made to look like ice. Ice, in its turn, usually looks like glass. Visually, they can be deceptively similar. But judging from work being produced today, the mimetic potential of glass might well be unlimited. Richard Clements, for example, can make it look temptingly edible.

A very near contemporary of Richard Morrell, Richard Clements was born in London in 1950. Before setting out on the life of the creative artist, Clements spent several years enduring the discipline of industrial glass blowing. He made scientific instruments with great precision. The experience must have driven him nearly insane but it provided a solid basis of skills which ultimately allowed him great freedom. He moved to Australia in the 1970s, settling in Sydney, and eventually began to make his name as a craft worker in that same decade. By the end of the 1970s, he decided to make Tasmania his physical and spiritual home as so many others in the crafts industry have done. Clements' endless variations on the theme of the perfume bottle are well known but he also makes free forms or, if you like, sculpture. Despite his industrial background or, rather, because of it, he works alone. He has little idea of what customers will like or dislike, which is a serious matter for someone who has to make a living. His method is to flame-work his forms over a torch, producing discrete parts and then fusing them together. He makes 'silly' pieces – his word, not mine. In a letter to the museum, he says: 'I am becoming more interested in bizarre pieces, (silly things). I get my influences from observing things in life, and let's face it there's enough silly things happening in the world to keep on going forever. I like trying to combine ugly things and beautiful things in one piece'.

Strawberry goblet is an example of what he means, although I can't see anything ugly in it. It is hardly an object of classical beauty but it makes a seductive appeal to the senses. It is an exercise in astonishing verisimilitude. The opaque glass cup of the goblet is an iced drink – Ukrainian champagne, perhaps – whatever tempts you. The rest is a delicious sweet, the kind that induces guilty longings. One

is tempted to lick the stem of the goblet; it could be a twist of custard or cream, or maybe blancmange. The glass strawberry nestling in this slightly soggy stem is as realistic as any Fabergé piece. Separately, another strawberry lies on the table nearby, its rich red hues warming the shadow it casts. It is much more realistic than any plastic sushi or tempura. And much more tempting.

I first saw *Strawberry goblet* in a craft exhibition which I had been asked to open in Deloraine, Tasmania, in 1994. I was so taken by it that, after a proper phone consultation with our curator in Sydney, I decided to acquire the piece for the collection. However, I do have a reservation about it: the separate strawberry seems solitary. If Richard Clements reads this book, I hope he will consider making a mate for it. Not that I wish to appear greedy!

One of the most extraordinary examples of cross-fertilisation involving glassmakers was between several Americans and a Czech husband and wife team based just outside Prague.

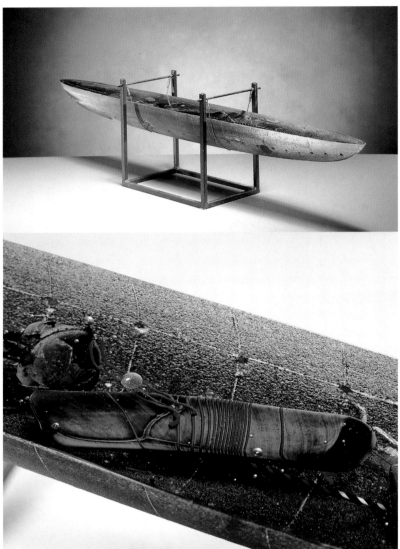

left and detail below **Glass sculpture, *Kite*, by Bertil Vallien, Sweden, 1989. A heavy, sand-cast glass sculpture in the form of a long, narrow boat, the outside matt-finished walls encapsulate the solid, clear glass interior cut flat at the top. Suspended inside the boat are differently coloured small glass elements, trapped at different levels of the cast glass. Purchased 1996.**

Zelezny Brod, the town where the Libenskys lived, 100 kilometres outside Prague.

There is no doubt that Libensky and Brychtova, by their example and by their teaching, have inspired a whole new movement among younger Czech glass artists around Zelezny Brod. Libensky became head professor of glass at the Academy of Applied Arts in Prague. However, all was not plain sailing, as we shall see.

The work of Libensky and Brychtova was characterised by an astonishing, a prodigious virtuosity, particularly in scale. They produced cast glass with all the brilliance of jewellery but on a scale that is epic. Architectural. To emerging American glass artists, college trained and dedicated to the notion of individual self-expression and freedom, for whom blowing was the preferred and most expressive technique, such formidable technical skill and such monumental scale was something to be reckoned with.

In 1958, before the studio glass movement had been alive long enough to make its presence felt, an international glass exhibition was held in New York at the Corning Museum of Glass. At that time, Scandinavia ruled the roost in craft fields and glass was known under company names rather than the names of individual designers. Several crates of work from behind the Iron Curtain arrived in New York, including a quantity of glass from Czechoslovakia. The great tradition of Bohemian glass was not well recognised in New York and had been lumped with German glass. Outstanding in the consignment of Czech glass was a work by Stanislav Libensky and his wife Jaroslava Brychtova. It was a green head made in solid glass, looking like one of those stone Modigliani heads. It was produced at the Specialised School for Glass Making at

One of the first Americans to visit Prague to meet the Czech virtuosos was **Dale Chihuly**, the earliest and brightest star of the new studio movement. He was followed by many more, including Richard Marquis. The appearance of several long-haired, hippy capitalists was not in the least welcomed by communist authorities. The growing international fame of Libensky and Brychtova caused difficulties for them. They were in demand at international seminars and workshops. Eventually they were expelled from the party which left them with a status akin to traitors, much worse than if they had never been members.

What Libensky and Brychtova taught was a philosophy of glassmaking whereby much conceptualisation and contemplation was undertaken, and many drawings and designs were produced before the execution of a work. This was a revelation to a generation brought up

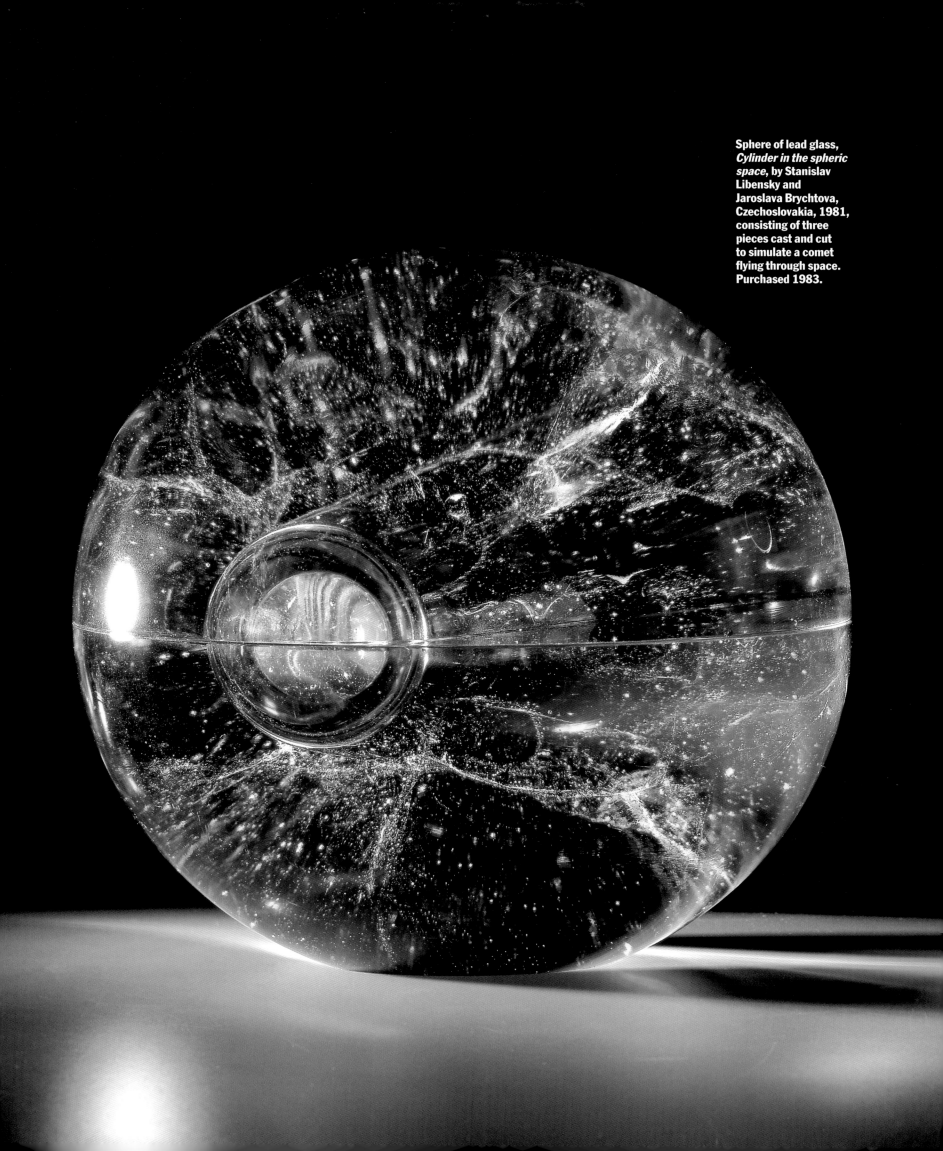

Sphere of lead glass, *Cylinder in the spheric space*, by Stanislav Libensky and Jaroslava Brychtova, Czechoslovakia, 1981, consisting of three pieces cast and cut to simulate a comet flying through space. Purchased 1983.

DALE CHIHULY

Dale Chihuly at work in Seattle.
main picture right An exhibition view
of the Dale Chihuly exhibition at the
Powerhouse Museum in 1993.

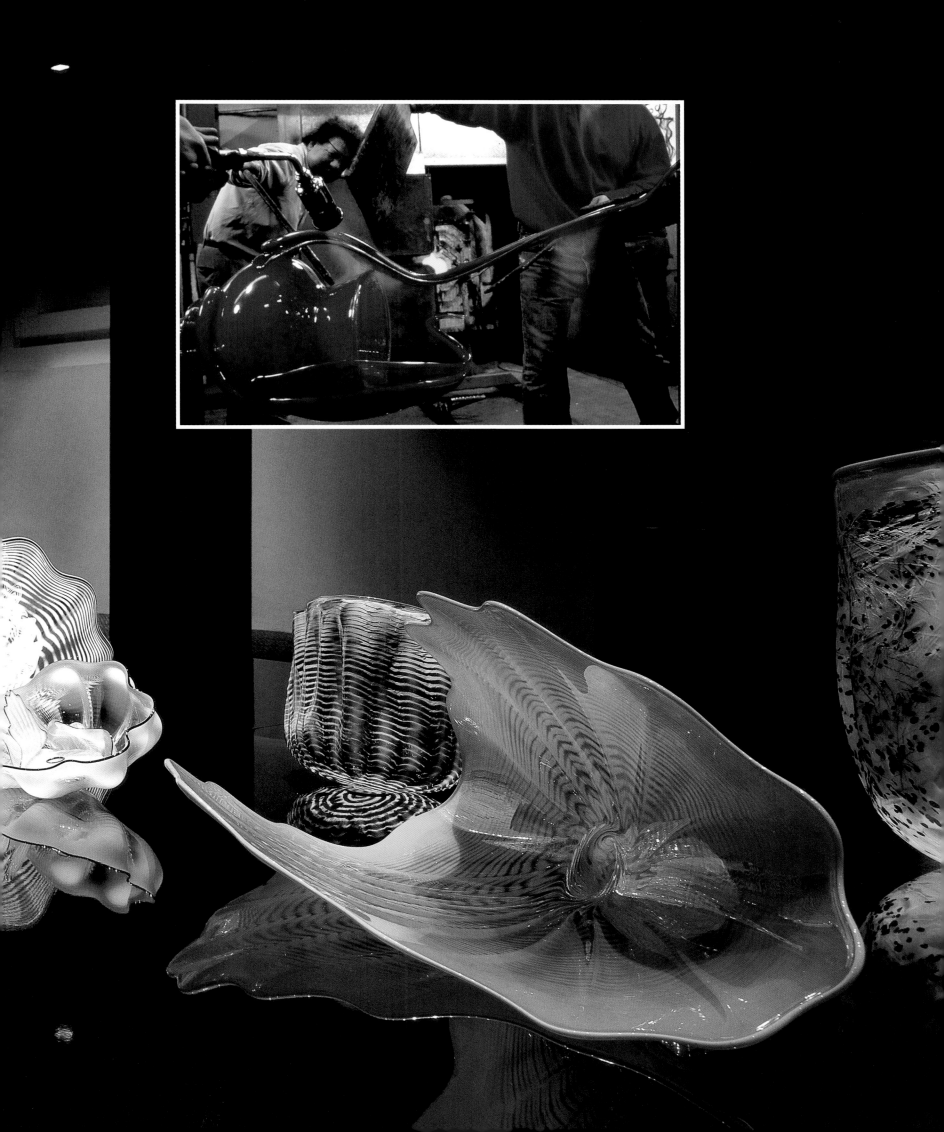

DEVILISH CHAOS

Glass bowl, *Devilish chaos*, by Toots Zynsky, Netherlands/France, 1995, of fused and slumped glass fibres. Acquired 1995.

on Jackson Pollock and instant expression. Their work also transcended themes of the individual. Most glass artists would be receptive to such a point of view because the very nature of the medium means that glass frequently has to be produced by teams, often of several people. Chihuly, for example, one of the most individualistic of them all, nowadays directs the complex processes of his workshop, which is more like a factory than a studio, instead of getting physically involved himself. In the case of Libensky and Brychtova, their work required the combination of their two personalities to produce it. But those two personalities were so finely attuned, so in sympathy that they were, as the French say, an *egoisme à deux*. In 1983 the museum acquired a 1981 example of their work, **Cylinder in the spheric space**. A large spherical form in solid glass, it is truly monumental.

In Europe in particular there has been a tension between industrial design in glass on the one hand, and free-form expression or handcraft on the other. In Sweden, the industrial tradition has been strong. The Kosta Boda Company and Orrefors, both of Sweden, make products that have long been famous. One designer who managed to marry this disciplined and methodical work background with his own freedom of expression is Bertil Vallien. It is by the very act of breaking free that people like Vallien have revitalised Swedish glass. He was able to go off in his own direction because of his contact with American glass artists, especially his association with Dale Chihuly and the Pilchuck School at Seattle. Started by Chihuly in the early 1970s, the school quickly became the most important centre for studio glass in the States.

Bertil Vallien has taught at Pilchuck or been artist in residence there over several years. The process which Vallien has made his own and has introduced into the Swedish industry is *sandcasting*. It is a technique which he appropriated from the metal industry. Like his friend Dale Chihuly, Vallien needs a team of talented assistants to carry through his creative process and in recent years they have helped him to produce a series of imagery based on the idea of a boat. Vallien starts with a large container of sand which must be damp in order to retain form and strength. Into the sand, he pushes a wooden template or formwork fashioned and constructed in the shape of a long, narrow boat. Then the wood is removed because it is the sand that provides the mould. Some of the sand will inevitably adhere to the glass poured into it and that is acceptable to Vallien who welcomes the way the sand contributes to the final colour of his sculpture. Pouring liquid crystal from long-handled ladles produces something of a shock and a thrill for the team every time. It is the shock of heat! Since the sand mould is large and the ladles small, the process takes some time. The episodic nature of the pouring creates dangers and difficulties of its own: stresses have to be even despite different cooling and drying times otherwise the whole thing breaks. But for Vallien, the staggered or staged nature of pouring allows him the opportunity for creative intervention. He places or suspends objects that he has ready into the transparent mass. These objects have a dada or surrealist lineage behind them; they are *objets trouvés* or certainly ready-mades. Finally, when the hollowed-out cast is full, Vallien grinds and polishes the top surface. The result is astounding! **Kite**, purchased by the Powerhouse in 1996, is an excellent example. As we look at the whole sculpture, it is as though he has filled the interior of a hulk with the clearest of liquids. It is literally crystal clear. Though solid glass, you feel that you could dip your finger into it.

The poetry of Bertil Vallien's sculptures is for the viewer to interpret. Boats of this shape inevitably connote Vallien's Viking ancestors, a reading that includes a sense of death, as dead Vikings were set sail in their own longships on the voyage to Valhalla. And, surely, the notion of a voyage itself is one of Vallien's themes, of movement from the past to the future, of never-ending travel to who knows where. One thinks, also, of debris washed up on the strand, of flotsam and jetsam on the foreshore, of wrecks and fragments from

TOOTS ZYNSKY EMBARKED ON A RADICALLY DIFFERENT PATH AND CONSTRUCTS BOWLS FROM STRANDS OF GLASS, ALMOST LIKE GLASS FIBRES.

163

Lantern-shaped pleated polyester dress by Issey Miyake, Tokyo, Japan, 1995. Miyake launched his 'Pleats Please' collection in the late 1980s. Since that time his pleated collection has been applauded by the high fashion industry and has significantly influenced popular fashion. Purchased 1995.

an incomprehensible past. But the sheer beauty of the work is life-enhancing. Even though Vallien's imagery conveys intimations of mortality, his magical craftwork affirms the value of life.

Powerhouse curators were excited and moved by the power of Bertil Vallien's exhibition at the Ken Done Gallery in the Rocks, Sydney, in May 1996. By the time I arrived there, they had already reserved the one they wanted and I was happy to endorse their choice in my recommendation to the Board.

As recent traditions of studio glass develop, we see more and more experimentation in techniques. Different ways of handling glass result in exciting new effects. One of the most interesting developments in glass technique in recent times is the work of Toots Zynsky. Born in 1951, Toots Zynsky is an American who now works in Europe. Though trained under fellow American Dale Chihuly, one of the great virtuoso producers of blown glass, Zynsky embarked on a radically different path and constructs bowls from strands of glass, almost like glass fibres. The artist herself likens the process to painting, building up patches of colour on colour. The exuberance of the final effect is indeed like a painting but, fibrous as it is, it also resembles the structure of textiles. So original is her technique that nobody else has yet been game enough to emulate it. The museum's striking example of Zynsky's work, with its vivid, flame-like colours, was acquired in 1995, the year she made it.

Glass is the most obvious translucent medium and has been through the ages, often with magical effect. We can all visualise the great cathedrals with their stained glass windows. The soaring and inspired nave of Chartres, for example, would seem far less spiritual, less uplifting, without its magical windows. That architectural casket, that stone reliquary, Sainte Chappelle, in Paris, has walls of glittering glass rather than windows. In the baroque period, too, natural light was admitted in astonishing ways to startle and to dramatise, to cause wonderment. Now imagine Sainte Chappelle in Paris or, say, St Vitus in Prague, with plastic windows. Stained plastic! The thought defies the mind. It shatters the sublime into bathos. Yet, in our own age, plastic is ubiquitous. In these secular times, when yobs, hoons and vandals lurch about our cities, perspex is even being used for church windows because it can withstand stones, bottles and other missiles.

As a museum seriously involved in contemporary technologies, the Powerhouse has been engaged over a period with the Australian plastics industries and has gladly collaborated in their efforts to reassure the public over matters of biodegradability, recycling and other ecologically and environmentally sound policies and programs. On the main, street level of the museum, we have a permanent exhibition of Australian innovation in industry. There, in a large case, the achievements of twentieth-century plastics are spelt out and illustrated: the fact that

These accessories of dress ...
a wide range of non-precious ...
and silver to glass and plast...
and decorative appeal. Pre...
...aterials, with designs creat...

of women in society have had on costume je...

...century to the present

social and economic events, technological

necklaces, earrings, bangles and rings — we...

inexpensive materials, ranging from gold-pla...

The value of costume jewellery has always be...

ous gemstones and gold are often imitated in inexpensive

to echo the splendours of fine jewellery. Imitation, however

Exhibition views of the Powerhouse Museum's *Jewels of fantasy* exhibition, which featured a collection of crystal jewellery.

Glass vase, *Stone vessel*, by Garry Nash, New Zealand, 1996. Height 370 mm; diameter 380 mm. Purchased 1996.

rather than ignore problems or even hide them.

Still on the theme of transparency (and, for that matter, bodies) it is noticeable how women's fashions in recent times have become ever more see-through. The effect is often riveting, particularly when seen *contre-jour*. A dress by Issey Miyake, which the museum acquired in 1995, is almost like a magic lantern. The Japanese designer Issey Miyake is one of the world's most admired fashion creators. Though he works in Paris, his designs are thoroughly Japanese in their elemental shapes and colours. Because our recent acquisition with its concentric corrugations *is* like a lantern, we have lit it up like one for the purposes of this book, and to bring out its essential qualities.

The dress is strikingly attractive in an abstract sense even before it is worn. Whether worn or simply folded like a flattened lantern, it makes a design statement. When worn, the pleating of the dress, its bouncy circles, make more than a passing reference to the crinolines of European tradition. Such hybrid ideas are fully conscious and

plastic materials can be made to perform almost any function and in any colour you like. But the exhibition also includes the downside. Because plastics are so inexpensive and because ours is a frantic society characterised by obsolescence in virtually all our products, we jettison plastic waste by the tonne. We live on a sea of plastic garbage. Most people know all this but it is still an important story to tell some 130 000 school students who enter the museum each year on planned and organised visits. And it is good of the Plastics and Chemicals Industries Association Inc to sponsor our exhibit. They prefer to be open about the pros and cons of plastics

determined in the mind of Issey Miyake. As our curator of Asian decorative arts and design, Claire Roberts, explains, Issey Miyake considers that clothing is comprised of 'three pleasures: the pleasure to design, the pleasure to wear, and the pleasure to see it worn'. It is a matter for wonderment that this native of Hiroshima, who witnessed the atomic devastation of his city when he was six years old, can take such pleasure in all that he does and give such pleasure to the world. It makes him especially appropriate and welcome in this book which is devoted to the pleasures that the museum gives to society.

Samples of material, such as cellulose acetate, used in plastics production. They are displayed in the 'Plastics' section of the museum's *Success and innovation: achieving for Australia* exhibition.

the magic of Moscow

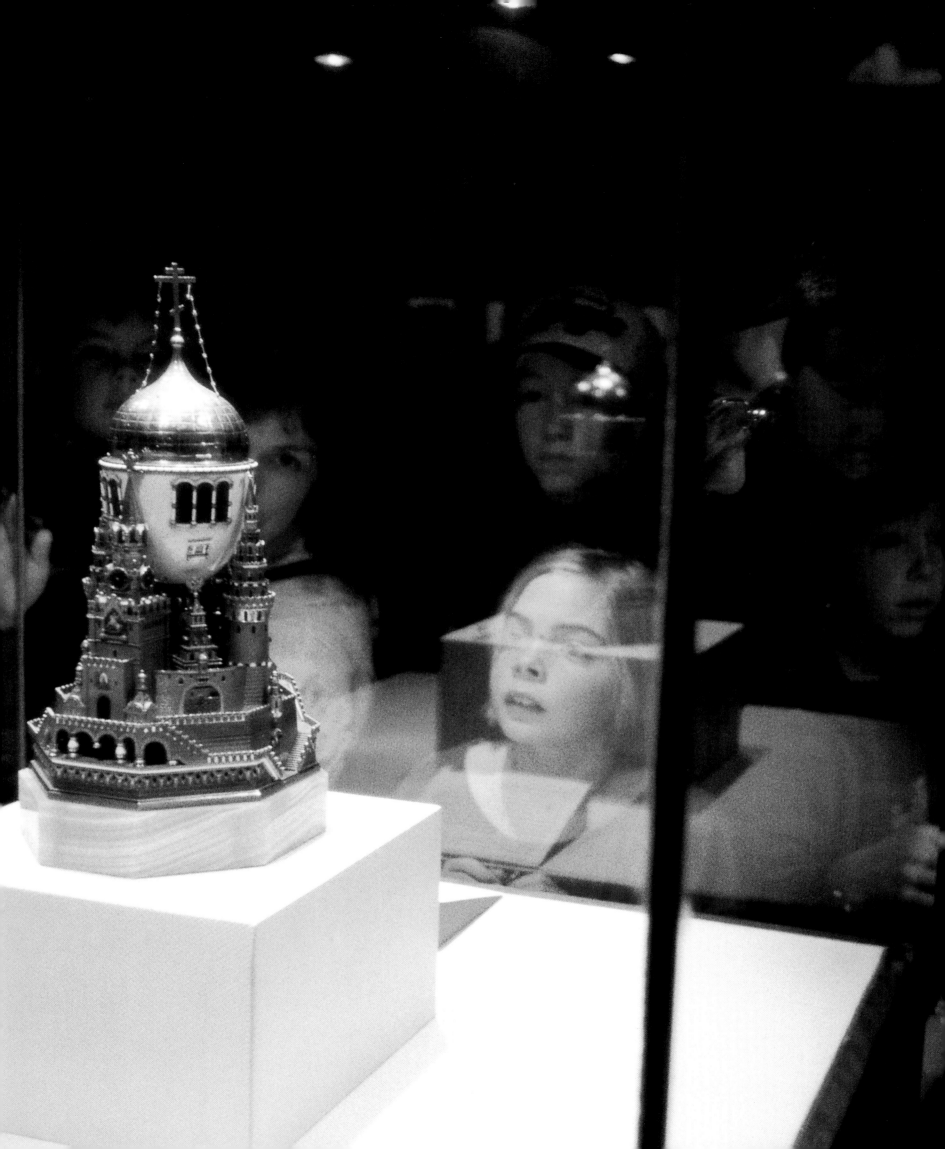

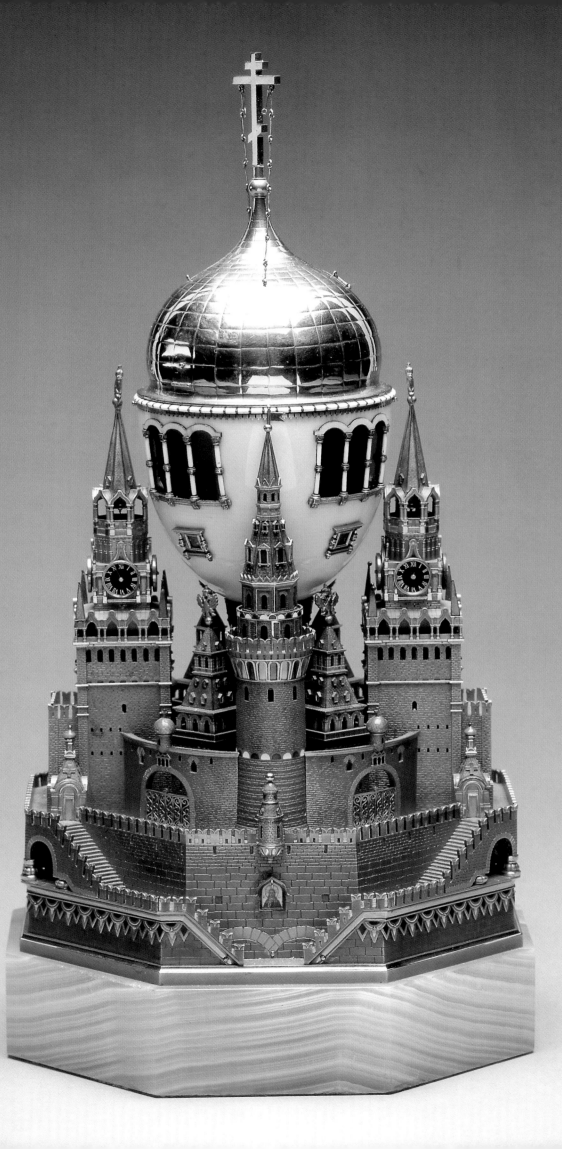

The Moscow Kremlin Egg
was made by the House
of Fabergé, St
Petersburg, 1904–1906,
from gold, silver, onyx,
glass, enamel, casting,
engraving, guilloche, oil
painting. Inside the
model is a music box with
a gold key. Egg and
stand: height 361 mm;
base 185 mm x 185 mm.
See also pages 175–77.
Collection of and
© Moscow Kremlin State
Museum-Preserve of
History and Culture.

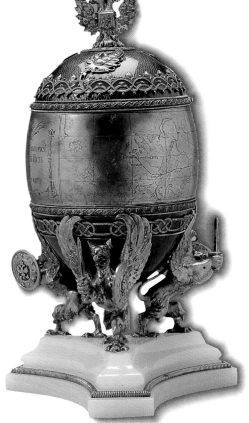

above **Fabergé cigarette case (see page 184).**
right **Trans-Siberian Express Egg (see page 179).**

This book is essentially about objects in the permanent collection of the museum; the permanent residents, so to speak, of our galleries and storerooms. However, like most museums, we also have temporary guests, most of them highly distinguished. For example, in Chapter 4, I mentioned a gold bracelet that we would have liked to own but which was a most welcome temporary resident for a year or so. Exchanging items with other museums is a commonplace activity and at any time, we have a large number of our own objects out on loan in other places where viewers can appreciate them.

A museum which does not engage in such exchange activities is rare but not unknown. An example of such an exception is the Wallace Collection in London. This national museum, containing the finest of both fine and decorative arts, is prohibited by its charter both from lending out objects and from receiving loans from other collections. The result is no change in their displays. The one advantage of such a policy is that repeat visitors can count on finding their favourite work in exactly the same place where they last saw it. It also follows that the Wallace cannot stage temporary exhibitions.

WILLIAM DOBSON (1611–46)
Charles Gerard, 1st Earl of Macclesfield, (Britain)
oil on canvas 715 x 605 mm (sight)
collection: Dunedin Public Art Gallery

Such special exhibitions are the life-blood of most museums and art galleries, although it is possible to have too much of a good thing. Some communities can become blasé about their museum's collection and demand the continual novelty of travelling exhibitions. I remember the occasion in 1990 when the then director of the Dunedin Art Gallery in New Zealand, Cheryll Sotheran, took the radical step of filling the building with its own permanent collection for the first time in anyone's memory. The Dunedin art collection is a highly distinguished one with some rare masterpieces bought during the days when the city grew rich on alluvial gold. Yet, by 1990, the people of Dunedin had come to regard their art gallery as a 'venue' for touring exhibitions. Cheryll's initiative gave the place new life, new respect, and attracted not only New Zealanders but overseas visitors such as myself! It was a revelation, for example, to find in Dunedin an excellent portrait of a cavalier, *Charles Gerard, 1st Earl of Macclesfield,* by William Dobson. Works by Dobson are extremely rare. *The* painter

of the English civil war in the seventeenth century, he was also the official artist at the court of King Charles I which exiled itself in Oxford, because London was in the hands of the parliamentarians. Though clearly taught by Sir Anthony van Dyck, Dobson came from nowhere, painted for only four years, 1640–44, and then disappeared without trace until he died in 1646. He was the first English-born master in the history of post-renaissance art. That one of his rare paintings should turn up in Dunedin is a good reason to go there.

Most museums strive for a balanced diet of the permanent and the transient. Temporary loans and exhibitions should always relate to and enhance the permanent collection of the museum in an obvious manner. Loans can temporarily fill gaps in the collection and complete exhibitions can do the same on a much larger scale. The *Christian Dior: the magic of fashion* exhibition, described in Chapter 1 is a good example. The best and most wonderful example in recent times is the exhibition **Treasures from the Kremlin: the world of Fabergé**, staged at the Powerhouse Museum for three months in 1996.

In the history of the decorative arts, the name of Carl Fabergé (1846–1920) is legendary. The Powerhouse owns just a few small pieces from the house of Fabergé (see pages 184–85), but we kept them well out of the way when our loan exhibition from the Armoury Museum in the Kremlin arrived. The Armoury is one of the plethora of distinguished buildings, including palaces, churches and four cathedrals that abut one another, cheek by jowl, within the 28 hectares of Moscow's magnificent Kremlin. My own first visit to the Armoury was in 1995. It was an overwhelming experience. Nowhere else, not even Versailles, had prepared me for such an exuberance of opulence. Armour, imperial coaches, costume, metalware – all seemed to be encrusted with precious stones. It is a hoard, a treasure-trove. Aladdin's cave pales by comparison. A first reaction to such overpowering wealth was a sense of futility. Despair! Australia, for obvious historical reasons, is not well-stocked with historic treasures. No Australian collection can be considered in the same league. Why not just give up? It was an understandable thought but a silly one. The culture which we are still building in Australia is a young one and its treasures are and will be different. As it happens, when

KREMLIN EGG

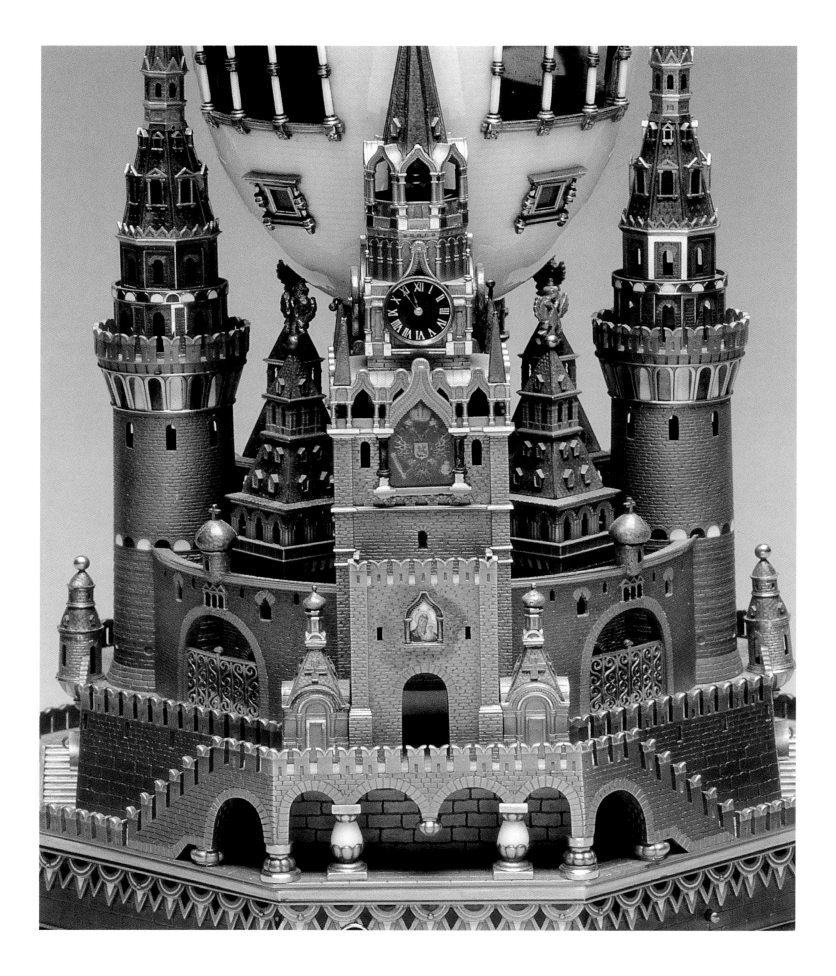

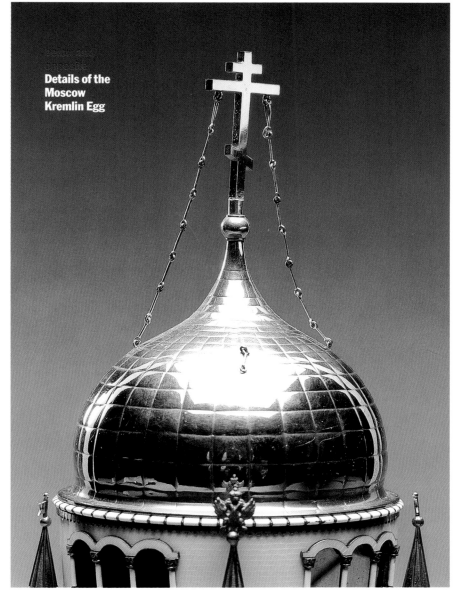

Details of the Moscow Kremlin Egg

In all, Faberge produced more than 60 royal Easter eggs. Of these, only ten remain in Moscow.

The entire exhibition brought from Russia by Bromley Management Services Pty Ltd, consisted of 240 items, of which eighty were by Carl Fabergé. Of these, five of his royal Easter eggs stood out. Tsar Alexander III began this imperial tradition when he commissioned an Easter egg as a present for Tsarina Maria Fyodorovna in 1885. The idea was such a success that an egg was commissioned every year. When their son Tsar Nicholas II succeeded in 1894, he continued the tradition and expanded it by commissioning two eggs each year, one for his wife Tsarina Alexandra Fyodorovna and one for his mother, the Dowager Empress. In all, Fabergé produced more than sixty royal Easter eggs. Of these, only ten remain in Moscow. It was therefore unimaginably generous of the Armoury Museum, under its director, Dr Irina Rodimtseva, to have lent no less than five for the exhibition.

The **Moscow Kremlin Egg** of 1906 was for me the most powerful object of them all. It appeals to me for several different reasons. I have had a lifelong love of gothic architecture, a taste which encompasses, with equal enthusiasm, gothic revival also. The magnificent Kremlin walls have fifteen towers, all but two of them having names. The two major towers that the Kremlin Egg copies are the *Spasskaya* (1491) and the *Vodovzvodnaya* (1488). The former, the Saviour Tower, is the primary entrance to the Kremlin, opposite the highly coloured and striped onion

senior figures from Moscow made their reciprocal visits, they were just as overwhelmed by the Powerhouse Museum. They saw it as vibrant, alive. They were particularly impressed by our exhibition design, the way we show things.

For our part, Powerhouse staff were so inspired by the Armoury material that they seemed to find unprecedented reserves of talent and imagination. Design staff transformed showcases into treasure vaults. Our electricians supplied lighting that gave the perfect glow to Fabergé's exquisite creations. Because of the staggering value of the objects, it was impossible to give our photographers their accustomed studio conditions. Despite having to make do with an enclosed, cramped space, they produced photographs of stupendous quality for use in promotional material.

PABLO PICASSO (1881–1973)
Bottle of 'Vieux Marc', Glass, Guitar and Newspaper **1913**
various on paper 46.7 x 62.5 cm
collection: Tate Gallery, London ©Succession Picasso/DACS 1997.

domes of Saint Basil's Cathedral in Red Square. At the centre of the Kremlin Egg is the large central dome of Uspensky Sobor, the Cathedral of the Dormition, the oldest, largest and most important of the Kremlin cathedrals, completed in 1491.

The thought of this cathedral had haunted me for twenty years until I was able to walk inside it in 1995. Through the 1970s, the decade I spent on the staff of the Tate Gallery, London, I lectured frequently on Picasso and cubism. The Tate has an important *papier collé* which Picasso made in 1913. He stuck into this a piece of yellowed newspaper, already thirty years old, which was a cutting from the newspaper *Figaro*. It was a report from the Moscow correspondent describing the coronation of Tsar Alexander III in 1883. The history of cubism, without doubt the most important and seminal art movement of the twentieth century, is well documented. From its beginnings in 1908 to its maturity in 1912, it was a grey art. It was cerebral rather than sensuous. There is little or no colour in cubism and that began to pall even for the artists themselves. They were searching for a way to bring colour into cubism. Picasso was so moved, in 1913, by the colour, the exoticism, the sensuousness and, with its description of swinging incense censers, the olfactory appeal, of the *Figaro* report, that he stuck it onto and into his current works (the Tate's example is one of a group). Why in 1913? Because that year was the 300th anniversary of the founding of the Romanov dynasty and there were ominous signs by 1913 that it might be nearing its end. As we now know, it had only five more years remaining.

178

Trans-Siberian Express Egg, made by the House of Fabergé, 1900, from gold, platinum, silver, rose-cut diamonds, ruby, onyx, cut-glass, wood, silk, velvet, enamel on guilloche, casting, chasing, engraving, filigree, seeds of gold. Egg and stand: height 260 mm; length of train 398 mm; height of coach 26 mm. Collection of and © Moscow Kremlin State Museum-Preserve of History and Culture.

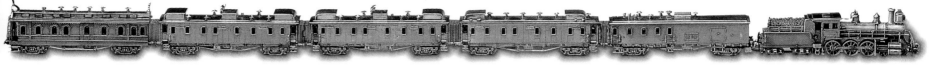

In the Paris of 1913, Russian influences were both welcome and celebrated. Two of the greatest early collectors of modern art were both Russian, Ivan Morosov and Sergei Shchukin.

The **Trans-Siberian Express Egg** fitted in well with its temporary home, the Powerhouse, where the history of transport is a major theme. Though a family gift from husband to wife, this extraordinary creation celebrates a public and historic event, the completion of the rail link from European Russia right across the continent to the Pacific coast. With Fabergé's remarkable but characteristic ingenuity, folded inside the egg is a model train, with locomotive and five coaches. It must be one of the smallest working model trains in existence, it is certainly the only one made of gold. Like its full-size Powerhouse counterpart, Loco No. 1, its carriages are marked according to class.

The **Alexandrovsky Palace Egg** is the most expensive, the most richly decorated, of the eggs. Though small enough to hold in your hand, its surface is encrusted with no less than 1805 diamonds! Not to mention an additional fifty-four rubies. The surprise inside this egg is a tiny model of the family's favourite home, the Alexandrovsky Palace, where Nicholas, Alexandra and their five children lived more or less reclusively. The miniature portraits of the children, painted on ivory, are placed at equal intervals around the circumference of the egg. This feature emphasises the private nature of this marvellous example of decorative art.

During an ABC radio interview on a national arts program, it was put to me, somewhat provocatively, that Fabergé's works can be labelled as kitsch. I was so shocked by the question, having just been looking at the

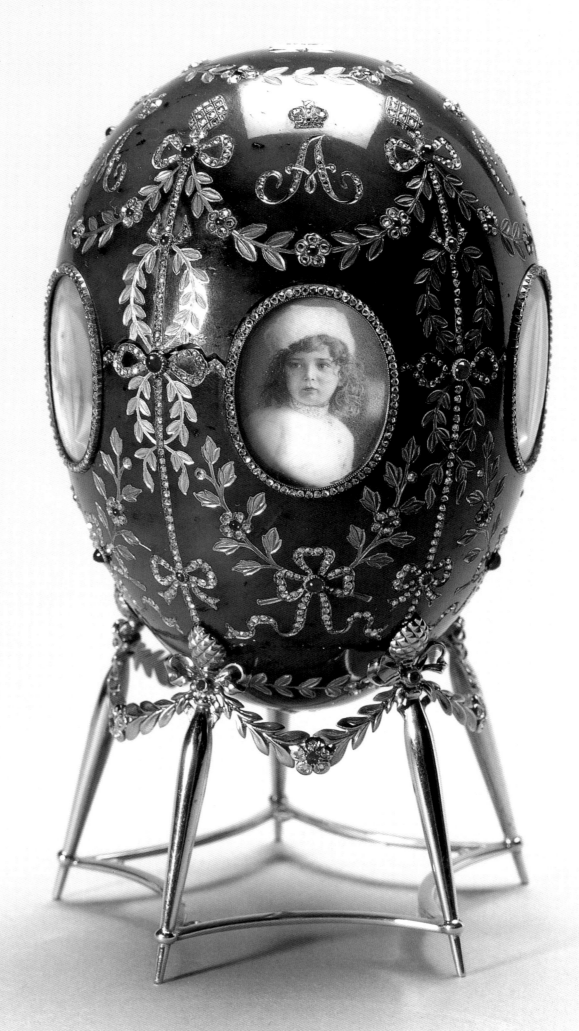

The Alexandrovsky Palace Egg, made by the House of Fabergé, was a present from Emperor Nicholas II to Empress Alexandra Fyodorovna for Easter 1908. Gold, silver, brilliants, rose-cut diamonds, rubies, jade, rock crystal, glass, wood, velvet, bone, enamel, casting, chasing, incrustation with gold and gems, engraving, stone carving, watercolour, gouache.
Egg: 110 mm x 68 mm; palace 30 mm x 65 mm. Collection of and © Moscow Kremlin State Museum-Preserve of History and Culture.
(detail opposite below)

Alexandrovsky Palace Egg, that I found it difficult to respond. Yet I have heard the smear before. In the USSR, during seventy years of communism, a period that closely coincides with modernism, it was said many times. For me, the question cannot be considered without taking into account the very private nature of these egg gifts. They had so much meaning at a personal level that I cannot see how they can ever be relegated to the despised category of kitsch with all the superficiality that the term embodies.

The question put to me by the interviewer reflects a difficulty many people in the late twentieth century experience with the private and personal mode of art. In our age of public museums and art galleries, we tend to think that all things are created for viewing by the public. Yet, throughout history, artists and craftspeople have worked for private patrons. Today, because so much art is publicly funded through grants, scholarships and so on, products are aimed at the public forum. This is why paintings, for example, are so often large. They clamour for the attention of a large audience. Of course there have been lots of big works throughout history, but for a different reason. Powerful patrons needed their palaces painted. Walls

and ceilings were decorated on an epic scale to overawe with authority. But mostly not to impress the masses. Fabergé had the means to work on any scale he chose. Cost was not a factor. But he invariably worked on a small, even miniature scale.

The same interviewer put it to me that the reason the works of Fabergé could be thought of as kitsch was because they were made for an autocratic client, a client of great wealth and power. By contrast, so said the radio personality, all other decorative art was free of such a context of power and authority. Such a suggestion was so astonishingly novel that I was again tongue-tied. Throughout history decorative arts have been made for wealthy clients on commission. The fact that the question had been posed in those terms confirmed my view that many see the past through the misleading filter of our times. Today, craftspeople exhibit their wares at craft fairs, craft bazaars in converted churches, and craft shops for cultural tourists. I'm one of them — a cultural tourist I mean. We look at this object and that, hold up a necklace, a bangle, admire a printed textile and then buy a souvenir or stock up on presents for relatives. We might even visit a studio or a pottery and look for a bargain among

the seconds. But it is a mistake to imagine that throughout history *objets d'art* have been so liberally available on a take it or leave it basis. Tsar Nicholas II liked to pretend total surprise at every successive Easter offering from Fabergé. Yet he, Alexandra and others in the family spent much time sketching and designing. There is no doubt that Carl Fabergé knew what they liked and knew what was required.

left The jewellery curator from the Kremlin's Armoury Museum, Tatiana Muntian, joined Powerhouse staff for three months in 1996. Here she examines the Alexandrovsky Palace Egg.

Crowds queuing to see the Powerhouse Museum's blockbuster 1996 *Treasures from the Kremlin: the world of Fabergé* exhibition.

Cigarette case, rock crystal basket and bowenite cat by Fabergé

left This Fabergé cigarette case was made by August Hollming in St Petersburg between 1896 and 1908. Gold, brilliant cut diamonds, enamel on guilloche, chasing, punchwork, wood, silk, velvet, gold stamping. The locking button is in the shape of a brilliant cut diamond, and at the centre of the upper cover there is a superimposed gold chasing-produced image of the State Emblem with another brilliant cut diamond. This cigarette case was given by the Russian Tsar Nicholas II to Australian Edmond Monson Paul who was Honorary Consul in Sydney to Imperial Russia for over 50 years. Length 95 mm; width 63 mm. Bequeathed to the museum by Edmond Monson Paul in 1953.

above Fabergé miniature figurine of a cat, c1890, carved from translucent milky green bowenite stone, the left eye inlaid with an oval cabachon ruby. Purchased 1966.
opposite Fabergé ornamental basket, made of rock crystal (carved from solid transparent quartz stone), 14 ct gold (three colours) and enamel, c1890. Height 990 mm (with handle raised); width 68 mm; depth 64 mm. Purchased 1965.

Susan Harrison performing at the Powerhouse Museum with the Flying Lotahs during the *Circus: 150 years in Australia!* exhibition in 1996 and 1997.

coda

The biggest change in museums over the last two or three decades has been the role they have developed as performance spaces and centres of activities. Such a direction was not unprecedented. There had been wartime concerts in London's National Gallery, for example. But nowadays ephemeral events are part and parcel of museum life. Certainly this is the case at the Powerhouse where visitors will find craft demonstrations, costumed actors, musicians and a plethora of activities for spectators and participants alike.

In Sydney, no particular cultural organisation has been specifically charged with the task of collecting material associated with the performing arts. Such material would include theatrical costumes, stage designs, props and manuscripts. The Powerhouse Museum has always collected in related fields such as fashion and dress and music. Social history, a major theme of Powerhouse collecting, includes community and folk events such as the history of circus in Australia.

For 150 years the tradition of circus has been carried on in Australia by a number of dynastic families, often rivals, sometimes intermarrying. In 1995, we were able to acquire the complete collection of costumes, props and memorabilia of a famous circus family, the Jandaschewskys. After twenty years of wandering the globe in typical circus fashion, and developing acts of typical circus versatility, the Jandaschewsky family arrived in Australia in 1900. Their troupe of acrobats, dancers, musicians and clowns held

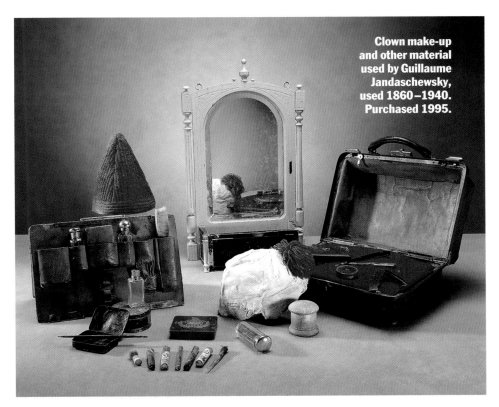

Clown make-up and other material used by Guillaume Jandaschewsky, used 1860–1940. Purchased 1995.

Shalmay musical clown instrument used by Theo Zacchini, Wirths Circus c1960. Lent by the Zacchini family.

Australian audiences enthralled for a period of sixty years. The phenomenal collection they left behind is a treasure of international significance. We presented it to the public as the core of a major exhibition in 1997 to mark the sesquicentenary of circus in Australia (the first circus opened in Launceston, Tasmania in 1847).

It would be unthinkable to stage such an exhibition, however marvellous, in a static manner. Instead we surrounded it with live performances by today's circus entertainers. The soaring spaces of the Powerhouse Museum are lofty enough to accommodate many of the acts you would normally see in the big top. Virtuoso trapezists thrilled Powerhouse visitors on a daily basis.

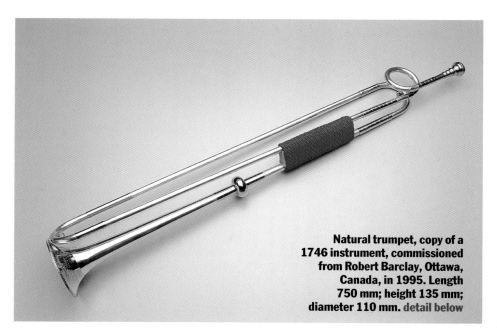

Natural trumpet, copy of a 1746 instrument, commissioned from Robert Barclay, Ottawa, Canada, in 1995. Length 750 mm; height 135 mm; diameter 110 mm. detail below

the active use of its instruments as far as possible. Some of them are too delicate and frail to be played any more but these still provide us with information about their times and how they were made.

For our program of recitals and demonstrations, the collection was, until recently, glaringly incomplete in one respect. We had a distinguished group of violins but we did not have a complete quartet of strings. This omission was remedied in 1994 by the purchase of two violins, viola and cello all made by Kitty Smith (b. 1912), the talented daughter of Arthur Smith (1880–1976), Australia's most distinguished violin maker.

We have realised that a blend of static objects – precious exhibits – with performance events is our best formula for a lively and relevant museum. That successful mixture is now essential to the Powerhouse style. Business strategists might call it one of our areas of special competence.

Such an approach is particularly appropriate to programs involving the music collection. The museum began collecting musical instruments in the 1880s, soon after the museum was founded. The first acquisitions were Chinese stringed instruments purchased from our neighbours in Sydney's Chinatown. Since then, the collection has grown to be one of great distinction by any standards.

A recent addition is a splendid trumpet. It is a valveless or **natural trumpet** which requires the player to produce all notes by lip pressure alone. We commissioned this beautiful instrument from an expert maker, Robert Barclay of Ottawa, Canada. The trumpet is made after the fashion of the Nuremberg school of the seventeenth and eighteenth centuries – in fact it is a copy of an instrument made by Johann Leonhard Ehe in 1746. The museum is committed to

Kitty Smith herself came to our *Soirée Musicale* in 1995 when we premiered her instruments. The acknowledged presence of the instrument maker at a performance adds a unique magic to the event. I have never known this happen in a conventional concert hall where all attention is directed to the composer, perhaps, and certainly to the performer. Program notes do not normally mention the instruments, which are taken for granted, like ballpoint pens! All instruments have a different sound and the choice of instrument of a virtuoso soloist is significant.

The very nature of musical instruments reminds us that the correct, statutory name of our organisation is still the Museum of Applied Arts and Sciences. There is a good deal of science in a well-crafted instrument, a didgeridoo, perhaps, or a Hawaiian-style ukulele. Indeed, the elegant Yamaha Disklavier grand piano employs leading-edge information technology. It can reproduce a pianist's performance instantly and with complete accuracy. It is for reasons like these that I have always seen the music

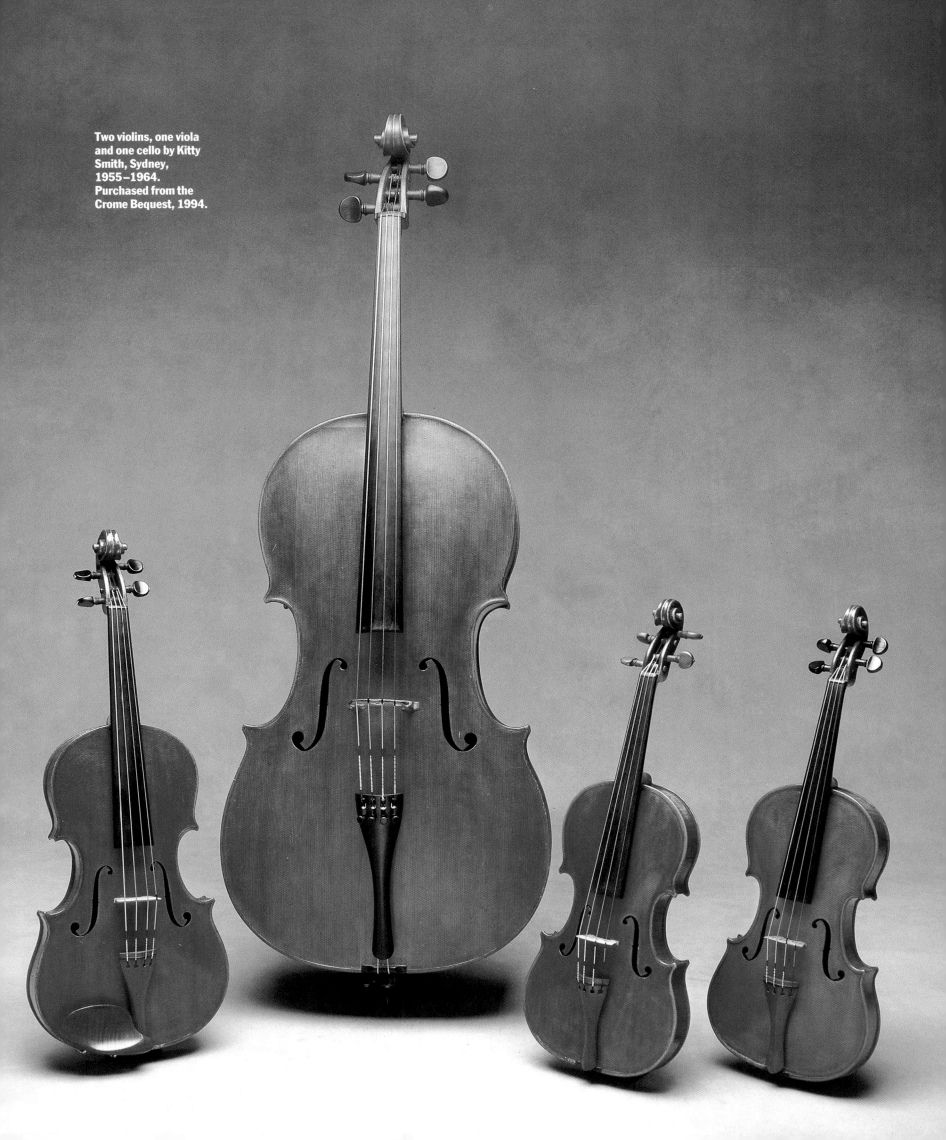

Two violins, one viola and one cello by Kitty Smith, Sydney, 1955–1964. Purchased from the Crome Bequest, 1994.

collection as central to the museum's programs. Everyone responds to music and our response is both emotional and cerebral. That about sums it all up, as a coda is meant to do. But I will stretch this endpiece to make a brief but risky speculation about a future role of museums.

It is becoming clear that society is made up increasingly of so-called minority groups and subcultures. One of Australia's greatest thinkers and writers, Donald Horne, has poured scepticism on the concept of the 'mainstream community'. Traditionally, museums have been produced by homogenous or dominant cultures to mirror and express their deepest myths and beliefs. For example, the creation of the Louvre was Napoleonic. Adolph Hitler threw more resources at museums, particularly art museums, than almost any other political leader in history. The British imperial attitude, one that knew no boundaries, one that gave explorers the confidence to travel and colonise anywhere on the globe, is embodied in the British Museum which conserves, stores and displays all that the British deemed worthy to appropriate.

Today, the largest museum group in the world is the Smithsonian in Washington. It occupies a special place – the word 'holy' comes to mind – in the hearts of Americans.

Receipt for violinist Claude des Matins, court of Louis XIV, France, 1675. Purchased from the Crome Bequest, 1995.

190

A violin display in the Powerhouse Museum.

It is a place of pilgrimage. For that very reason, it is a conservative place. Fairly recently, the inclusion of a very small and faded photograph of a nude woman caused an emotional upheaval at the National Portrait Gallery. At the National Air and Space Museum, controversy raged over the museum's treatment of the dropping of the atom bomb.

It seems very probable that museums will experience more controversy in the future as finely balanced factions in society fight over the values which they expect to be reflected in collections and exhibitions. The so-called gun debate is a good example. Traditionally, museums have collected weaponry. Should they continue to do so? If so, what kind of weapons and how should they display them? The issue arouses passionate attitudes towards museums on the part of many people who don't visit them. On such a topic museums, whatever they do, are likely to offend many.

In contemporary society, other controversies can break out on non factional lines. Individual attitudes on voluntary euthanasia, for example, are far from predictable and that particular issue can and has split families. What does

euthanasia have to do with museums? There are two aspects that might be said to be the concern of museums. They are historical and technological, and arise from the Northern Territory's decision in 1996 to allow voluntary euthanasia. First, the legislation was of undoubted historical significance, even though it was overturned subsequently. Second, the apparatus used is of significance in a technological sense; that is to say that a new application has been found for information technology, permitting the patient to control the process. The opinions of society are deeply divided on this whole issue, and if a museum were to become involved in any way, it is likely that it would provoke the hostility of many.

The topic is frequently reported on and discussed in the print and electronic media. The fact that it is discussed in that forum is not in itself controversial. There are some positive implications in this for museums. The obvious one is that museums, or at least the objects they collect, have considerable power, authority and significance in society. They are often revered, whereas newspapers rapidly become fish and chips wrapping. Nonetheless, museums cannot continue to be temples and monuments to the traditional values of homogenous societies because these are being replaced by multicultural societies with diverse value systems.

Tolerance would seem to be the watchword as changes work their way through. Given a degree of that tolerance, museums will find a useful role to play in mediating some of society's more emotional changes. Museology is an international field and already museum people are discussing with their colleagues in other countries ways to do so. The talk is of museums as safe places where people who wish to do so can come to terms with difficult issues. On many contentious issues, such as gun control, euthanasia or Aboriginal land titles, it is obvious that many have already made up their minds, possibly from religious or other convictions. But there are many others who need time, space and information to think through the implications.

Museums might just be places where people can work to understand one another better. They might just be places where people can enjoy and take pleasure in society's diversity.

BIBLIOGRAPHY

The age of Macquarie, edited by James Broadbent and Joy Hughes, Melbourne University Press in association with Historic Houses Trust of New South Wales, 1992

Allwood, John, *The great exhibitions*, Studio Vista London, 1977

Australian gold & silver 1851–1900, edited by Eva Czernis-Ryl, Powerhouse Publishing, Sydney, 1995

Bickersteth, Julian, 'The three Macquarie Chairs', *Australiana*, vol. 14, no. 1, February 1992

Bowen, John, *A ship modelmaker's manual*, Arco Publishing Inc New York, 1982

Charles Babbage and his calculating engines – selected writings by Charles Babbage, edited and with an introduction by Philip Morrison and Emily Morrison, Dover Publications Inc, New York, 1961

Clarke, C M H, *A history of Australia*, Melbourne University Press, 1981

Cohen, Lysbeth, *Elizabeth Macquarie – her life and times*, Wentworth Books Pty Ltd, Sydney, 1979

The Crystal Palace Exhibition illustrated catalogue London (1851), introduction by John Gloag, FSA, Dover Publications Inc, New York, 1970

Denholm, David, *The colonial Australians*, Penguin Books, Australia, 1980

Dover, Harriet, *Home front furniture – British utility design 1941-1951*, Scolar Press, University Press, Cambridge, 1991

Edwards, Geoffrey, *Klaus Moje glass/glas – a retrospective exhibition*, National Gallery of Victoria, 1995

The encyclopaedia of space, advisory editor Maurice Allward, Foreword by Malcolm Scott Carpenter, Paul Hamlyn, Paris, 1968

Fabergé eggs – imperial Russian fantasies, introduction and commentaries by Christopher Forbes, Harry N Abrams, Inc, New York, 1980

Freeland, J M, *Architecture in Australia – a history*, Penguin Books, Australia, 1988

Hawkins, J B, *Australian silver 1800–1900*, National Trust of Australia, Sydney, 1973

Hazzard, Margaret, *Australia's brilliant daughter Ellis Rowan – artist, naturalist, explorer*, Greenhouse Publications, Victoria, 1984

Hobbs, Edward W, *How to make clipper ship models*, Brown, Son & Ferguson Limited, 1971

Holzmann, Gerard J and Pehrson, Björn, *The early history of data networks*, IEEE Computer Society Press, Los Alamitos, 1995

Horne, Donald, *The great museum – the re-presentation of history*, Pluto Press, London and Sydney, 1984 [This is the most thoughtful and intelligent book on museums I have ever read – TM.]

Hughes, Robert, *The fatal shore*, Collins Harvill, London, 1987

Joels, Kerry M, Kennedy, Gregory P and Larkin, David, *The space shuttle operator's manual*, Macmillan, London, 1983

Kerrod, Robin, *Living in space*, Crescent Books, New York, 1986

Kruckenberg, Sven, *The symphony orchestra and its instruments*, Crescent Books, New York, 1993

McKay, Judith, *Ellis Rowan – a flower-hunter in Queensland*, Queensland Museum, 1990

Measham, Terence, *The Moderns: 1945–1975*, Phaidon Press Limited, Oxford, UK, 1976

Measham, Terence, *Treasures of the Powerhouse Museum*, Powerhouse Publishing, 1994

Monaghan, Jan, *Australians and the gold rush – California and Down Under 1849–1854*, University of California Press, Berkeley and Los Angeles, 1966

Moyal, Ann, *Clear across Australia – a history of telecommunications*, Thomas Nelson Australia, Melbourne, 1985

Nangle, James, OBE FRAS, *The Sydney Observatory – its history and work*, Sydney Technical College, 1930

Norman Lindsay's ship models, preface and commentary by Norman Lindsay, foreword by Douglas Stewart, photographed by Quinton F Davis, Angus & Robertson, Sydney, 1966

Pogue, William R, *How do you go to the bathroom in space?*, a Tom Doherty Associates Book, New York, 1985

Ritchie, John, *Lachlan Macquarie – a biography*, Melbourne University Press, 1988

Scale model sailing ships, edited by John Bowen, Conway Maritime Press Ltd, 1979

Schofield, Anne and Fahy, Kevin, *Australian jewellery: 19th and early 20th century*, David Ell Press, Sydney, 1990

Science and reform – selected works of Charles Babbage, edited by Anthony Hyman, Cambridge University Press, 1989

Simpson, Margaret, *Old Sydney buildings – a social history*, Kangaroo Press, Kenthurst, NSW, Australia

Sladen, Christopher, *The conscription of fashion – utility cloth, clothing and footwear 1941–1952*, Scolar Press, London, 1995

Smolders, Peter, *Living in space – a manual for space travellers*, Airlife, England, 1986

Swade, Doron, *Charles Babbage and his Calculating Engines*, Science Museum, London, 1991

Taylor, Peter, *An end to silence – the building of the overland telegraph line from Adelaide to Darwin*, Methuen of Australia, Sydney, 1980

Trevelyan, G M, *English social history*, The Reprint Society, London, 1944

von Solodkoff, Alexander, *Masterpieces from the House of Fabergé*, Abradale Press, New York, 1989

Ward, Russel, *Australia – a short history*, Ure Smith, Sydney, 1975

White, Harrison C and Cynthia A, *Canvases and careers: institutional change in the French painting world*, Wiley, New York, 1965

Willis, J L, *From Palace to Powerhouse: the first 100 years*, unpublished manuscript

Ella Lotah at the Powerhouse – a sense of 'Degas vu'!

PHOTOGRAPHIC CREDITS

All single objects illustrated are in the collection of the Powerhouse Museum except where otherwise indicated. Installation views may include Powerhouse objects and/or loan items.

Cover
View of *Cats on the prowl* exhibition of Jaguar cars. Foreground car, 1949 Jaguar XK120 lent by, and reproduced with permission from, Michael R. Downey. Photograph by Penelope Clay.

Introduction
page 1
Crowds queuing to see the 1996 exhibition, *Treasures from the Kremlin: the world of Fabergé.* Photograph by Scott Donkin.
pages 2–3
The Powerhouse Museum (detail). Photograph by Andrew Frolows.
page 4
The Powerhouse Museum. Photograph by Andrew Frolows.
pages 4–5
Miniature reproduction of fifteenth-century German armour, by Paul Hardy, England, c1890. Height 680 mm; width 280 mm; depth 110 mm. Gift of Mrs M Cippico, 1965. Photograph by Sue Stafford. H7652
pages 6, 9, 10
Screenprints from a suite, *Blueprint for a museum of the future*, by Eduardo Paolozzi, Germany, 1981 (6 black and white, 1 colour). Height 750 mm; width 630 mm. Gift of Ove Arup & Partners, 1986. Photograph by Penelope Clay. © Eduardo Paolozzi 1997. All rights reserved DACS. 86/1407/1:6 and 86/1408
page 7
Space suit used aboard *Soyuz TM 10* in 1990. Purchased 1994. Photograph by Andrew Frolows. 94/65/1
page 8
A view of aircraft in the museum. Photograph by Penelope Clay.
page 11
Objects in one of the museum's storage warehouses. Photograph by Nitsa Yioupros.
pages 12–13
A view over the *Transport* exhibition. Photograph by Andrew Frolows.

When one Dior opens
pages 14–15
A view of the 1994 exhibition, *Christian Dior: the magic of fashion.* Photograph by Sue Stafford. Collection and © Archives Christian Dior/Collection and © UFAC.
pages 16–17
Christian Dior bridal gown, *Fidelité (Fidelity)*, 1949. Photograph by Sue Stafford. © Archives Christian Dior.
page 17
Guitar with laser beams in place of strings. Photograph by Andrew Frolows.
page 17
Costume, *Gingham woman*, by Brenton Heath-Kerr (1962–95), 1991. Purchased 1994. Photograph by Penelope Clay. Reproduced courtesy of Brendon Williamson and Irene Flanagan. 94/111/2
page 18
(top) Marcel Duchamp (France) 1887–1968
Bicycle wheel 1913, (reconstructed by Galleria, Milan 1964, No 4 of edition of 8); painted wooden stool and bicycle wheel; bicycle wheel 64.8 (d) cm, mounted on stool 50.4 (h) cm
Collection: National Gallery of Australia, Canberra

© Copyright 1964 Marcel Duchamp/ADAGP. Reproduced by permission of VI$COPY, Sydney 1997.
(below) Andy Warhol (United States) 1930–87
Electric chair 1967 synthetic polymer paint screen printed onto canvas 137.2 x 185.1 cm
Collection: National Gallery of Australia, Canberra. © 1997 Andy Warhol Foundation for the Visual Arts/ARS, New York.
page 19
(top) Imants Tillers (Australia) born 1950
Mount Analogue 1988 oil stick, synthetic polyer paint on 165 canvas boards 279.0 x 571.0 cm.
Collection: National Gallery of Australia, Canberra. Reproduced with permission from Imants Tillers.
(below) Eugène von Guérard Austria 1811–Australia 1901
North-east view from the northern top of Mount Kosciusko 1863 oil on canvas 66.5 x 116.8 cm.
Collection: National Gallery of Australia, Canberra.
pages 20–21
Logo at the entrance to *Real wild child*, designed by Reg Mombassa, Sydney, 1994. Photograph by Andrew Frolows.
pages 22, 23
Real wild child featured the story of Johnny O'Keefe. Photographs: (p. 22) by Andrew Frolows, (p. 23) by Jane Townsend.
page 24
(top left) Steam engine made by Maudslay, Sons & Field, England, 1837. Height 3825 mm; width 3825 mm; depth 870 mm. Gift of Mr W J Bartlett, 1929. Photograph: Powerhouse Museum. B558
page 24
(inset, below) Interactive mixing desk. Photograph by Andrew Frolows.
pages 24–25
(main picture) Amplified, electronic drum kit modified by museum Interactives staff. Photograph by Andrew Frolows.
(inset) A visitor demonstrates the drum kit. Photograph by Penelope Clay.
pages 26–27
Costume worn by the singer William Shakespeare, designed by Billy Goodwin in 1977. Purchased 1995. Photograph by Penelope Clay. 95/212/1
page 27
A *Real wild child* exhibition view. Photograph by Andrew Frolows.
pages 28–29
Exhibition views of the museum's *Christian Dior: the magic of fashion* exhibition. Photographs by Sue Stafford. Collection and © Archives Christian Dior/Collection and © UFAC.
page 30
Christian Dior bridal gown, *Fidelité (Fidelity)*, 1949. Photograph by Sue Stafford. Collection of and © Archives Christian Dior.
page 31
Christian Dior three-piece day ensemble, 1950. Purchased 1994. Photographs by Penelope Clay. 94/37/1
pages 32–33
Christian Dior ivory silk satin evening sheath dress, 1957. Purchased 1994. Photographs by Penelope Clay. 94/47/1
page 34
Know-how: the guide to innovation in Australia CD-ROM. Photograph by Sue Stafford.
page 35
(top) A re-creation of Ken Done's cabin studio for the museum's exhibition, *Ken Done: the art of design*.
(below) The real studio. Photographs by Penelope Clay. Reproduced with permission from Ken Done AM.
pages 36–37
Winners in the 1995 Australian *Student fashion awards* exhibition. (left to right) Melinda Hordicek; Ilias

Fotopoulos; Kimbra Doran; Joanne Rapa, Janet Irving and Lilian Rosa; and Nicole Serjeant. Photograph by Sue Stafford.
page 38
Nicole Serjeant based her creation on a space suit. Photographs by Sue Stafford. Collection of, and reproduced courtesy of Nicole Serjeant.
page 39
(top and top right) Details as page 38, above.
(lower left) Space suit used aboard *Soyuz TM 10* in 1990. Purchased 1994. Photograph by Andrew Frolows. 94/65/1
page 40
(main picture) The Mary MacKillop Commemorative Toile, designed by Pamela Griffith in 1993. Gift of Mary MacKillop Secretariat, 1993. Photograph by Penelope Clay. Reproduced courtesy of the Trustees of the Sisters of St Joseph. 93/147/1
(inset) Outfit by Nicole Serjeant, incorporating the MacKillop Toile. Photograph by Sue Stafford. Collection of, and reproduced courtesy of, Nicole Serjeant.
page 41
Outfit by Jocelyn Pitsillidi, *CD-ROM*. Photograph by Sue Stafford. Collection of, and reproduced courtesy of, Jocelyn Pitsillidi.
page 42
Costume, *Cotton blossom*, 1993–94, by Ron Muncaster. Purchased 1996. Photograph by Marinco Kojdanovski. 96/305/2
page 43
Costume, *Mardi Gras*, 1990, by Peter Tully (1947–92). Photograph by Sue Stafford. Reproduced courtesy of Merlene Gibson. 95/172/1
page 44
Costume, *Gingham woman*, 1991, by Brenton Heath-Kerr (1962–95). Purchased 1994. Photograph by Penelope Clay. Reproduced courtesy of Brendon Williamson and Irene Flanagan. 94/111/2
page 45
Costume, *Woodwoman*, 1993 by Brenton Heath-Kerr (1962–95). Purchased 1994. Photograph by Marinco Kojdanovski. Reproduced courtesy of Brendon Williamson and Irene Flanagan. 94/111/1

A model museum
pages 46–47
Model of a 1934 C30 Cierva autogiro. Height 420 mm; width 820 mm; depth 820 mm. Purchased 1935. Photograph by Scott Donkin. H3824
pages 48–49
Locomotive 3801. Photograph by Jane Townsend.
page 49
(inset) Model of Locomotive 3801 (see pages 51–53 for details)
(top right) Qantas Boeing 747-400 aircraft model, *Wunala Dreaming*, design mock-up by John and Ros Moriarty, Balarinji, 1993–94. Height 300 mm; width 660 mm; length 700 mm. Gift of Qantas Airways Ltd. Photograph by Andrew Frolows. Reproduced with permission from Balarinji and Qantas Airways Ltd. 95/103/1
page 50
Locomotive No. 1. Height 4.22 m; width 2.2 m; length 7.3 m. Gift of the NSW Government Railways, 1884. Photograph: Powerhouse Museum. 7949
pages 51, 52–53
Locomotive models, NSWGR 38 Class 'Pacific' 3801 and 3830, researched and commissioned by Precision Scale Models, Melbourne, Australia; made by Samhongsa Company, South Korea, 1995. Length 363 mm; width 62 mm; height 73 mm. Purchased 1996. A model of Locomotive 3801 and a model of Locomotive 3830 were also generously donated to the museum by

193

Precision Scale Models for the purpose of fundraising for the conservation of Locomotive 3830. Photographs by Penelope Clay. Reproduced courtesy of Mr John Sargent. 96/113/1:2

pages 54–61
Steam locomotive 3830 undergoing restoration. Height 4.3 m; width 2.95 m; depth 3.3 m. Purchased 1988. Photographs by Scott Donkin and Andrew Frolows. 88/4D

pages 54–55
Photographs by Andrew Frolows.

pages 56–57
(main picture) Photograph by Andrew Frolows.
(insets from top left) Photograph by Scott Donkin.
Photograph by Andrew Frolows.
Photograph by Andrew Frolows.
Photograph by Andrew Frolows.
Photograph by Andrew Frolows.

page 58
Photograph by Andrew Frolows.

page 59
Photograph by Andrew Frolows.

pages 60–61
Photograph by Andrew Frolows.

page 62
The real Qantas *Nalanji Dreaming* aircraft takes off. Reproduced with permission from Qantas Airways Ltd and Balarinji.

pages 62–63
Qantas Boeing 747-338 aircraft model, *Nalanji Dreaming*, with livery by John and Ros Moriarty of Balarinji, 1995–96. Height 300 mm; width 640 mm; length 720 mm. Gift of Qantas Airways Ltd, 1996. Photograph by Sue Stafford. Reproduced with permission from Balarinji and Qantas Airways Ltd. 96/233/1

page 64
Qantas Boeing 747-338 aircraft model, *Nalanji Dreaming* (see above for details), and Qantas Boeing 747-400 aircraft model, *Wunala Dreaming*, livery by John and Ros Moriarty, Balarinji, 1993–94. Height 300 mm; width 640 mm; length 720 mm; and height 300 mm; width 660 mm; length 700 mm, respectively. Gift of Qantas Airways Ltd. Photograph by Andrew Frolows. Reproduced with permission from Balarinji and Qantas Airways Ltd. 96/233/1 and 95/103/1 respectively

page 65
The real Qantas *Wunala Dreaming* takes off. Reproduced with permission from Qantas Airways Ltd and Balarinji.

pages 66, 67
(top centre) Details from a silk scarf which is part of the merchandising exclusively available to passengers on Qantas *Nalanji Dreaming* flights. Gift of Qantas Airways Ltd. Photographs by Sue Stafford. Reproduced with permission from Balarinji and Qantas Airways Ltd.

page 67
(top left) Scarf, *River turtle*, designed by John and Ros Moriarty for Balarinji. Purchased 1994. Photograph by Penelope Clay. Reproduced with permission from Balarinji. 94/8/1

page 67
(bottom) *Wunala Dreaming* sandshoes, painted by the Balarinji Studio in 1995. Above them is the card which accompanied the sandshoes. Gift of Qantas Airways Ltd, 1996. Photographs by Scott Donkin. 96/297/1

page 68
Model of a 1934 C30 Cierva autogiro. Height 420 mm; width 820 mm; depth 820 mm. Purchased 1935. Photograph by Scott Donkin. H3824

pages 68–69
1934 Cierva C30A autogiro. Height 3370 mm; length 5910 mm. Purchase funded by the Andrew Thyne Reid Charitable Trust, 1979; restoration funded by the Thyne Reid Education Trust No. 1, 1991. Photograph by Andrew Frolows. B2361

pages 70–71
Model of Her Majesty's ship *Sirius*, made by Geoffrey Ingleton R N, 1937. Scale 1:20. Height 1970 mm; width 680 mm; length 2130 mm. Presented, Australian Sesqui-centenary Committee, 1938. Photographs: Powerhouse Museum. H4052

pages 72–73
Model of a brig (c1775), made in 1963 by Commander S L Beeston RAN of Newcastle. Scale 1:48. Length 860 mm; width 350 mm; height 750 mm. Purchased 1963. Photograph by Penelope Clay. Reproduced courtesy of Elizabeth Gibson. B1517

page 74
Acrylic architectural model, *Split level house*, designed by Ken Woolley and Michael Dysart in Sydney in 1962 for Pettit and Sevitt merchant builders; model made by R & F Modelmakers Pty Ltd. Scale 1:25. Width 835 mm; depth 835 mm. Purchased 1992. Photographs by Scott Donkin. Reproduced courtesy of Brian Pettit/Ronald Sevitt/Ken Woolley/Michael Dysart/Porter Models. 92/1995

pages 74, 75
Model of an English warship (c1750) of the third rate, made by Captain S D Kirk of Sydney, 1975–1978. Scale 1:75. Length 1410 mm; width 670 mm; height 1060 mm. Gift of Captain S D Kirk, 1978. Photograph by Penelope Clay. Reproduced courtesy of Captain Stan Kirk. B2345

page 76
Joseph Mallord William Turner (1775–1851) *The Fighting Temeraire, tugged to her last berth to be broken up*, 1838, 1839 oil on canvas 90.8 x 121.9 cm. Collection: National Gallery, London (BJ377). Reproduced courtesy of the Trustees, The National Gallery, London.

page 77
Robert Klippel making a ship model for the Navy in 1944. Reproduced courtesy of Robert Klippel.

page 78
(top) Defensively equipped merchant ship model, made by Robert Klippel in 1942. Height 80 mm; width 55 mm; length 170 mm. Gift of Robert Klippel, 1972. Photograph by Jane Townsend. Reproduced courtesy of Robert Klippel. B1977:3

(below) Tim Morris doing conservation work on *Le canot imperial*, made by G Scardinale, Australia, 1975–1980. Gift of G Scardinale, 1982. Height 400 mm; width 930 mm; depth 320 mm. Photograph by Penelope Clay. Reproduced with permission from Australian Navy Models di G Scardinale e Sons. B2442

page 79
(top) Minesweeper model, HMAS *Bombo*, made by Robert Klippel in 1941, set in painted plaster seascape by John Allcot, in three-sided wooden box. Width 260 mm; height 110 mm; length 290 mm. Gift of Robert Klippel, 1972. Photograph by Jane Townsend. Reproduced courtesy of Robert Klippel. B1977:2

(below) Pilot ship model, made by Robert Klippel in 1940, set in a painted plaster seascape by John Allcot. Height 90 mm; width 120 mm; length 265 mm. Gift of Robert Klippel, 1972. Photograph by Jane Townsend. Reproduced courtesy of Robert Klippel. B1977:5

page 80
406 mm repeating circle, Reichenbach, Munich, Germany, c1820. Acquired 1983. Photograph: Powerhouse Museum. H9892

page 81
(left) Detail of a 70 mm transit refractor telescope, Edward Troughton, London, c1820. Acquired 1983. Photograph: Powerhouse Museum. H9891

(right) Refractor telescope, 29 cm, made by Hugo Schroeder, Hamburg, Germany, in 1874. Acquired 1983. Photograph by Andrew Frolows. H9886

page 82
(top) Sydney Observatory. Photograph by Andrew Frolows.

(below) The time ball at Sydney Observatory. Acquired 1984. Photograph by Andrew Frolows. H10401

page 83
The 1:3 scale *Soyuz 4-5* model. Length 10 m; height 5 m; width 4 m. *Luna 9* replica. Height 3.86 m; width 2.4 m; depth 2.7 m. Purchased 1997. Photograph by Sue Stafford. 97/2/9 and 97/2/2

pages 84–85
A view of the Powerhouse Museum's *Space: beyond this world* exhibition. Photograph by Peter Garrett.

page 86
(top) Cosmic ray detector, designed by Dr Ken McCracken, Australia, manufactured by Ball Brothers Research Corporation, USA, 1965. Photograph by Penelope Clay. Lent for the museum's *Space: beyond this world* exhibition by, and reproduced with permission from, Dr Ken McCracken.

(below) Space food from 1968 *Apollo 8* mission. Purchased 1995. Photograph by Jane Townsend. 95/48/2

pages 86–87
Full size replicas of the *Lunakhod* remotely controlled Moon roving vehicle; 3.11 m high x 2.8 m wide x 4.8 m long and the *Soviet Mars 3* probe (at left); 2.8m high x 3.3m wide x 2.2m deep. Purchased 1997. Photograph by Sue Stafford. 97/2/3 and 97/2/4

page 88
The Space Shuttle *Endeavour* lifts off. Photograph courtesy of NASA.

page 89
Space debris from the *Skylab* space station which crashed in 1979. Height .25 m; width 1 m; length 1 m. Purchased from the Crome Bequest, 1994. Photograph by John Graham. 94/254/1

page 90
Resolution and *Adventure* medal struck by Matthew Boulton in 1772 to commemorate Captain Cook's second voyage. Diameter 42 mm. Purchased 1977. Photograph by Scott Donkin. N20846

page 91
Crew of the Space Shuttle *Endeavour* in May 1996. Photograph courtesy of NASA.

pages 92–93
Soviet male and female 'waste management devices'. Collector dimensions (excluding tubes etc): male (left): 450 mm deep x 250 mm high x 130 mm wide; female: 370 mm deep x 250 mm high x 130 mm wide. Purchased 1997. Photographs by Scott Donkin. 97/4/1 and 97/4/2

page 93
Space razor from the *Soyuz 16* mission in 1974. Height 85 mm; width 65 mm; depth 43 mm. Purchased 1997. Photograph by Scott Donkin. 97/3/1

pages 94–95
View of *Space: beyond this world* exhibition. The MMU backpack is a loan from Lockheed Martin Astronautics, Denver, USA. The reproduction space suit is a gift of the US Information Agency. Photograph by Peter Garrett.

The Babbage enigma
pages 96–97
A component from the museum's specimen piece of the Babbage Difference Engine No. 1. Purchased October 1995. Photograph by Scott Donkin. 96/203/1

pages 98–99
The museum's specimen piece of the Babbage Difference Engine No.1 after conservation. Height 300 mm; width 380 mm; length 300 mm. Purchased October 1995. Photograph by Scott Donkin. 96/203/1

page 99
(left) Dr Neville Babbage (left) with Dr Michael Babbage. Photograph by Scott Donkin.

(right) A component from the Babbage Difference Engine No. 1. Photograph by Scott Donkin.

page 100

(top) Carey Ward, museum conservator, Terence Measham, and Allan G Bromley, Associate Professor, Computer Science, University of Sydney, study the Babbage's componentry. Photograph by Scott Donkin.

pages 100–105

The museum's Specimen Piece of Babbage's Difference Engine No. 1 during various stages of conservation. Photographs by Scott Donkin.

page 106

Watercolour miniatures of Charles Babbage and his fiancée, Georgiana Whitmore, 1813. Photograph lent by, and reproduced courtesy of, Dr N Babbage.

page 107

The portion of Charles Babbage's Difference Engine No. 1 in the collection of the Science Museum, London. 720 mm x 590 mm x 610 mm. Photograph: Science & Society Picture Library, London.

page 108

British 22p postage stamp featuring Charles Babbage, released in 1991. Height 41 mm; width 38 mm. Purchased 1996. Photograph by Sue Stafford. Reproduced by permission of the British Post Office. 96/137/1

page 109

United Kingdom Royal Mail first day cover and insert, 'Scientific achievements', 1991. Featuring four stamps (from left): Michael Faraday (electricity), Charles Babbage (computer), Robert Watson-Watt (radar) and Frank Whittle (jet engine). Width 115 mm; length 216 mm. Purchased 1996. Photograph by Sue Stafford. Reproduced by permission of the British Post Office. 96/137/2

page 110

Gothic-revival walnut secretaire, designed by John Dibblee Crace, England, 1862. Height 2065 mm; width 1200 mm; depth 585 mm. Purchased 1992. Photograph by Sue Stafford. 92/296

page 111

(left) One of two letters written by Countess Ada Lovelace to Charles Babbage, 1838 and 1847. Width 115 mm; length 185 mm. Purchased October 1995. Photograph by Sue Stafford. 96/203/2

(right) Portrait of Ada Lovelace, c1844. Collection: The Earl of Lytton. Reproduced courtesy of the Earl of Lytton/Science & Society Picture Library, London.

Gilt by association

pages 112–113

A Sydney Mint display. Photograph by Andrew Frolows.

pages 114, 115

Views of the exhibition at the Sydney Mint. Photograph by Sue Stafford.

page 115

(top) Detail of infantry officer's dress sword, c1850. Height 81 mm; width 95 mm; length 962 mm. Gift from the estate of Miss Margaret Swann, 1989. Photograph by Scott Donkin. 89/804

pages 116, 117

Armchair owned by Governor Lachlan Macquarie. Height 1310 mm; width 703 mm; depth 584 mm. Transferred to the museum by the Vancouver City Museum in 1961. Photographs: details page 116 by Scott Donkin; page 117 by Andrew Frolows. H6862

pages 118–119

Infantry officer's dress sword. c1850. Height 81 mm; width 95 mm; length 962 mm. Gift from the estate of Miss Margaret Swann, 1989. Photograph by Scott Donkin. 89/804

page 118

Watercolour painting of *Honeysuckle Banksia* by Ellis Rowan (1848–1922). Height 758 mm; width 563 mm.

Gift of Sydney Technical College, 1922. Photograph by Geoff Friend. P2592

page 120

(top) Watercolour portrait miniature, *General Sir Ralph Darling*, gold frame, by Henry Edridge, England, c1805. Height 64 mm. Purchased 1995. Photograph by Sue Stafford. 95/151/1

(below) Rare Queen Victoria gold half sovereign with minting error ('sovrreign'), Sydney Mint, Australia, 1858. Diameter 19 mm. Purchased 1995. Photograph by Scott Donkin. 95/49/1

page 121

Hyde Park Barracks, Sydney. Photograph by Roger Deckker.

pages 122–123

The Sydney Mint on Macquarie Street. Photographs by Andrew Frolows.

pages 124–125

(main picture) A selection of coins on display at the Sydney Mint. Photograph by Penelope Clay. (inset) The rear courtyard of the Sydney Mint. Photograph by Andrew Frolows.

page 126

The Garden Palace, destroyed by fire in 1882. Photograph: Powerhouse Museum.

page 126

The Jubilee Nugget (also known as the Maitland Bar Nugget). Weight 10.7 kg; containing 8.87 kg of gold. Lent to the Sydney Mint by the NSW Department of Mineral Resources. Photograph by Scott Donkin.

page 127

A display in the *Gods, gowns and dental crowns* exhibition at the Sydney Mint. Photograph by Sue Stafford.

pages 128–129

(main picture) Interior, Sydney Mint. Photograph by Sue Stafford.

(inset, top) Gold brooch produced by Hogarth, Erichsen & Co. in Sydney c1858. Height 53 mm; length 66 mm. Purchased 1976. Photograph by Andrew Frolows. A6486

(insets, below) Gold bracelet produced by Hogarth, Erichsen & Co. in Sydney c1858. Height 55 mm. Lent anonymously for exhibition at the Sydney Mint. Photograph by Andrew Frolows. Reproduced with permission from the owner.

page 130

This display at the Sydney Mint features a gilded Erard harp in the Grecian style, made in London about 1815, and a girandole (mirror with candle sconces attached) made in the 1860s. Gift of Dr Joseph Brown, and gift of Mrs Caroline Simpson, respectively, both through the Taxation Incentives for the Arts Scheme. Photograph by Sue Stafford. 93/379/1, 93/285/1

page 131

Silver figure of an Aboriginal man, by Julius Hogarth, c1854–1860. Height 150 mm; diameter 75 mm. Purchased 1996. Photographs by Andrew Frolows. 96/22/1

page 132

(top) Painting, *Mermaid, the owner and the trainer*, by Frederick Woodhouse Snr, Australia, 1871. Purchased 1994. Photograph by Andrew Frolows. 94/223/2

pages 132, 133

The 1871 Sydney Gold Cup, by Sydney silversmith, Christian Ludwig Qwist (1818–77). 25 cm high; 458 grams. Purchased 1994. Photograph by Andrew Frolows. 94/223/1

page 134

Windscreen of Boeing 747 aircraft, made by PPG Industries and The Boeing Company, USA, 1960–1980. Height 960 mm; width 1540 mm. Gift of Qantas Airways, 1996. Photograph by Sue Stafford. 96/154/1

page 135

Wheel-thrown stoneware bottle, glazed with 24 carat gold lustre, crazed, by Alan Peascod, Canberra, Australia, 1984. Height 390 mm; width 260 mm; diameter of mouth 40 mm; diameter of base 80 mm. Purchased 1984 with the assistance of the Crafts Board of the Australia Council. Photographs by Scott Donkin. Reproduced courtesy of Alan Peascod. A9881

Truth and transparency

pages 136–137

Detail of full-size, sectioned Audi 200 Turbo automobile, designed and manufactured by Audi AG, Germany, in 1986. Gift of TKM Automotive Australia Pty Ltd, 1996. Photograph by Scott Donkin. 96/155/1

pages 138–139

Possibly the first X-ray tube used in Australia, 1896. Gift of the Hon H M Doyle, MLC, 1941. Length 200 mm; diameter 80 mm. Photograph by Sue Stafford. H4327

page 139

(left) Petrological microscope. See page 146 for details.

(right) The Transparent (or Plastic) Woman. Purchased 1954. Photograph by Geoff Friend. H5789

pages 140–141

Full-size, sectioned Audi 200 Turbo automobile, designed and manufactured by Audi AG, Germany, in 1986. Gift of TKM Automotive Australia Pty Ltd, 1996. Photograph by Scott Donkin. 96/155/1

page 141

(top) Full-size, sectioned 7M-GTE Toyota Supra, Toyota Motor Corporation, Japan, 1987. Gift of Toyota Motor Corporation, 1988. Photograph: Powerhouse Museum. 88/771

page 142

(left) Booklet, *The transparent woman*, produced by the Museum of Applied Arts and Sciences in the 1950s. Photograph by Sotha Bourn.

(right) Porcelain nude figure, *Bather surprised*, Royal Worcester, 1882. Height 662 mm; width 215 mm. Purchased 1883. Photograph by Sue Stafford. A2776

page 143

The Transparent (or Plastic) Woman. Purchased 1954. Photograph by Geoff Friend. H5789

pages 144, 145

Taking precautions exhibition views. Photographs by Andrew Frolows.

page 146

Petrological microscope, Watson & Sons, London, early 20th century. Height 440 mm; width 246 mm; depth 184 mm. Acquired (ex museum stock) 1956. Photograph by Sue Stafford. H5600

page 147

Binocular microscope, Pickard and Curry, London, England, 1875–1925. Height 565 mm; width 170 mm; depth 250 mm. Gift of Mrs O Vickery, 1980. Photograph by Sue Stafford. H9490-4

Crystal clear

pages 148–149

Rectangular, fused glass bowl-form, by Klaus Moje, Canberra, ACT, 1990. Height 70 mm; width 440 mm; length 445 mm. Purchased 1991. Photograph by Sue Stafford. Reproduced courtesy of Klaus Moje. 91/83

pages 150, 151

Three glass goblets with teapot-shaped stems, by US artists, Richard Marquis and Dante Marioni, while on tour in Australia in 1994. Left to right: Height 257 mm; diameter 90 mm; height 250 mm; diameter 117 mm; height 190 mm; diameter 130 mm. Purchased 1994. Photographs by Scott Donkin. Reproduced courtesy of Richard Marquis and Dante Marioni. 94/104/2, 94/104/3, 94/104/1

page 151
Glass bowl, *Devilish chaos*, by Toots Zynsky. See page 162 for details.

pages 152–153
A *Klaus Moje: a retrospective exhibition* view. Reproduced courtesy of Klaus Moje. Photograph by Andrew Frolows.

page 154
(right) Circular, fused glass bowl-form, by Klaus Moje, Canberra, Australia, 1990. Height 80 mm; diameter 535 mm. Purchased 1991. Photograph by Sue Stafford. Reproduced courtesy of Klaus Moje. 91/82
(below left) Glass dish by Klaus Moje, Canberra, Australia, 1985. Diameter 390 mm. Purchased with the assistance of the Crafts Board of the Australia Council and Mojo MDA, 1985. Photograph: Powerhouse Museum. Reproduced courtesy of Klaus Moje. 85/654

page 155
Bowl of choices, glass, by Richard Morrell, Melbourne, Australia, 1993. Height 250 mm; width 250 mm; depth 170 mm. Purchased 1993. Photograph by Scott Donkin. Reproduced courtesy of Richard Morrell. 93/441/1

pages 156, 157
Glass *Strawberry goblet*, by Richard Clements, Tasmania, Australia, 1994. Height 225 mm; width 100 mm. Purchased 1995. Photograph by Scott Donkin. Reproduced courtesy of Richard Clements. 95/22/1

page 158:
Glass sculpture, *Kite*, by Bertil Vallien, Sweden, 1989. Length 1170 mm; width 230 mm; height (including stand) 300 mm. Purchased 1996. Photographs by Penelope Clay. Reproduced courtesy of Bertil Vallien, Eriksmala, Sweden. 96/202/1

page 159
Sphere of lead glass, *Cylinder in the spheric space*, by Stanislav Libensky and Jaroslava Brychtova, Czechoslovakia, 1981, consisting of three pieces. Purchased 1983. Diameter 300 mm. Photograph by Scott Donkin. Reproduced with permission from Stanislav Libensky and Jaroslava Brychtova. 83/A9560

page 160
Dale Chihuly at work in Seattle. Photographs courtesy of Dale Chihuly.

page 161
(main picture) An exhibition view of the Dale Chihuly exhibition at the Powerhouse Museum in 1993. Photgraph by Andrew Frolows.
(insets) Dale Chihuly at work in Seattle. Photographs courtesy of Dale Chihuly.

page 162
Glass bowl, *Devilish chaos*, by Toots Zynsky, Netherlands/France, 1995, 240 x 310 x 201 mm. Acquired 1995. Photographs by Penelope Clay. Reproduced courtesy of Elliott Brown Gallery, Seattle, Washington. 96/16/1

pages 164, 165
Lantern-shaped pleated polyester dress by Issey Miyake, Tokyo, Japan, 1995. Purchased 1995. Photograph by Sue Stafford. Reproduced courtesy of Issey Miyake. 95/143/1

pages 166–167
Exhibition views of the Powerhouse Museum's *Jewels of fantasy* exhibition, organised and sponsored by Swarovski. Photographs by Penelope Clay.

page 168
Glass vase, *Stone vessel*, by Garry Nash, New Zealand, 1996. Height 370 mm; diameter 380 mm. Purchased 1996. Photograph by Sue Stafford. Reproduced with permission from Garry Nash. 96/197/1

page 169
Samples of material used in plastics production. Photograph by Penelope Clay.

The magic of Moscow

pages 170–171
Visitors admiring the Moscow Kremlin Egg. Photograph by Scott Donkin.

pages 172, 175, 176, 177
The Moscow Kremlin Egg was made by the House of Fabergé, St Petersburg, 1904–06. It was a present from Emperor Nicholas II to Empress Alexandra Fyodorovna for Easter 1906. Egg and stand: height 361 mm; base 185 mm x 185 mm. Collection of and © Moscow Kremlin State Museum-Preserve of History and Culture. Photographs by Sue Stafford and Scott Donkin.

page 173
(left) Fabergé cigarette case (see page 184 for details).
(right) Trans-Siberian Express Egg, made by the House of Fabergé, 1900 (see page 179 for details).

page 174
William Dobson (1611–46), Britain, *Charles Gerard, 1st Earl of Macclesfield* oil on canvas 71.5 x 60.5 cm (sight size). Collection and photograph: Dunedin Public Art Gallery.

page 178
Pablo Picasso (1881–1973), *Bottle of 'Vieux Marc', Glass, Guitar and Newspaper* 1913 various on paper 46.7 x 62.5 cm. Collection: Tate Gallery, London. Photograph by John Webb. Photo: Tate Gallery, London. ©Succession Picasso/DACS 1997.

page 179
Trans-Siberian Express Egg, made by the House of Fabergé, 1900. Egg and stand: height 260 mm; length of train 398 mm; height of coach 26 mm. Photographs by Sue Stafford and Scott Donkin. Collection of and © Moscow Kremlin State Museum-Preserve of History and Culture.

page 180
(top) Miniature train from Trans-Siberian Express Egg, made by the House of Fabergé, 1900 (see above for details).
(below) The palace from within the Alexandrovsky Palace Egg, made by the House of Fabergé, 1908 (see below for details).

page 181
The Alexandrovsky Palace Egg, made by the House of Fabergé, 1908. Egg: 110 mm x 68 mm; palace 30 mm x 65 mm. Photographs by Sue Stafford and Scott Donkin. Collection of and © Moscow Kremlin State Museum-Preserve of History and Culture.

page 182
The jewellery curator from the Kremlin's Armoury Museum, Tatiana Muntian, examining the Alexandrovsky Palace Egg. Photograph by Scott Donkin.

pages 182–183
Crowds queuing to see the Powerhouse Museum's blockbuster 1996 *Treasures from the Kremlin: the world of Fabergé* exhibition. Photograph by Scott Donkin.

page 184
(left) Fabergé cigarette case made in St Petersburg between 1896 and 1908. Length 95 mm; width 63 mm. Bequeathed to the museum by Edmond Monson Paul in 1953. Photograph by Scott Donkin. A4431
(above) Fabergé miniature figurine of a cat, c1890. Height 45 mm; width 28 mm; depth 46 mm. Purchased 1966. Photograph by Scott Donkin. A5360

page 185
Fabergé ornamental basket, carved from solid transparent quartz stone, c1890. Height 990 mm (with handle raised); width 68 mm; depth 64 mm. Purchased 1965. Photograph by Scott Donkin. A5285

Coda

page 186
Susan Harrison performing at the Powerhouse museum with the Flying Lotahs during the *Circus: 150 years in Australia!* exhibition in 1996 and 1997. Photograph by Scott Donkin.

page 187
(top) Clown make-up and other material used by Guillaume Jandaschewsky; part of the museum's Jandaschewsky collection (279 objects), used 1860–1940. Purchased 1995. Photograph by Sue Stafford. 95/28/54; 95/28/175; 95/28/47; 95/28/49
(below) Shalmay musical clown instrument used by Theo Zacchini, Wirths Circus c1960. Photograph by Sue Stafford. Lent for *Circus: 150 years in Australia!* exhibition by, and reproduced with permission from, the Zacchini family.

page 188
Natural trumpet, copy of a 1746 instrument, commissioned from Robert Barclay, Ottawa, Canada, in 1995. Length 750 mm; height 135 mm; diameter 110 mm. Photograph by Sue Stafford. 95/224/1

page 189
Two violins, one viola and one cello, by Kitty Smith, Sydney, 1955–1964. Purchased from the Crome Bequest, 1994. Photographs by Sue Stafford. 94/230/1:4.

page 190
Receipt for violinist Claude des Matins, court of Louis XIV, France, 1675. Height 280 mm; width 205 mm. Purchased from the Crome Bequest, 1995. Photograph by Sue Stafford. 95/96/1

pages 190–191
A violin display in the Powerhouse Museum. Photograph by Marinco Kojdanovski.

page 192
Ella Lotah at the Powerhouse. A sense of 'Degas vu'! Photograph by Scott Donkin.

page 200
View of *Cats on the prowl* exhibition of Jaguar cars. Foreground car, 1949 Jaguar XK120 lent by, and reproduced with permission from, Michael R. Downey. Photograph by Penelope Clay.

Endpaper
Tallboy, *Cityscape*, made of fibreboard clad with aluminium, screenprinted with black enamel sign-writer's ink, by Patrick Hall, Tasmania, Australia, 1991. Height 1300 mm; width 600 mm; depth 350 mm. Purchased 1995. Photographs by Sue Stafford. 95/5/1

INDEX

Produced by The Beagle Press
Designed by Catherine Martin
Text edited by Julia Cain
Printed by Toppan Singapore
Published by The Powerhouse Museum 1997
© Trustees of the Museum of Applied Arts
and Sciences
First published 1997 by Powerhouse Publishing,
part of the Museum of Applied Arts and Sciences
PO Box K346 Haymarket NSW 1238 Australia
http:\\www.phm.gov.au

Cataloguing in Publication data

Measham, Terence
Discovering the Powerhouse Museum.

Bibliography.
Includes index.
ISBN 1 86317 063 4.
ISBN 1 86317 062 6 (pbk).

1. Powerhouse Museum. 2. Museums - New South
Wales - Sydney. I. Powerhouse Museum. II. Title.
069.09941

Distributed by Peribo
58 Beaumont Road Mount Kuring-gai
NSW 2080

View of *Cats on the prowl*
exhibition of Jaguar cars.
Foreground car, 1949
Jaguar XK120 lent by,
and reproduced with
permission from, Michael
R Downey.

Endpapers
Tallboy, *Cityscape*, made of fibreboard
clad with aluminium, screenprinted
with black enamel sign-writer's ink, by
Patrick Hall, Tasmania, Australia,
1991. Height 1300 mm; width 600
mm; depth 350 mm. Purchased 1995.
Photographs by Sue Stafford. 95/5/1